A Course on Partial Differential Equations

Equations

Walter Craig

DEPARTMENT OF MATHEMATICS & STATISTICS, MCMASTER UNIVERSITY, HAMILTON, ONTARIO L8S 4K1 CANADA

E-mail address: craig@math.mcmaster.ca

2010 *Mathematics Subject Classification.* Primary 35

Partially supported by the Canada Research Chairs Program, the Fields Institute, and by NSERC with grant number 238452-11.

Contents

Preface

Under the wave off Kanagawa. K. Hokusai 1829-33.

This textbook is intended to cover material for an introductory course in partial differential equations (PDEs), aimed for fourth year undergraduate or a first year graduate mathematics students. The material focuses on the three most important aspects of the subject; namely (i) theory, which is to say the questions of existence, uniqueness and continuous dependence on given data or on parameters, (ii) phenomenology, meaning the study of properties of solutions of the PDEs that we examine, and (iii) applications, by which we mean that we will make an attempt to exercise good scientific taste in choosing the topics in this text, often based on physical or geometrical applications. In taking up this subject, it is invariable that there are

many editorial choices that one must make. The area of PDEs is not a topic, rather it is a a union of numerous areas of research, with different sources of problems, motivations and goals. My own point of view in this area has been strongly influenced by my teachers and colleagues; Louis Nirenberg, Jürgen Moser, Henry McKean, Joe Keller, Constantine Dafermos, as well as my many friends and collaborators, including Catherine Sulem, Claude Bardos, Jean-Claude Saut, Eugene Wayne, Sergei Kuksin and Håkan Eliasson. Members of my McMaster PDE class in 2015-2016 helped with the preparation of the text and the figures for this publication; for their input I would like to thank in particular Alexandr Chernyavsky, Nikolay Hristov, Kyle Mac-Donald, and Adam Sliwiak. As well I want to extend a special thanks to Shaniyemu Nijiati (Nia) for her rendering of numerous figures. However the material itself in this text and its presentation is based on my own judgement and experiences, both scientific and pedagogical, and responsibility for omissions and incompleteness are entirely my own. The present form of the course material follows from having given courses on partial differential equations many times over the years; certainly I have taught similar courses during my time on the faculty at McMaster University. But the kernel of the course material also comes from previous experiences with the graduate Mathematical Physics course at Stanford University, the two-semester sequence of courses on Partial Differential Equations at Brown University, and a year-long graduate course in PDEs at the Fields Institute in Toronto, in conjunction with the year-long thematic program on PDEs. I am hopeful that the point of view we adopt in this text, which brings phenomenology and applications along with the theory, and which intends to introduce the class to a spectrum of techniques, will be useful to students entering the field.

Walter Craig,
Hamilton Ontario

Introduction

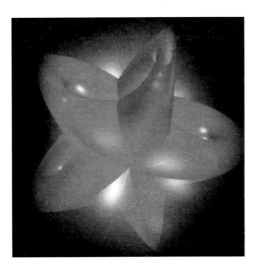

Wente Torus: a genus-one surface of constant nonzero mean curvature discovered by Henry Wente in 1986. Image made in 1988 by Jim Hoffman and Yi Fang from the Geometry, Analysis, Numerics & Graphics research group at the University of Massachusetts and the Mathematical Sciences Research Institute.

1.1. Overview of the subject

It is the irony of taking university courses that one doesn't understand the real reason for studying a subject until one knows it already and has been steeped in its culture. With this paradox in mind, I will attempt to give an

introduction that will motivate the material we are going to address in this course, so we can at least start with a sense of its content.

The first questions are possibly 'Where do partial differential equations (PDEs) arise, and why are they useful?'. In fact, the language of the sciences is mathematics (the joke has it that the language of the sciences is English with an accent). Many if not most statements in the physical sciences are in the form of mathematical equations, and the vast majority of these are differential equations, quantifying the change of one quantity in terms of others. Indeed, equations describing physical, chemical and sometimes biological phenomena are for the most part PDEs, and the same statement holds for the engineering sciences.

Disciplines of mathematics such as geometry and dynamical systems also often give rise to PDEs. Conditions such as (i) a surface is of minimal area, (ii) a submanifold is invariant under a flow, (iii) a mapping is conformal, or (iv) the curvature tensor satisfies a particular property, are PDEs. For example, the statement that "the tensor $(g_{\mu\nu})$ is an Einstein metric for a manifold M" is a system of PDEs.

The course material will discuss the most commonly occurring PDEs, and the implications that it has for a function u to be a solution. We are particularly interested in knowing whether solutions exist, whether thay are unique, and what their properties are of smoothness, positivity, etc.

1.2. Examples

Some common PDEs, including situations where they appear as descriptions of mathematical properties of an object.

Conformal mappings. A mapping between two Euclidian spaces $x \in \mathbb{R}^n \mapsto u(x) \in \mathbb{R}^N$ can be explicitly locally represented as

$$x = (x_1, \ldots, x_n) \in \mathbb{R}^n \mapsto u(x) = (u_1(x), \ldots, u_N(x)) \in \mathbb{R}^N$$
$$u : x \mapsto u(x) .$$

A conformal mapping is one that preserves angles. The tangent space of the image of the mapping $u(x)$ is spanned by the vectors $(\partial_{x_1} u, \ldots \partial_{x_n} u)$. Set $n = N = 2$ for our example. In the x-variables the tangent vector fields $e_{x_1} = (1, 0)$ and $e_{x_2} = (0, 1)$ are orthogonal and have the same length in the domain \mathbb{R}^2; a conformal mapping $u(x)$ must preserve this property for the two tangent vectors $\partial_{x_1} u$ and $\partial_{x_2} u$ in the image;

$$(1.1) \qquad \partial_{x_1} u \cdot \partial_{x_2} u = 0 , \quad |\partial_{x_1} u|^2 = |\partial_{x_2} u|^2 .$$

The equations (1.1) are equivalent to the Cauchy – Riemann equations for either $u = (u_1(x_1, x_2), u_2(x_1, x_2))$ or for $\overline{u} = (u_1(x_1, x_2), -u_2(x_1, x_2))$. That

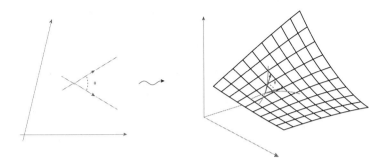

Figure 1. A conformal mapping between \mathbb{R}^n and its image as a submanifold of \mathbb{R}^N

is, either u is holomorphic (analytic) in $x_1 + ix_2$

$$(1.2) \qquad \partial_{x_1} u_1 = \partial_{x_2} u_2 \ , \quad \partial_{x_2} u_1 = -\partial_{x_1} u_2$$

or else u is anti-holomorphic

$$(1.3) \qquad \partial_{x_1} u_1 = -\partial_{x_2} u_2 \ , \quad \partial_{x_2} u_1 = \partial_{x_1} u_2 \ .$$

The study of such mappings is thus a central topic of complex analysis. Problem 1.1 of this chapter is to show that (1.1) implies either (1.2) or (1.3).

Laplace's equation. Starting with the Cauchy Riemann equations (1.2) and differentiating again, we have

$$\partial_{x_1}^2 u_1 = \partial_{x_1}(\partial_{x_2} u_2) = \partial_{x_2}(\partial_{x_1} u_2) = -\partial_{x_2}^2 u_1 \ ,$$

thus

$$(1.4) \qquad (\partial_{x_1}^2 + \partial_{x_2}^2)u_1 = 0 \ ,$$

that is u_1 is *harmonic*. The same goes for u_2 of course. The operator $\Delta = \partial_{x_1}^2 + \partial_{x_2}^2$ is called the *Laplacian*; its higher dimensional version is

$$(1.5) \qquad \Delta u := (\partial_{x_1}^2 + \cdots + \partial_{x_n}^2)u(x) = \left(\sum_{j=1}^{n} \partial_{x_j}^2\right)u(x) \ .$$

In general Laplace's equation is

$$(1.6) \qquad \Delta u = 0 \ ,$$

and in solutions of (1.6) are called *harmonic* as well. This equation is a principal example of an elliptic equation. The Laplacian operator appears very often in mathematics, partially because it is the only second order linear

differential operator which is invariant under the symmetries of Euclidian space, that is translations and rotations;

$$(1.7) \qquad x \mapsto y = x + c \, , \qquad\qquad x \mapsto y = Rx \, ,$$

with the rotation R represented by an orthogonal matrix $R^T = R^{-1}$. This is one elementary manifestation of the principle of relativity, which is that equations which describe physical phenomena should be invariant under symmetries of the underlying space.

The heat equation. Given coordinates of time and space as $(t, x) = (t, x_1, \ldots x_n) \in \mathbb{R}^{1+n}$, the heat equation for a function $u(t, x)$ is

$$(1.8) \qquad \partial_t u = \Delta u \, ;$$

it is the principal example of a parabolic equation. It was originally derived to study problems of heat conduction, and it occurs very often in probability and in problems of gradient flow, among other places.

The wave equation. Again in coordinates $(t, x) \in \mathbb{R}^{1+n}$ of space-time, the wave equation for a function $u(t, x)$ is

$$(1.9) \qquad \partial_t^2 u = \Delta u \, .$$

It is a principal example of a hyperbolic equation; we will study a number of related equations in the next chapter, including the case of the wave equation in one space dimension.

Maxwell's equations. The propagation of electromagnetic radiation is governed by Maxwell's equations, the derivation of which is a towering achievement of 19^{th} century science. This is a system of equations coupling two vector quantities in \mathbb{R}^3, the electric and the magnetic vector fields;

$$(1.10) \qquad E(t, x) = (E_1(t, x), E_2(t, x), E_3(t, x))$$
$$B(t, x) = (B_1(t, x), B_2(t, x), B_3(t, x)) \, .$$

These six functions satisfy the coupled system of equations

$$(1.11) \qquad \begin{aligned} \partial_t E &= \nabla \times B - 4\pi j \, , \\ \partial_t B &= -\nabla \times E \, , \\ \nabla \cdot E &= 4\pi \rho \, , \\ \nabla \cdot B &= 0 \, . \end{aligned}$$

This is a system of 8 equations for the six components of (E, B). The vector calculus notation is that the divergence operator $\nabla \cdot E$ is

$$\nabla \cdot E := \partial_{x_1} E_1 + \partial_{x_2} E_2 + \partial_{x_3} E_3 = \sum_{j=1}^{3} \partial_{x_j} E_j$$

and the curl is given by

$$\nabla \times B := (\partial_{x_2} B_3 - \partial_{x_3} B_2, \partial_{x_3} B_1 - \partial_{x_1} B_3, \partial_{x_1} B_2 - \partial_{x_2} B_1) \ .$$

The function $\rho(t, x)$ of the third line of system (1.11) represents the electric charge density and vector function $j(t, x) = (j_1(t, x), j_2(t, x), j_3(t, x))$ of the first line is the electric current density. If there were magnetic monopoles, as there are electrons, protons and other electrically charged particles, then the other two equation components would have the analogous magnetic charge and current densities.

Proposition 1.1. In the case that $\rho = 0$ and $j = 0$ (the conditions for electromagnetic wave propagation in a vacuum) Maxwell's equations (1.11) are equivalent to wave equations for the components of the electric and the magnetic fields.

Proof. In the case $\rho = 0$ and $j = 0$, one differentiates the equations (1.11) to find;

$$\partial_t^2 E = \partial_t (\nabla \times B) = \nabla \times (\partial_t B)$$
$$= -\nabla \times (\nabla \times E) = -(-\Delta E + \nabla(\nabla \cdot E))$$
$$= \Delta E \ .$$

This is to say that each component of the electric field $E_j, j = 1, 2, 3$ satisfies individually the wave equation (1.9). The second line of this calculation uses a vector calculus identity and the fact that in a vacuum $\nabla \cdot E = 0$. There is a similar calculation for the components of the magnetic field. $\quad\square$

The standard three equations above, namely the wave equation, the heat equation and Laplace's equation are linear constant coefficient and of second order, however this short list of equations of interest is far from being exhaustive. Many other forms of equations, both linear and nonlinear, occur frequently.

Monge – Ampère equations. This equation arises when a mapping $u(x) : \mathbb{R}^n \mapsto \mathbb{R}^n$ is constructed as the gradient of a potential function $u(x) = \nabla f(x)$. If the mapping is required to be volume preserving, then $f(x)$ satisfies the Monge – Ampère equation

$$(1.12) \qquad\qquad \det(\partial_{x_j} \partial_{x_\ell} f(x)) = 1 \ .$$

Similar equations play a role in the construction of Calabi – Yau metrics on manifolds. The matrix of second partial derivatives of a function $f(x)$ is known as the *Hessian* of f, and (1.12) is a fully nonlinear equation for f involving the determinant of the Hessian of f. If the function f is convex

then this is an elliptic equation. We note in this context that the Laplacian is the trace of the Hessian

$$\Delta f = \operatorname{tr}\left(\partial_{x_j}\partial_{x_\ell} f\right) .$$

Schrödinger's equation. The complex valued function $\psi(t,x) = X(t,x) + iY(t,x)$ is called the *wave function* of quantum mechanics when it solves the equation

$$(1.13) \qquad\qquad i\partial_t \psi = -\tfrac{1}{2}\Delta\psi + V(x)\psi .$$

The lower order coefficient $V(x)$ is called the *potential term*; it serves to represent the environment in which the quantum particle evolves. A commonly occurring nonlinear Schrödinger equations is

$$(1.14) \qquad\qquad i\partial_t \Psi = -\tfrac{1}{2}\Delta\Psi + c|\Psi|^2\Psi ,$$

where the local intensity $|\Psi|^2$ of the wave function creates its own potential. This nonlinearly self-interacting potential has the effect of focusing the wave function when $c < 0$ and defocusing it when $c > 0$.

Einstein's equations. In general relativity our space-time is a manifold M^4 with a metric tensor $g = (g_{\mu\nu}(x))$ with Lorentzian signature. The Riemann curvature tensor $(R_{ijk\ell})$ is a certain nonlinear function of the metric coefficients and their derivatives, $R_{ijk\ell}(g, \partial_{x_j}g, \partial_{x_j x_\ell}g)$, as is the Ricci curvature tensor $(R_{\mu\nu})$. Einstein's equations in a vacuum consist of the system of partial differential equations

$$R_{\mu\nu} - \tfrac{1}{2}Rg_{\mu\nu} = 0 ,$$

where $R = \operatorname{tr} R_{\mu\nu} = \sum_{\mu\nu} R_{\mu\nu}g^{\mu\nu}$ is the scalar curvature tensor. The Einstein summation convention allows us to omit the summation symbol over repeated indices in the latter expression, so it can be represented as $R = R_{\mu\nu}g^{\mu\nu}$. When energy and/or matter are present, Einstein's equations become

$$(1.15) \qquad\qquad R_{\mu\nu} - \tfrac{1}{2}Rg_{\mu\nu} = T_{\mu\nu} ,$$

where T is the energy - momentum tensor.

Minimal surfaces. Given a mapping $u : D \to \mathbb{R}^N$ defined on a domain D, the surface area of the image is

$$A(u) := \int_D \sqrt{\det(\partial_{x_j} u \cdot \partial_{x_\ell} u)}\, dx .$$

In the case that the mapping u is given as a graph of a function $f(x)$ over $D \subseteq \mathbb{R}^n$ (where $N = n+1$), namely that $u(x) = (x_1, \ldots, x_n, f(x))$, then

$$A(f) = \int_D \sqrt{1 + (\partial_x f)^2}\, dx .$$

A *minimal surface* is the result of a mapping for which the area functional $A(u)$ is minimal (or at least a critical point), generally with given additional constraints such as boundary conditions. That is to say, the variations of A about u all vanish, namely

$$0 = \delta A(u) \cdot v := \frac{d}{d\tau}\Big|_{\tau=0} A(u + \tau v)$$

for all variations $v(x)$ such that $u + \tau v$ continues to satisfy the constraints. For the case where $n = 2$, and for a graph, if f is such a critical point then it must satisfy the partial differential equation

$$(1.16) \quad (1 + (\partial_{x_2} f)^2)\partial_{x_1}^2 f + (1 + (\partial_{x_1} f)^2)\partial_{x_2}^2 f - 2\partial_{x_1} f \partial_{x_2} f \partial_{x_1} \partial_{x_2} f = 0 \ .$$

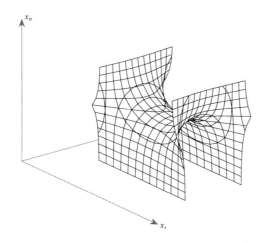

Figure 2. A minimal surface that is a graph in \mathbb{R}^3 whose boundary lies on a specified curve.

The Navier – Stokes equations. In Eulerian coordinates on describes a fluid in motion in a region $D \subseteq \mathbb{R}^n$ by its velocity vector field $u(t, x) = (u_j(t, x))_{j=1}^n$ at each point of D and at eact time t. An incompressible but viscous fluid will satisfy the system of equations

$$(1.17) \qquad\qquad \partial_t u + (u \cdot \nabla)u + \nabla p = \nu \Delta u \ ,$$
$$\nabla \cdot u = 0 \ .$$

The *pressure* $p(t, x)$ can be thought of as the extra degrees of freedom that allow the flow determined by (1.17) to satisfy the constraint of incompressibility $\nabla \cdot u = 0$. The vorticity of the fluid is given by $\omega(t, x) := \nabla \times u$. It is an open question whether every solution of (1.17), even given smooth initial data, will remain smooth at all future times.

Exercises: Chapter 1

Exercise 1.1. Prove that statement (1.1) characterizing conformal mappings implies that either (1.2) or (1.3) holds.

Exercise 1.2 (*). Determine the class of conformal mappings in the case that $n = N \geq 3$. The conditions (1.1) are much more rigid than in two dimensions.

Exercise 1.3. Prove that the Laplacian (1.6) is invariant under Euclidian symmetries (1.7).

Exercise 1.4. In dimension $n = 2$ some elementary harmonic functions are polynomials, they include:

$$u(x) = x_j , \quad j = 1, 2 ,$$
$$u(x) = x_1^2 - x_2^2 , \quad u(x) = x_1 x_2 .$$

How many independent harmonic polynomials are there of general degree ℓ?

When the dimension $n \geq 3$ how many independent harmonic polynomials of degree ℓ are there?

Exercise 1.5. Prove the vector calculus identity

$$\nabla \times (\nabla \times V) = -\Delta V + \nabla(\nabla \cdot V) ,$$

for a vector fields $V(x)$, where in our notation the gradient of a function F is

$$\nabla F = (\partial_{x_1} F, \ldots, \partial_{x_n} F) .$$

Wave equations

Wind blown ocean waves at sunrise. Lindsay imagery/iStock/Getty Images Plus

We will start the topic of PDEs and their solutions with a discussion of a class of wave equations, initially with several transport equations and then for the standard second order wave equation (1.9) in one space dimension. We will use this mission as motivation to introduce the Fourier transform.

2.1. Transport equations - the Fourier transform

The transport equation is a first order equation that describes the displacement of a quantity u in a background that possesses a (possibly) variable

wave velocity $c(t, x)$, namely

$$(2.1) \qquad\qquad \partial_t u + c(t, x) \cdot \partial_x u = 0 \ .$$

This typically gives rise to an *initial value problem*, where one asks that

$$u(0, x) = f(x) \ .$$

The function $f(x)$ is called the *initial data*. The problem is to describe how the solution $u(t, x)$ evolves, given its initial 'shape' $f(x)$ at $t = 0$. Often these equations are known as first order wave equations for the unknown function $u(t, x)$. The coefficient $c(t, x)$ is a vector, known as the 'speed of propagation', we will see the reason for this when we describe the solution process.

A first example is given by the case of c, the speed of propagation, is a constant; we will solve this using the Fourier transform. For convenience restrict ourselves to one space dimension. The process is elementary, but nevertheless it serves to introduce a surprisingly powerful technique for the study of PDEs.

Definition 2.1. The Fourier transform of a function $f(x)$ is given by

$$(2.2) \qquad\qquad \hat{f}(\xi) = \frac{1}{\sqrt{2\pi}} \int_{-\infty}^{+\infty} e^{-i\xi y} f(y) \, dy := \mathcal{F} f(\xi) \ .$$

One aspect of the power of the Fourier transform is its invertibility.

Theorem 2.2 (Fourier inversion formula). *Under suitable hypotheses on $f(x)$, there is an inversion formula for the Fourier transform*

$$f(x) = \frac{1}{\sqrt{2\pi}} \int_{-\infty}^{+\infty} e^{i\xi x} \hat{f}(\xi) \, d\xi \ .$$

At a later point we will discuss the hypotheses under which this theorem holds in much more detail; for now a perfectly reasonable condition would be that $f \in L^2(\mathbb{R})$, that is

$$\left(\int_{-\infty}^{+\infty} |f(x)|^2 \, dx \right)^{\frac{1}{2}} := \|f\|_{L^2(\mathbb{R})} < +\infty \ .$$

The Fourier transform is well adapted for representing derivatives.

Proposition 2.3. Under further suitable hypotheses,

$$\partial_x f(x) = \frac{1}{\sqrt{2\pi}} \partial_x \int_{-\infty}^{+\infty} e^{i\xi x} \hat{f}(\xi) \, d\xi = \frac{1}{\sqrt{2\pi}} \int_{-\infty}^{+\infty} \partial_x(e^{i\xi x}) \hat{f}(\xi) \, d\xi$$

$$= \frac{1}{\sqrt{2\pi}} \int_{-\infty}^{+\infty} e^{i\xi x} \, i\xi \hat{f}(\xi) \, d\xi \ .$$

That is

(2.3)
$$\widehat{\partial_x f}(\xi) = i\xi \hat{f}(\xi) \ .$$

The suitable hypotheses mentioned above will be needed in order to justify the Fourier inversion formula and the exchange of the derivative ∂_x with the integral in the above calculation.

Let us assume that the propagation speed c in (2.1) is constant, and that the solution $u(t, x)$ satisfies the required hypotheses of Proposition 2.3 at each time t (to ultimately have a rigorous argument this assumption must be verified, but for the present we will not do so). Then in order to be a solution of (2.1) the function

$$u(t, x) = \frac{1}{\sqrt{2\pi}} \int_{-\infty}^{+\infty} e^{i\xi x} \hat{u}(t, \xi) \, d\xi$$

must satisfy

$$(\partial_t + c\partial_x)u(t, x) = \frac{1}{\sqrt{2\pi}} \int_{-\infty}^{+\infty} e^{i\xi x}(\partial_t \hat{u} + ci\xi \hat{u})(t, \xi) \, d\xi = 0 \ .$$

Since the Fourier transform is invertible, this means that for all $\xi \in \mathbb{R}^1$,

$$\partial_t \hat{u}(t, \xi) + ic\xi \hat{u}(t, \xi) = 0 \ ,$$

and this is a straightforward ordinary differential equation (ODE) in time for each value of the Fourier transform variable ξ;

$$\partial_t v(t) + ic\xi v(t) = 0 \ ,$$

with solution

$$v(t) = e^{-ic\xi t} v(0) = e^{-ic\xi t} \hat{f}(\xi) \ .$$

Therefore an expression for our solution is

$$u(t, x) = \frac{1}{\sqrt{2\pi}} \int_{-\infty}^{+\infty} e^{i\xi x} \hat{u}(t, \xi) \, d\xi = \frac{1}{\sqrt{2\pi}} \int_{-\infty}^{+\infty} e^{i\xi x} \left(e^{-ic\xi t} \hat{f}(\xi) \right) d\xi$$

$$= \frac{1}{\sqrt{2\pi}} \int_{-\infty}^{+\infty} e^{i\xi(x-ct)} \hat{f}(\xi) \, d\xi = f(x - ct) \ .$$

The Fourier inversion formula was used in the last line. A picture of the evolution of a solution is given in Figure 1.

You could ask whether the identical procedure using the Fourier transform works for the case of a variable speed of propagation $c(t, x)$; it does not in general, nor for a time independent speed $c(x)$. However when $c(t)$ is independent of x the answer is 'yes' and a similar solution representation is possible. This is given as an exercise at the end of the section.

Figure 1. This is an example of the evolution of a solution of a transport equation.

2.2. Transport equations - the method of characteristics

There is a second method for solving equations of the form (2.1) which doesn't involve the Fourier transform. Again for simplicity we will take the case that $x \in \mathbb{R}^1$. Let $f \in C^1(\mathbb{R}^1)$, the space of once continuously differentiable functions, and examine the equation

$$(2.4) \qquad (\partial_t + c\partial_x)u = 0 \ .$$

This is the statement that the directional derivative of $u(t, x)$ in the $(1, c)$ direction in the (t, x) plane vanishes;

$$(1, c) \cdot (\partial_t, \partial_x)u = 0 \ .$$

That is to say, $u(t, x)$ is constant along lines with tangent direction $(1, c)$, and therefore for all x, x' such that $(x - x') = ct$ we have $u(t, x) = u(0, x') = f(x - ct)$. Verifying this for any initial data $f \in C^1(\mathbb{R}^1)$

$$\partial_t u(t, x) = \partial_t f(x - ct) = -cf'(x - ct) \ ,$$
$$c\partial_x u(t, x) = c\partial_x f(x - ct) = cf'(x - ct) \ ,$$

and the sum of the two terms cancels.

This observation extends to give a solution method for the general transport equation, which uses ordinary differential equations and which is known as the method of characteristics. Consider the equation

$$(2.5) \qquad \partial_t u + c(t, x)\partial_x u = 0 \ ,$$
$$u(0, x) = f(x) \ .$$

Interpret the statement (2.5) in terms of directional derivatives

$$(1, c(t, x)) \cdot (\partial_t, \partial_x)u = 0 \ ,$$

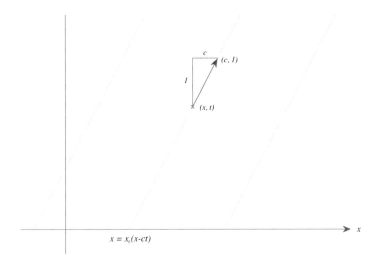

Figure 2. Geometric interpretation of a transport equation.

which in turn is the statement that $u(t, x)$ is constant along integral curves of the vector field $X = (1, c(t, x))$ in the (t, x) plane;

$$(2.6) \qquad X\, u(t, x) = (\partial_t + c(t, x)\partial_x)u = 0 \ .$$

The *characteristic equations* for the transport equation (2.5) are

$$(2.7) \qquad \frac{dt}{ds} = 1 \ , \qquad \frac{dx}{ds} = c(t, x) \ ,$$

whose solutions are the integral curves for X, called the *characteristic curves* of (2.5). This family of curves $(t(s) = s, x(s, \beta))$ is parametrized by the points $\beta \in \mathbb{R}^1$ at which the curves intersect the initial surface $\{t = 0\}$. Now define the solution by $u(t, x) = f(\beta)$, where $\beta = \beta(t, x)$ is the point of intersection with the initial surface of the characteristic curve which passes through (t, x). To verify that our construction satisfies the partial differential equation (2.5), evaluate $u = u(t(s), x(s))$ along a characteristic curve and use the chain rule

$$0 = \frac{d}{ds}u(t(s), x(s))$$
$$= \partial_t u \frac{dt}{ds} + \partial_x u \frac{dx}{ds} = \partial_t u + c(t, x)\, \partial_x u \ .$$

Two examples of transport equations with differing behavior are given by the following:

$$(2.8) \qquad \partial_t u + x\partial_x u = 0 \ ,$$

and

$$(2.9) \qquad \partial_t u + x^2 \partial_x u = 0 \ .$$

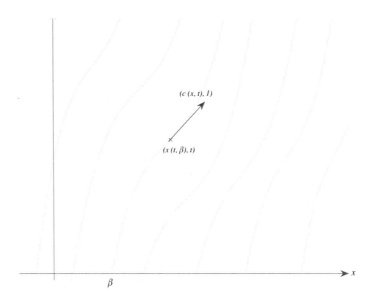

Figure 3. Characteristic curves of the vector field (2.6).

Exercise 2.3 asks to solve these two equations, giving a solution representation for the initial value problem $u(0, x) = f(x)$, using explicit expressions for the respective functions $\beta(t, x)$.

2.3. The d'Alembert formula

We now take up the study of the second order wave equation, starting with the one space dimensional case. In one dimension there is a particularly simple and explicit formula for solutions of

$$(2.10) \qquad \partial_t^2 u - \partial_x^2 u = 0 \ ,$$

$$u(0, x) = f(x) \ , \quad \partial_t u(0, x) = g(x) \ .$$

The initial data comprises the two functions f and g that are to be specified. Introduce characteristic coordinates

$$x + t := r \ , \quad x - t := s \ ,$$

so that the differential operators are transformed as follows:

$$\partial_t - \partial_x = 2\partial_r \ , \quad \partial_t + \partial_x = -2\partial_s \ ,$$

then equation (2.10) is transformed to

$$(2.11) \qquad (\partial_t - \partial_x)(\partial_t + \partial_x)u = -4\partial_r \partial_s u = 0 \ .$$

The meaning of equation (2.10) is now interpreted to be that $\partial_s(\partial_r u) = 0$, which is to say that $\partial_r u$ is independent of the variable s. That is,

$$\partial_r u = v(r)$$

for some function $v(r)$. Therefore, using $W = W(s)$ as an integration constant in the r-integral,

$$u(r, s) = \int^r v(r') \, dr' + W(s) := V(r) + W(s) \ .$$

Returning to the original variables (t, x) the solution takes the form

$$(2.12) \qquad u(t, x) = V(x + t) + W(x - t) \ ,$$

which has the interpretation of a decomposition of the solution $u(t, x)$ into a left-moving component V and a right-moving component W. That is, any solution of the one-dimensional wave equation (2.10) can be decomposed into the sum of a left-moving wave $V(x + t)$ and a right-moving wave $W(x - t)$.

The components V and W are to be expressed in terms of the initial data $u(0, x) = f(x)$ and $\partial_t u(0, x) = g(x)$. In order to do this, evaluate the expression (2.12) of the decomposition on the surface $x = 0$;

$$u(0, x) = V(x) + W(x) = f(x) \ ,$$

$$\partial_t u(0, x) = V'(x) - W'(x) = g(x) \ .$$

Differentiating the first line with respect to x and solving for V' and W', we find

$$V'(x) = \tfrac{1}{2} f'(x) + \tfrac{1}{2} g(x) \ , \quad W'(x) = \tfrac{1}{2} f'(x) - \tfrac{1}{2} g(x) \ ;$$

thus

$$V(x) = \tfrac{1}{2} f(x) + \tfrac{1}{2} \int_0^x g(x') \, dx' + c_1$$

$$W(x) = \tfrac{1}{2} f(x) - \tfrac{1}{2} \int_0^x g(x') \, dx' + c_2 \ ,$$

where necessarily $c_1 + c_2 = 0$. This is to say that

$$u(t, x) = V(x + t) + W(x - t)$$

$$(2.13) \qquad = \tfrac{1}{2} \big(f(x + t) + f(x - t) \big) + \tfrac{1}{2} \int_{x-t}^{x+t} g(x') \, dx' \ .$$

This is known as *d'Alembert's formula* for solutions of the one dimensional wave equation. We note that the wave equation is a second order partial differential equation, however (2.13) is well defined for data $f, g \in C(\mathbb{R}^1)$ (continuous functions) and gives a certain sense of a solution even though the resulting expression for $u(t, x)$ is not necessarily C^2. It gives a sense of *weak solution* to the wave equation in this case, a topic that will be explored more deeply at a later point.

The solution formula (2.13) shows how the solution u at a space-time point depends upon the initial data. Indeed at the point (t, x) the solution $u(t, x)$ depends only upon data in the backward *light cone*, and in particular it depends upon f at the two points $x \pm t$, and on $g(x')$ only over the interval

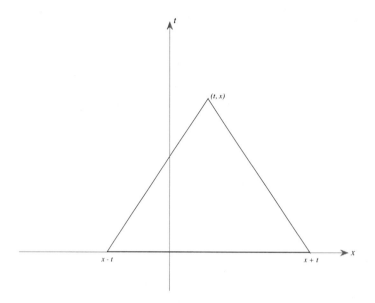

Figure 4. Solution of (2.10) using the d'Alembert formula (2.13), exhibiting the dependence on the initial data.

$x - t \leq x' \leq x + t$. This is an instance of solutions satisfying the principle of *finite propagation speed*. Defining the support of a function to be $\mathrm{supp}(h) := \overline{\{x \in \mathbb{R}^1 : h(x) \neq 0\}}$, and taking both (f, g) to have compact support, then if $\mathrm{supp}(f), \mathrm{supp}(g) \subseteq [-R, +R]$, then the support of the solution $u(t, x)$ satisfies $\mathrm{supp}(u(t, x)) \subseteq [-R - |t|, R + |t|]$ as can be seen in Figure 5. At time t the solution vanishes outside of the region $\{-R - |t| \leq x \leq R + |t|\}$, this property of finite propagation speed is called *Huygens' principle*, and is a common feature of solutions of wave equations. Furthermore, it is evident from the d'Alembert formula and Figure 5 that the solution $u(t, x)$ is constant *inside* the union of light cones emanating from the support of the initial data. Indeed, for $t > R$ and then for $|x| < t - R$,

$$u(t, x) = \tfrac{1}{2} \int_{x-t}^{x+t} g(x') \, dx' = \tfrac{1}{2} \int_{-R}^{+R} g(x') \, dx'$$

which is a constant, independent of both (t, x). This property is called the *strong Huygens' principle*; it holds for solutions of the wave equation (1.9) in odd space dimensions, but not in even space dimensions nor for most other wave equations.

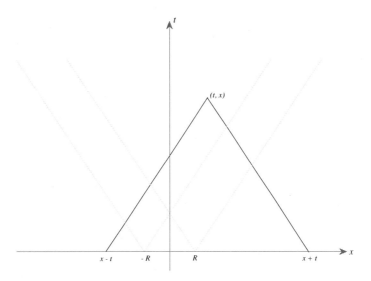

Figure 5. The d'Alembert formula (2.13) exhibits the principle of finite propagation speed and the strong Huygens principle.

2.4. The method of images

We have been discussing the initial value problem, or the *Cauchy problem* for the one dimensional wave equation, with initial data given for $x \in \mathbb{R}^1$. However in many situations the spatial domain has boundaries, on which the solution is normally required to satisfy additional boundary conditions. Such problems are called *initial - boundary value problems*. For the one dimensional problem let us take the case of the spatial domain $\mathbb{R}^1_+ := \{x > 0\}$, with the boundary at $x = 0$. Two typical boundary conditions are *Dirichlet conditions*

$$(2.14) \qquad\qquad\qquad u(t, 0) = 0 \ ,$$

and alternatively *Neumann conditions*

$$(2.15) \qquad\qquad\qquad \partial_x u(t, 0) = 0 \ .$$

Of course if the support of the initial data does not include $x = 0$, by the property of finite propagation speed the solution will satisfy the boundary conditions for a certain time interval. However even in this case the situation will not in general last for all time $t \in \mathbb{R}^1$. The method of images is a classical technique used to solve these two cases, and as well it works for some others.

The method as applied to the problem of Dirichlet boundary conditions is based on the simple fact that a function that is odd, $h(-x) = -h(x)$

and continuous at zero must necessarily satisfy $h(0) = 0$. Since the spatial domain is \mathbb{R}^1_+, the initial data $f(x), g(x)$ are only defined for $x \geq 0$. Assume for simplicity that both $f, g \in C(\overline{\mathbb{R}^1_+})$. We require that both $f(0), g(0) = 0$ as compatibility conditions between the initial and the boundary values of the solution. The method of images consists in defining $f(x) = -f(-x)$ and $g(x) = -g(-x)$ for $x < 0$, the odd reflections of $f(x)$ and $g(x)$ through the origin; these are defined and continuous on all of $x \in \mathbb{R}^1$. The d'Alembert formula gives a solution to the Cauchy problem, namely

$$u(t,x) = \tfrac{1}{2}\big(f(x+t) + f(x-t)\big) + \tfrac{1}{2}\int_{x-t}^{x+t} g(x')\,dx' \ .$$

For any $x > t$ this expression only involves the arguments of f, g for positive x, however for $x < t$ the expression involves negative arguments. To remedy this we use the fact that f, g are odd to rewrite the expression as

$$(2.16) \qquad u(t,x) = \tfrac{1}{2}\big(f(t+x) - f(t-x)\big) + \tfrac{1}{2}\int_{t-x}^{x+t} g(x')\,dx' \ .$$

The effect is that the solution satisfies Dirichlet boundary conditions as the expression for u is odd in x for each t; it is as though the solution is reflected off of the boundary with a negative mirror image of the incident signal, as in the Figure 6

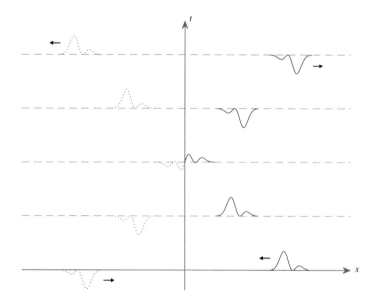

Figure 6. The method of images for Dirichlet boundary conditions.

In the case of Neumann boundary conditions at $x = 0$, ask that the boundary data $f, g \in C^1(\overline{\mathbb{R}^1_+})$ and that it satisfy the compatibility conditions

that

$$\partial_x f(0) = 0 = \partial_x g(0) \ .$$

Then reflect f, g to be even functions of $x \in \mathbb{R}^1$. We use the fact that an even function $h(x)$ whose first derivative is continuous at $x = 0$ must satisfy $\partial_x h(0) = 0$. Using the even property in the d'Alembert formula, for $x < t$

$$u(t, x) = \tfrac{1}{2}\big(f(x + t) + f(x - t)\big) + \tfrac{1}{2}\int_{x-t}^{x+t} g(x')\, dx'$$

$$= \tfrac{1}{2}\big(f(t + x) + f(t - x)\big) + \tfrac{1}{2}\int_{t-x}^{t+x} g(x')\, dx' + \int_0^{t-x} g(x')\, dx' \ .$$

The reflection of the solution off of the boundary is now a positive mirror image of the incident signal. There is also a component of the solution coming from the continuing reflection off the boundary of the contribution of g.

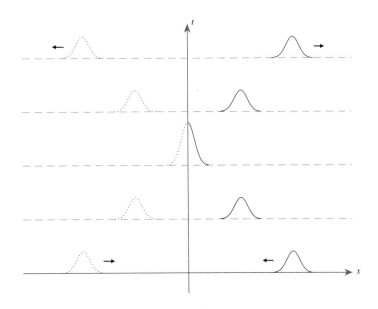

Figure 7. The method of images for Neumann boundary conditions.

One further case is where nonzero boundary conditions are imposed along the t-axis, for example one might specify the inhomogeneous data

(2.17) $u(t, 0) = h(t) \ ,$

along with the initial conditions

$$u(0, x) = f(x) \ , \qquad \partial_t u(0, x) = g(x) \ .$$

The wave equation is linear, so that a sum of two solutions is also a solution of the partial differential equations. Therefore we may take the solution to be a sum of two components; $u_1 = u_1(t, x)$ which solves (2.10) with zero boundary data (2.14), and a second solution $u_2(t, x)$ which has homogeneous initial data $f = g = 0$ but satisfying the requested boundary conditions (2.17). The first component u_1 can be expressed as above in (2.16). The second component can be taken to vanish for $t < x$ as backwards characteristics do not intersect the boundary for positive times t. However for $t > x$ define

$$u_2(t, x) = h(t - x) \, ,$$

which satisfies both the wave equation (2.10) and the boundary conditions (2.14). The full solution is then $u(t, x) = u_1(t, x) + u_2(t, x)$. This solution has its own compatibility conditions to satisfy. Namely $h(0) = f(0)$ to avoid discontinuities being introduced at $u(0, 0)$, then as well $\partial_t h(0) = g(0) = \partial_t u(0, 0)$, and finally $\partial_t^2 h(0) = \partial_t^2 u(0, 0) = \partial_x^2 u(0, 0) = \partial_x^2 f(0)$, to avoid incompatibilities in the first and second derivatives of the solution at $(t, x) = (0, 0)$.

2.5. Separation of variables

The method of separation of variables is a time-honored technique that, if one's information comes from the standard undergraduate mathematics textbook on partial differential equations, constitutes the entirety of the subject. In this section we will attempt to bring the topic to life by presenting it in several compelling contexts, working with the example of the wave equation. Other applications follow with straightforward modifications.

Wave equation. As a first example consider the wave equation

$$(2.18) \qquad \partial_t^2 u - \partial_x^2 u = 0 \, , \quad x \in (0, 2\pi)$$

as in (2.10), with Dirichlet boundary counditions

$$(2.19) \qquad u(t, 0) = 0 = u(t, 2\pi) \, .$$

The premise is to seek special solutions in the form of a product $u(t, x) = v(t) w(x)$, so that

$$(2.20) \qquad \partial_t^2 v \, w = v \, \partial_x^2 w \, ,$$

which implies that there is a common constant λ (ignoring possible zeros of v and w) such that

$$\frac{\partial_t^2 v}{v} = \lambda = \frac{\partial_x^2 w}{w} \, .$$

Here λ is necessarily a constant because the LHS depends only upon t while the RHS depends only on x. Thus the solution form (2.20) decomposes the problem into ordinary differential equations; an evolution problem for $v(t)$,

and an eigenvalue problem for an ordinary differential operator for $w(x)$. The eigenvalue problem is for $(w(x), \lambda)$, where the function $w(x)$ satisfies Dirichlet boundary conditions on $x \in (0, 2\pi)$;

$$(2.21) \qquad \partial_x^2 w = \lambda w , \quad w(0) = 0 = w(2\pi) .$$

Given an eigenfunction and an eigenvalue from this problem, the evolution equation for v is

$$\frac{d^2}{dt^2} v = \lambda v ,$$

with initial data $v(0) = a$, $\dot{v}(0) = b$ free to be specified. The eigenvalue problem (2.21) has a countable number of solutions, which in the case above are

$$w_k(x) = \frac{1}{\sqrt{\pi}} \sin(\tfrac{1}{2} kx) , \quad \lambda_k = -\frac{k^2}{4} , \quad k = 1, 2, \dots .$$

Thus we may choose countably many constants (a_k, b_k), $k = 1, 2 \dots$ such that

$$v_k(t) = a_k \cos(\omega_k t) + b_k \frac{\sin(\omega_k t)}{\omega_k} ,$$

with temporal frequencies $\omega_k = \sqrt{-\lambda_k} = \tfrac{1}{2} k$. For each $k \in \mathbb{N}$ this constitutes a two parameter family of such special solutions. Linear combinations of these special solutions give solutions to the initial value problem (2.10) with general initial data, and satisfying Dirichlet boundary conditions (2.19), as the following theorem attests.

Theorem 2.4. *The general solution of the initial-boundary value problem (2.18) is a linear superposition of these special solutions;*

$$u(t, x) = \sum_{k=1}^{+\infty} \left(a_k \cos(\omega_k t) + b_k \frac{\sin(\omega_k t)}{\omega_k} \right) \frac{1}{\sqrt{\pi}} \sin(\tfrac{1}{2} kx) ,$$

where initial data is specified by

$$u(0, x) = f(x) = \sum_{k=1}^{+\infty} a_k \frac{1}{\sqrt{\pi}} \sin(\tfrac{1}{2} kx)$$

$$\partial_t u(0, x) = g(x) = \sum_{k=1}^{+\infty} b_k \frac{1}{\sqrt{\pi}} \sin(\tfrac{1}{2} kx) .$$

Furthermore, the sine series used to describe $f(x), g(x)$ is complete as an orthonormal basis of the Hilbert space $L^2(0, 2\pi)$; thus any initial $f(x)$, $g(x) \in L^2$ can be represented by their Fourier sine series coefficients $(a_k, b_k)_{k \in \mathbb{N}}$, giving rise to a solution $u(t, x)$.

Quantum mechanics. There are a number of fundamental problems in mathematical physics, in particular in quantum mechanics, that have a central role in the foundations of condensed matter theory and of quantum chemistry. Indeed the connection between the evolution problem given in terms of the Schrödinger equation and the spectral problem presented by the Schrödinger operator is made through separation of the time variable. Two settings which continue to play a central role in the physical sciences are the quantum harmonic oscillator and the hydrogen atom. The fact that their full time evolution is captured in terms of the spectral problem is a basic fact that is related to the completeness of spectral representations.

Theorem 2.5. *Let* **A** *be a self adjoint operator on a Hilbert space H. Then its spectrum is contained in* \mathbb{R} *and its spectral representation is complete. If for some* $\lambda \in \mathbb{C}$ *the resolvant operator* $(\lambda \mathbf{I} - \mathbf{A})$ *is compact, then completeness means that there is a complete set of orthonormal eigenfunctions* $\{\psi_k \in H\}$, *whose eigenvalues are real:*

$$\mathbf{A}\psi_k = \lambda_k \psi_k \ , \quad \lambda_k \in \mathbb{R} \ ,$$

$$\|\psi_k\|_H^2 = 1 \ , \quad \langle \psi_k, \psi_\ell \rangle_H = \delta_{l\ell} \ .$$

The key point to using this theorem is to show that the operator **A** is self adjoint. For operators that are bounded on H this is equivalent to being Hermitial symmetric;

$$\langle \varphi, \mathbf{A}\psi \rangle_H = \langle \mathbf{A}\varphi, \psi \rangle_H \ .$$

In the case of unbounded operators including differential operators such as $\mathbf{A} = \frac{d^2}{dx^2}$, self-adjointness depends upon the operator and on boundary conditions. For example, for $\frac{d^2}{dx^2}$ one requires boundary conditions so that **A** is Hermetian symmetric, and as well one needs to produce a dense subspace $D_A \subseteq H$ of elements of H which satisfy the boundary conditions, with the property that the graph $(D_A, \mathbf{A}(D_A)) \subseteq H \times H$ is closed. We will not give a proof of this theorem, as it lies outside the main focus of the course.

Quantum harmonic oscillator: For $x \in \mathbb{R}^1$ the quantum harmonic oscillator describes the quantum mechanical wave functions that correspond to electron states that are confined by a quadratic potential well $V(x) = \frac{1}{2}x^2$;

$$\frac{1}{i}\partial_t \psi = -\frac{1}{2}\partial_x^2 \psi + \frac{1}{2}x^2 \psi \ .$$

By the method of separation of variables, the time evolution can be reduced to be

$$\psi(t, x) = e^{i\lambda_k t}\varphi_k(x) \ ,$$

where the boundary value problem for $\varphi_k(x)$ is the spectral problem

$$-\frac{1}{2}\frac{d^2}{dx^2}\varphi_k + \frac{1}{2}x^2\varphi_k = \lambda_k \varphi_k \ , \quad x \in \mathbb{R}^1 \ , \quad \psi_k \in L^2(\mathbb{R}^1) = H \ .$$

The eigenfunctions of this Schrödinger operator are the classical Hermite functions $\{h_k(x)\}_{k\in\mathbb{N}}$, whose eigenvaues are given by $\lambda_k = \frac{1}{2}k(k+1)$. The eigenfunction corresponding to the lowest eigenvalue is the ground state, in this case

$$h_1(x) = c_1 e^{-\frac{1}{2}x^2} , \quad \lambda_1 = \frac{1}{2} .$$

Hydrogen atom: In this case $x \in \mathbb{R}^3$ and one solves for the orbitals of electrons in the presence of the attractive Coulomb potential of the atomic nucleus. The Schrödinger equation describing this situation is

$$\frac{1}{i}\partial_t\psi = -\tfrac{1}{2}\Delta^2\psi - \frac{Z}{|x|}\psi .$$

Again, to solve this problem we separate variables in time and space to

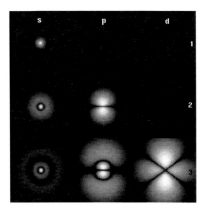

Figure 8. Cross section of probability densities $|\psi_n(x)|^2$ of electron orbitals of the hydrogen atom. Licensed under the Creative Commons Attribution-Share Alike 3.0 Unported.

reduce the question to a spectral problem;

$$(2.22) \qquad\qquad -\tfrac{1}{2}\Delta^2\varphi - \frac{Z}{|x|}\varphi = \lambda\varphi .$$

The eigenfunctions of this Schrödinger operator are the orbitals of electrons bound to the atomic nucleus. The spectral lines seen in atomic spectroscopy correspond to the differences in energy between these eigenstates. Besides the obvious scientific relevance of the spectrum and the structure of the eigenstates, the interest in this spectral problem is that it also is handled through separation of the spatial variables, for which one encounters an interesting variety of classical special functions. Indeed one writes $x = (r, \theta, \phi) \in \mathbb{R}^3$ in polar coordinates, and then making the Ansatz of a product decomposition

$$\varphi_k(x) = R_j(r)\Theta_\ell(\theta)\Phi_m(\phi) ,$$

one finds that $\Phi_m(\phi)$ are given in terms of complex exponentials, while $\Theta_\ell(\theta)$ are Legendre polynomials, and the radial dependence $R_j(r)$ is given in terms of Laguerre polynomials. The operator (2.22) has continuous spectrum for $\lambda \geq 0$ and an infinite number of discrete negative eigenvalues $\lambda_n = -\frac{C}{n^2}$, corresponding to the energies of bound electron orbitals.

Physics of music. In the hands of a good player, a musical instrument is a machine that creates a sequence of vibrations in the air that we enjoy as music. Different instruments produce these vibrations in different ways, which can be studied by modeling them mathematically.

Strings: Stringed instruments, from violins and basses to guitars to pianos, produce sounds from a bowed, plucked or hammered string, which is a taught elastic continuum that vibrates according to the wave equation (2.18) (with units chosen so that the speed of propagation in the string is $c = 1$). The string is held fast at the bridge ($x = 0$) and at the nut or by a musician's finger on the fingerboard (at $x = 2\pi$), hence the solution satisfies Dirichlet boundary conditions. According to our analysis of the initial-boundary value problem for the wave equation above, the eigenmodes $w_k(x)$ and eigenfrequencies ω_k of vibration of a string are given by

$$w_1(x) = \frac{1}{\sqrt{\pi}} \sin(\tfrac{1}{2}x) , \quad \omega_1 = -\sqrt{-\lambda_1} = \tfrac{1}{2}$$

$$w_2(x) = \frac{1}{\sqrt{\pi}} \sin(x) , \quad \omega_2 = -\sqrt{-\lambda_2} = 1 \ldots$$

$$w_k(x) = \frac{1}{\sqrt{\pi}} \sin(\tfrac{1}{2}kx) , \quad \omega_k = -\sqrt{-\lambda_k} = \tfrac{1}{2}k .$$

There is certainly a significance in the fact that the k^{th} frequency satisfies

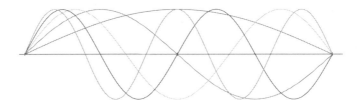

Figure 9. The first five eigenmodes of a string. Blue $= w_1(x)$, Orange $= w_2(x)$, Yellow $= w_3(x)$, Purple $= w_4(x)$ and Green $= w_5(x)$.

$\omega_k = k\omega_1$, forming an arithmetic progression. When a string is played, the resulting note is a superposition of the eigenfrequencies $\omega_1, \omega_2 \ldots$, with

some weights (a_k, b_k) which generally decrease in increasing k. These are the harmonics of the fundamental tone ω_1, namely $\omega_2 = 2\omega_1$ etc. Part of the skill of the musician is to control these weights, as our ear hears this combination of these frequencies, giving the character of the sound of the instrument. In fact the diatonic scale of western music, as well as the pentatonic scales of eastern music and the tone selections of many other music traditions, is based very closely on these frequency relations, see Table 1.

Table 1. Overtones of a string with their correspondance to the diatonic scale.

overtone	relation to fundamental	common name
ω_1		fundamental
ω_2	$2\omega_1$	octave
ω_3	$3\omega_1$	twelfth, or major fifth plus one octave
ω_4	$4\omega_1$	second octave
ω_5	$5\omega_1$	major third above second octave
ω_6	$6\omega_1$	major fifth above second octave
ω_7	$7\omega_1$	first anharmonic overtone
ω_8	$8\omega_1$	third octave

One may check the fact that the hammers of a piano are designed to strike the string at one seventh the distance from the end, which tends to suppress the presence of the anharmonic seventh overtone in the sound of the note.

Woodwinds: The vibrations in an air column of a wind instrument obey the Euler equations of fluid dynamics, which can be treated in the form of a linearized equation about constant ambient density ρ_0 and zero velocity. This is the system of equations

$$(2.23) \qquad \partial_t \rho + \rho_0 \partial_x v = 0 \ ,$$
$$\rho_0 \partial_t v + p'(\rho_0) \partial_x \rho = 0 \ ,$$

for small density variations $\rho(t, x)$ and small air velocities $v(t, x)$ in the air column of the instrument. The pressure $p(\rho)$ is determined as a function of ρ by a constitutive law. Taking an additional time derivative of the first equation (or the second) of (2.23), and then using the second (or the first, respectively) we are led to the two essentially equivalent wave equations

$$(2.24) \qquad \partial_t^2 v - p'(\rho_0) \partial_x^2 v = 0 \ ,$$
$$\partial_t^2 \rho - p'(\rho_0) \partial_x^2 \rho = 0 \ ,$$

which differ through treatment at the boundaries $x = 0, 2\pi$. The wave speed is $c = \sqrt{p'(\rho_0)}$, and we will take the liberty of choosing units so that

conveniently $c = 1$. Boundary conditions for $\rho(t, x)$, respectively for $v(t, x)$ vary according to the design of the instrument.

The flute: This instrument has a large hole at the mouthpiece and at the end of the active part of the flute body, which effectively imposes that the pressure of the air column in the flute coincides with atmospheric pressure at these two boundary points; this gives boundary conditions

$$\rho(t, 0) = 0 = \rho(t, 2\pi) \ , \quad \text{equivalently} \quad \partial_x v(t, 0) = 0 = \partial_x v(t, 2\pi) \ .$$

Solving for the density $\rho(t, x)$ using the method of separation of variables gives us the eigenmodes $w_k(x) = \pi^{-1/2} \sin(\frac{1}{2}kx)$, resulting in the expression

$$\rho(t, x) = \sum_{k \geq 1} \left(a_k \cos(\omega_k t) + b_k \frac{\sin(\omega_k t)}{\omega_k} \right) \frac{1}{\sqrt{\pi}} \sin(\tfrac{1}{2}kx) \ .$$

The frequencies are clearly $\omega_k = \frac{1}{2}k$ in our chosen units, and evidently $\omega_2 = 2\omega_1$, $\omega_3 = 3\omega_1$ *etc.* Typically only several overtones are present in a well-played flute note (so that $a_k \sim 0$, $b_k \sim 0$ for $k > 3$ or so) reflecting the purity and simplicity of the tone of the instrument. Overblowing the flute to the second overtone to achieve the second register of the instrument increases the tone by one octave.

The clarinet: The clarinet is roughly the same length as a flute and has a similar cylindrical air column, however the mouthpiece holds a reed in position which essentially closes this end. This imposes Dirichlet boundary conditions $v(t, 0) = 0$ for the velocity, while at the bell the boundary conditions are $\partial_x v(t, 2\pi) = 0$, the same as for the flute. Solving by separation of variables for the velocity in this instance, we find that the fundamental mode is $w_1(x) = \pi^{-1/2} \sin(x/4)$ with frequency $\omega_1 = 1/4$, while the higher eigenmodes are $w_k(x) = \pi^{-1/2} \sin((2k - 1)x/4)$ and the frequencies of the overtones are $\omega_k = \frac{1}{2}(k - \frac{1}{2})$. Evidently $\omega_1 = 1/4$, $\omega_2 = 3/4 = 3\omega_1$ and

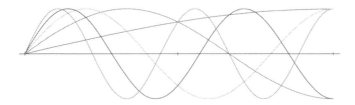

Figure 10. The first five eigenmodes of a clarinet. Blue $= w_1(x)$, Orange $= w_2(x)$, Yellow $= w_3(x)$, Purple $= w_4(x)$ and Green $= w_5(x)$.

$\omega_3 = 5/4 = 5\omega_1$ *etc.*. We remark that all of the even multiples of the fundamental frequency are absent, and that the lowest note of a clarinet is about one octave lower that that of a flute while they are about the same size of instrument. A clarinetist overblowing to the second overtone to achieve the second register of the instrument increases the tone by one twelfth, or one octave and a major fifth. This absence of even overtones is an explanation for the composer's rule of thumb, to write the clarinet parts above the string parts. Otherwise the strings may be obliged to accord their notes with overtones that are absent in the notes of the clarinet.

The oboe and the saxophone: Both the oboe and the saxophone are reed instruments; the saxophone uses a single reed similar to the clarinet, while the oboe has a famously difficult double reed arrangement. Both impose boundary conditions at the mouthpiece and at the bell similarly to the clarinet. However both overblow an octave rather than a twelfth. The answer to this conundrum is that they are both conical bore instruments, unlike the cylindrical bore clarinet, and must be analysed in terms of a three dimensional rather than a one dimensional air column. Making the reasonable assumption that the density variation in the air column (expressed in polar coordinates) is $\rho(t, r)$, namely independent of angles (θ, ϕ), the wave equation (2.24) becomes

$$\partial_t^2 \rho - p'(\rho_0)(\partial_r^2 + \frac{2}{r}\partial_r)\rho = 0 ,$$

with boundary conditions $\partial_r \rho(t, 0) = 0$ and $\rho(t, 2\pi) = 0$. Making the sub-

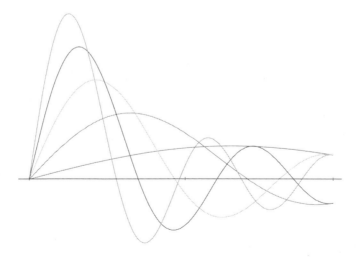

Figure 11. The first five eigenmodes of a saxophone or oboe, expressed in terms of the velocity $v(r)$ (see exercise 2.5). Blue $= w_1(x)$, Orange $= w_2(x)$, Yellow $= w_3(x)$, Purple $= w_4(x)$ and Green $= w_5(x)$.

stitution $R = r\rho(t,r)$ (d'après R. Beals) leads to the equation

$$\partial_t^2 R - p'(\rho_0)\partial_r^2 R = 0 \; ,$$

satisfying boundary conditions $R(t,0) = 0 = R(t,2\pi)$. This is now addressed as before by separation of variables techniques. The fundamental is $R_1(r) = \pi^{-1/2}\sin(\frac{1}{2}r)$ with frequency $\omega_1 = \frac{1}{2}\sqrt{p'(\rho_0)}$, while just as in the case of the stringed instruments or the flute, the higher eigenfrequencies are $\frac{1}{2}\sqrt{p'(\rho_0)}\,k$. Again we find that $\omega_2 = 2\omega_1$, $\omega_3 = 3\omega_1$, *etc.* Eigenmodes in terms of the original variables are given by $\rho_n(r) = \frac{R_n(r)}{r}$. A similar analysis can be performed in terms of the velocity variables $v(r)$, giving eigenmodes $w_n(r)$ and the same sequence of eigenvalues ω_n, this is the topic of exercise 2.5.

The drum: The eigenmodes of a drum correspond to those of a two dimensional disk $B_A(0) = \{x = (x_1,x_2) : |x|^2 < A^2\}$. By separation of variables one seeks solutions $(w_k(x),\lambda_k)$ of the eigenvalue problem for Laplaces equation, which in polar coordinates is

$$(\partial_r^2 + \frac{1}{r}\partial_r)w_k + \frac{1}{r^2}\partial_\theta^2 w_k = \lambda_k w_k \; , \quad w(A,\theta) = 0 \; .$$

The angular dependence can be described in terms of complex exponentials $e^{i\ell\theta}$. However the radial dependence involves Bessel functions, whose zeros do not generally give rise to an arithmetic series of frequencies $\omega_k = \sqrt{-\lambda_k}$ as is the case for the one dimensional instruments described above. And as we know, drums are quite noisy instruments.

Synthesizers have allowed musicians to create new instruments with the sound of a note determined by a chosen overtone series. D. DeTurck has used this idea to synthesize the sound of an imaginary piano-like instrument, where the role of the strings is replaced by higher dimensional geometrical objects such as spheres, tori or hyperbolic Riemann surfaces, and the subsequent overtone series of each note is determined by the square roots of the first number of Laplace – Beltrami eigenvalues. You can hear some of this work on the website `www.toroidalsnark.net/som.html`.

Exercises: Chapter 2

Exercise 2.1. For the wave speed $c(t)$ which is a general (locally integrable) function of time, give a Fourier integral representation of the solution of the transport equation (2.1).

Exercise 2.2. Find an explicit expression for the solution of the equation

$$\partial_t u + c\partial_x u + ru = 0 \; , \qquad u(0,x) = f(x) \; ,$$

using either (or both) of the above solution methods. When $r > 0$ what happens to the solution $u(t,x)$ asymptotically for $t \to +\infty$.

Exercise 2.3. Give the solution of both equations (2.8) and (2.9) using the method of characteristics. Then differentiate to check your answer. Explain the differences between the two cases. Are the solutions unique in both cases? What are the asymptotic states

$$v(x) = \lim_{t \to \pm\infty} u(t, x) \,,$$

if the limit exists, that is.

Exercise 2.4. Solving the Schrödinger equation for the quantum harmonic oscillator

$$\frac{1}{i} \partial_t \psi = -\frac{1}{2} \partial_x^2 \psi + \frac{1}{2} x^2 \psi \,,$$

by separation of variables, one is led to the expression

$$\psi(t, x) = \sum_k a_k e^{i\lambda_k x} \varphi_k(x) \,.$$

The eigenfunctions and eigenvalue pairs $(\varphi_k(x), \lambda_k)$ are given by the problem in spectral theory;

$$(2.25) \qquad -\frac{1}{2} \partial_x^2 \varphi_k(x) + \frac{1}{2} x^2 \varphi_k(x) = \lambda_k \varphi_k(x) \,.$$

(a) Show that under Fourier transform the eigenvalue problem (2.25) is transformed to itself. Conclude that the eigenfunctions of the quantum harmonic oscillator are also eigenfunctions of the Fourier transform, and vice versa.

(b) The first eigenfunction $\psi_1(x)$ is given above as a normalized Gaussian. Derive the orthonormalized higher eigenfunctions for (2.25), and show that the corresponding eigenvalues λ_k are all real. Verify that they are as stated in the text.

(c) What are the corresponding eigenvalues of the Fourier transform?

Exercise 2.5. *Outline:* A problem on the eigenmodes of the oboe, stated in terms of $\rho(r)$ and alternatively in terms of $v(r)$. It will involve the gradient and the divergence in polar coordinates in three dimensions, and the boundary conditions for ρ and alternatively for v.

The heat equation

White hot steel on an anvil. Mediaphotos/E+/Getty Images

The Fourier transform was originally introduced by Joseph Fourier in an 1807 paper in order to construct a solution of the heat equation on an interval $0 < x < 2\pi$, and we will also use it to do something similar for the equation

$$(3.1) \qquad \partial_t u = \tfrac{1}{2}\partial_x^2 u \ , \qquad t \in \mathbb{R}_+^1 \ , \quad x \in \mathbb{R}^1$$
$$u(0,x) = f(x) \ ,$$

The first thing to notice is that the equation (3.1) is invariant under *Brownian scaling*, which is the change of variables

$$t' = \varepsilon t \ , \quad x' = \sqrt{\varepsilon} x \ .$$

This rescaling transformation is closely related to certain principles of probability and the properties of Brownian motion. To see how the equation behaves, the change of variables gives that

$$\partial_t = \varepsilon \partial_{t'} \ , \quad \partial_x = \sqrt{\varepsilon} \partial_{x'} \ ,$$

and therefore if $u(t,x)$ solves the heat equation (3.1) then so does $u' := u'(t',x') = u(\varepsilon t, \sqrt{\varepsilon} x)$;

$$\varepsilon \big(\partial_{t'} u' - \tfrac{1}{2}\partial_{x'}^2\big) u'(t',x') = \big(\partial_t - \tfrac{1}{2}\partial_x^2\big) u(\varepsilon t, \sqrt{\varepsilon} x) = 0 \ .$$

We will see that the ratio x/\sqrt{t}, which is invariant under Brownian scaling, appears in a central way in expressions for the solution, and indeed it plays an related role in probability.

3.1. The heat kernel

A derivation of the solution of (3.1) by Fourier synthesis starts with the assumption that the solution $u(t,x)$ is sufficiently well behaved that is satisfies the hypotheses of the Fourier inversion formula. This will be verified *a postiori*. Writing

$$u(t,x) = \frac{1}{\sqrt{2\pi}} \int_{-\infty}^{+\infty} e^{i\xi x} \hat{u}(t,\xi) \, d\xi \ ,$$

then solutions of (3.1) must satisfy

$$0 = \big(\partial_t - \tfrac{1}{2}\partial_x^2\big) u(t,x) = \frac{1}{\sqrt{2\pi}} \int_{-\infty}^{+\infty} e^{i\xi x} \big(\partial_t - \tfrac{1}{2}(i\xi)^2\big) \hat{u}(t,\xi) \, d\xi \ .$$

We have used Proposition 2.3 to express the spatial derivatives in terms of the Fourier transform. Reasoning as before, the Fourier transform of the solution must satisfy the family of ODEs

$$\frac{d}{dt}\hat{u} + \tfrac{1}{2}\xi^2 \hat{u} = 0 \ ,$$

parametrized by ξ. The solution is

$$\hat{u}(t,\xi) = e^{-\frac{1}{2}\xi^2 t} \hat{u}(0,\xi) = e^{-\frac{1}{2}\xi^2 t} \hat{f}(\xi) \ ,$$

where $\hat{f}(\xi)$ is the Fourier transform of the initial data. With this we can express the solution in integral operator form;

$$
\begin{aligned}
u(t,x) &= \frac{1}{\sqrt{2\pi}} \int_{-\infty}^{+\infty} e^{i\xi x} \big(e^{-\frac{1}{2}\xi^2 t} \hat{f}(\xi) \big) \, d\xi \\
(3.2) \qquad &= \frac{1}{2\pi} \iint e^{i\xi(x-y)} e^{-\frac{1}{2}\xi^2 t} f(y) \, dy d\xi \\
& \int \Big(\frac{1}{2\pi} \int e^{i\xi(x-y)} e^{-\frac{1}{2}\xi^2 t} \, d\xi \Big) f(y) \, dy := \int H(t, x-y) f(y) \, dy \ .
\end{aligned}
$$

Justification of the exchanges of the order of integration comes from the Fubini theorem, as long as the initial data satisfies $f \in L^1(\mathbb{R}^1)$. The function $H(t, x - y)$ is the *heat kernel*, the integral kernel for the solution operator $\mathbf{H}(t)$ for the heat equation with the initial data $f(x)$;

$$u(t, x) = \big(\mathbf{H}(t)f\big)(x) .$$

Complete the square to evaluate this Fourier integral definition of the heat kernel;

$$H(t, x) = \frac{1}{2\pi} \int_{-\infty}^{+\infty} e^{i\xi x} e^{-\frac{1}{2}\xi^2 t} \, d\xi$$

$$= \frac{1}{2\pi} e^{-\frac{1}{2}x^2/t} \int_{-\infty}^{+\infty} e^{\frac{1}{2}x^2/t + i\xi x - \frac{1}{2}\xi^2 t} \, d\xi$$

$$= \frac{1}{2\pi} e^{-\frac{1}{2}x^2/t} \int_{-\infty}^{+\infty} e^{-\frac{1}{2}(\xi\sqrt{t} - ix/\sqrt{t})^2} \, d\xi .$$

Substitute $\xi' = \xi\sqrt{t} - ix/\sqrt{t}$ (which is actually an application of Cauchy's theorem of complex analysis) to find the expression

$$(3.3) \qquad H(t, x) = \frac{1}{2\pi} e^{-\frac{1}{2}x^2/t} \int e^{-\frac{1}{2}(\xi')^2} \frac{d\xi'}{\sqrt{t}} d\xi' = \frac{1}{\sqrt{2\pi t}} e^{-\frac{1}{2}x^2/t} .$$

Theorem 3.1. *A solution of the heat equation for initial data $f \in L^1(\mathbb{R}^1)$ is given by the convolution of the initial data with the heat kernel;*

$$u(t, x) = \int_{-\infty}^{+\infty} H(t, x - y) f(y) \, dy = \int_{-\infty}^{+\infty} \frac{1}{\sqrt{2\pi t}} e^{-\frac{1}{2}(x-y)^2/t} f(y) \, dy .$$

Take note of the invariance under Brownian scaling of the quantity

$$dP_t(x) = \frac{1}{\sqrt{2\pi t}} e^{-\frac{1}{2}x^2/t} \, dx ,$$

which is the Gaussian measure that is relevant to heat flow. It is a probability measure since

$$\int_{-\infty}^{+\infty} \frac{1}{\sqrt{2\pi t}} e^{-\frac{1}{2}(x-y)^2/t} \, dy = 1 .$$

This procedure via the heat kernel gives a unique solution among the class of bounded solutions, or among solutions which are in $L^1(\mathbb{R}^1_x)$, or simply among solutions which do not grow too rapidly as $|x| \to +\infty$. It is a surprising fact, which will come up in a later discussion, that solutions of the heat equation are not unique if we admit ones that are badly unbounded [A. N. Tykonov (1977)].

The heat kernel $H(t, x - y)$ for $t > 0$ has its maximum at $x = y$, where the maximim value is $\frac{1}{\sqrt{2\pi t}}$, and width \sqrt{t} (defined as the distance between

Figure 1. Superposition of the graph of the heat kernel at several times
$0 < t_1 < t_2 < t_3$.

its center and inflection point). A graph of the heat kernel, taken at several
snapshots in time, is given in Figure 1.

It is reasonable to expect that we will obtain the same solution $u(t, x)$ at
time $t > 0$ starting with data $f(x)$ at time $t = 0$, if we alternatively solved
the heat equations up to time $0 < s < t$, and then starting again at s with
data $u(s, x)$, continued the solution for time $t - s$. That, is, in operator
notation

$$(3.4) \qquad \mathbf{H}(t)f = \mathbf{H}(t - s)\mathbf{H}(s)f , \qquad 0 < s < t .$$

This is the *semigroup property*, and it is related to the question of uniqueness.

3.2. Convolution operators

The evolution operator for the heat equation is an example of a convolution
operator, with convolution kernel the heat kernel $H(t, x)$.

Definition 3.2. Let $h(x) \in L^1(\mathbb{R}^1)$, and define the *convolution product* with
$f(x) \in L^1(\mathbb{R}^1)$ to be

$$\big(h * f\big)(x) = \int_{-\infty}^{+\infty} h(x - x')f(x') \, dx' .$$

In these terms the evolution operator for the heat equation can be written as

$$u(t,x) = \mathbf{H}(t)f(x) = \big(H(t,\cdot) * f\big)(x) = \int_{-\infty}^{+\infty} H(t, x - x')f(x')\,dx' \ .$$

The convolution product is well defined between functions that are *integrable*, which is to say that

$$\|h\|_{L^1(\mathbb{R}^1)} := \int_{\mathbb{R}^1} |h(x)|\,dx < +\infty \ .$$

The linear space of such functions is known as $L^1(\mathbb{R}^1)$. In fact, whenever $f(x), h(x) \in L^1(\mathbb{R}^1)$, then also $h*f(x) \in L^1(\mathbb{R}^1)$ as is shown in the following Proposition.

Proposition 3.3. Given two functions $h(x), f(x) \in L^1(\mathbb{R}^1)$, the convolution product $g(x) := h*f(x)$ is well defined. Furthermore $g(x) \in L^1(\mathbb{R}^1)$ and

$$\|g\|_{L^1(\mathbb{R}^1)} \le \|h\|_{L^1(\mathbb{R}^1)}\|f\|_{L^1(\mathbb{R}^1)} \ .$$

Proof. These assertions will follow if we show that $g(x)$ is integrable. To this end, estimate

$$\int_{\mathbb{R}^1} |g(x)|\,dx = \int_{\mathbb{R}^1} \big| \int_{\mathbb{R}^1} h(x-x')f(x')\,dx' \big|\,dx$$

$$\le \int_{\mathbb{R}^1} \int_{\mathbb{R}^1} |h(x-x')||f(x')|\,dx'dx = \|h\|_{L^1(\mathbb{R}^1)}\|f\|_{L^1(\mathbb{R}^1)} \ ,$$

the last step following after an exchange of order of integration. $\qquad\square$

Convolution operators with kernels $h \in L^1(\mathbb{R}^1)$ have a number of convenient algebraic features, the most elementary ones are covered in the following proposition.

Proposition 3.4. Let $h(x), f(x), g(x) \in L^1(\mathbb{R}^1)$. Then

(i) The convolution product is commutative and associative;

$$\big(h*f\big)(x) = \big(f*h\big)(x)$$

$$h*\big(g*f\big) = \big(h*g\big)*f(x) \ .$$

(ii) If in addition $\partial_x f \in L^1(\mathbb{R}^1)$ then differentiation commutes with the operation of convolution;

$$\partial_x\big(h*f\big)(x) = h*\big(\partial_x f\big)(x) \ .$$

(iii) Under Fourier transform, convolution with $h(x)$ becomes a multiplication operator

$$\widehat{h*f}(\xi) = \sqrt{2\pi}\hat{h}(\xi)\hat{f}(\xi) \ .$$

Proof. Address the statement (iii) first of all;

$$\frac{1}{\sqrt{2\pi}} \int_{-\infty}^{+\infty} e^{-i\xi x} \left(\int_{-\infty}^{+\infty} h(x-x')f(x')\,dx' \right) dx$$
$$= \frac{1}{\sqrt{2\pi}} \iint e^{-i\xi(x-x')}h(x-x')e^{-i\xi x'}f(x')\,dx'dx\ ,$$

by using Fubini's Theorem. Then this quantity can be rewritten as

$$= \sqrt{2\pi}\left(\frac{1}{\sqrt{2\pi}}\int e^{-i\xi x'}f(x')\left(\frac{1}{\sqrt{2\pi}}\int e^{-i\xi(x-x')}h(x-x')\,dx\right)dx'\right)$$
$$= \sqrt{2\pi}\hat{f}(\xi)\hat{h}(\xi)\ ,$$

which is the statement of (iii). This can now be used to prove (i) and (ii). Indeed, since

$$\widehat{h*f}(\xi) = \sqrt{2\pi}\hat{h}(\xi)\hat{f}(\xi)$$

the order of multiplication does not play a role, and therefore the properties of commutativity and associativity clearly hold. Furthermore,

$$\widehat{\partial_x(h*f)}(\xi) = i\xi\widehat{h*f}(\xi) = \sqrt{2\pi}(i\xi)\hat{h}(\xi)\hat{f}(\xi)\ ,$$

and the derivative can be seen either to be acting on the convolution product or on f alone. The fact is that the Fourier transform has simultaneously diagonalized the operations of convolution with $h(x)$ and differentiation, from which the results of the proposition are corollaries. \square

3.3. The maximum principle

This fundamental principle is a feature of solutions of parabolic equations such as the heat equation; we will encounter it as well when we take up the topic of elliptic equations such as Lapace's equation. The following section concerns the solution $u(t,x)$ of the heat equation that is given by the heat operator $u(t,x) = (\mathbf{H}(t)f)(x) = (H(t,\cdot)*f)(x)$.

Theorem 3.5. *[maximum principle] Suppose that the initial data $f \in L^1(\mathbb{R}^1)$ satisfies $f(x) \geq 0$ for all $x \in \mathbb{R}^1$. Then either $u(t,x) > 0$ for all $t > 0$, or else both $u(t,x) \equiv 0$ and $f(x) \equiv 0$.*

The conclusion is powerful because of the fact that the existence of one zero of the solution implies that both the whole solution and the initial data mush vanish identically.

Proof. Observe that the heat kernel $H(t,x) = \frac{1}{\sqrt{2\pi t}}e^{-\frac{1}{2}x^2/t} > 0$ for all $t > 0$. Hence if $f(x) \geq 0$ then clearly

$$u(t,x) = \left(H(t,\cdot)*f\right)(x) = \int_{-\infty}^{+\infty} H(t,x-x')f(x')\,dx' \geq 0\ .$$

This non-strict inequality is called the *weak maximum principle*. By a further argument we can prove that $u(t, x) > 0$ unless $f \equiv 0$. Suppose that $f(x) \geq 0$ and define sets $B_\delta = \{x : f(x) > \delta\}$. If f is not identically zero (excluding sets of zero Lebesgue measure) then B_δ is nonempty for some δ and there is a bounded set $A \subseteq B_\delta$ with positive measure. Then

$$u(t, x) = \int_{-\infty}^{+\infty} H(t, x - x') f(x') \, dx'$$

$$\geq \int_A H(t, x - x') f(x') \, dx'$$

$$\geq \int_A H(t, x - x') \delta \, dx' \, .$$

This last expression is surely positive, by the positive character of the heat kernel $H(t, x)$. There is more precise information available on a lower bound for $u(t, x)$ if we consider the Gaussian nature of the heat kernel;

$$u(t, x) \geq \delta \operatorname{meas}(A) \inf_{x' \in A} \left(\frac{1}{\sqrt{2\pi t}} e^{-\frac{(x - x')^2}{2t}} \right) \, .$$

\square

The maximum principle provides a partial ordering of solutions of the heat equation, at least for those given by the heat kernel, and thus gives a uniqueness theorem for the heat equation.

Theorem 3.6. *Suppose that $f_1(x), f_2(x) \in L^1(\mathbb{R}^1)$ and that $f_1(x) \leq f_2(x)$ for all $x \in \mathbb{R}^1$. Then the respective solutions $u_1(t, x)$, $u_2(t, x)$ either satisfy*

$$u_1(t, x) < u_2(t, x)$$

for all $t > 0$, or else $u_1(t, x) \equiv u_2(t, x)$ and $f_1(x) \equiv f_2(x)$.

Proof. The difference $u_2 - u_1$ also satisfies the heat equation, and it is given by convolution of the heat kernel with the initial data $f_2 - f_1 \geq 0$. The maximum principle asserts that either $(u_2 - u_1)(t, x) > 0$ for all $t > 0$, or else $u_2 - u_1 = 0$ and $f_2 - f_1 = 0$. \square

3.4. Conservation laws and the evolution of moments

The heat equation is often called the *diffusion equation,* and indeed the physical interpretation of a solution is of a heat distribution or a particle density distribution that is evolving in time according to equation (3.1). That is, in probabilistic terms, the quantity

$$P_t[a, b) = \int_a^b u(t, x) \, dx$$

represents the probability of the outcome of a random event taking its value in the interval $[a, b)$ at time t. For instance $P_t[a, b)$ might represent the probability that a random particle lies in the interval at that time. For this interpretation we should ask that the initial data $f(x)$ satisfy $f(x) \geq 0$, and normalize it so that $\int_{\mathbb{R}^1} f(x)\, dx = 1$. In particular we require that $f \in L^1(\mathbb{R}^1)$. We can derive the heat equation itself from this interpretation, given one more piece of information, namely Fourier's law of heat conservation and flux. Take $[a, b)$ to be an arbitrary interval, the change in heat over this interval in time is given by

$$\partial_t P_t[a, b) = \partial_t \int_a^b u(t, x)\, dx = F(a) - F(b)\ ,$$

where Fourier's law of heat conservation posits that this change is given by the flux of heat across the boundary. Namely, $F(a)$ is interpreted to be the flux of heat across the boundary point a into the interval, and $F(b)$ is interpreted to be the flux of hear out of the interval across the boundary point b. Fourier's law for the heat flux gives the form as

$$F(a) := -\tfrac{1}{2}\partial_x u(t, a)\ ,$$

and similarly for b, so that

$$\partial_t P_t[a, b) = \int_a^b \partial_t u(t, x)\, dx = F(a) - F(b)$$

$$= \tfrac{1}{2}\partial_x u(t, b) - \tfrac{1}{2}\partial_x u(t, a) = \int_a^b \tfrac{1}{2}\partial_x^2 u(t, x)\, dx\ .$$

Since the interval $[a, b)$ is arbitrary, the heat density $u(t, x)$ must satisfy the heat equation $\partial_t u = \tfrac{1}{2}\partial_x^2 u$.

This interpretation must satisfy two conditions in order to be consistent; (i) the total amount of heat must be conserved, and (ii) if the initial heat distribution $f(x) \geq 0$ then for all $t \geq 0$ we should have $u(t, x) \geq 0$. The second condition is already satisfied for us by the maximum principle. Regarding the first, there is the following result.

Theorem 3.7. *If $u(t, x) \in L^1(\mathbb{R}^1)$ is a solution of (3.1) then for all $t \geq 0$*

$$\int_{-\infty}^{+\infty} u(t, x)\, dx = \int_{-\infty}^{+\infty} f(x)\, dx\ .$$

Proof.

$$\partial_t \int_{-\infty}^{+\infty} u(t, x)\, dx = \int_{-\infty}^{+\infty} \partial_t u(t, x)\, dx$$

$$= \int_{-\infty}^{+\infty} \tfrac{1}{2}\partial_x^2 u(t, x)\, dx = \tfrac{1}{2} \lim_{R \to +\infty} \left(\partial_x u(t, R) - \partial_x u(t, -R) \right) = 0\ .$$

\square

In fact the proof is incomplete for we should also have shown that when $f(x) \in L^1(\mathbb{R}^1)$ then for $t > 0$ we have $\partial_x^2 u(t,x) \in L^1(\mathbb{R}^1)$, and then justify the exchanges of differentiation and integration and the integrations by parts. These facts will be addressed in the later Chapter on the properties of the Fourier transform.

The interpretation of a solution $u(t,x)$ of (3.1) as the density of a probability measure motivates a discussion of the time evolution of its moments. For a given distribution $f(x)\,dx$ define the k^{th} moment to be the quantity

$$(3.5) \qquad m_k(f) = \int_{-\infty}^{+\infty} x^k f(x)\,dx .$$

For an arbitrary $f(x) \in L^1(\mathbb{R}^1)$ this may be infinite or not well defined, but for sufficiently well localized functions it makes perfectly good sense. To give examples, take the case of the heat kernel itself, then

$$m_0(H(t,\cdot)) = \int_{-\infty}^{+\infty} \frac{1}{\sqrt{2\pi t}} e^{-\frac{x^2}{2t}}\,dx = 1$$

$$m_1(H(t,\cdot)) = \int_{-\infty}^{+\infty} \frac{1}{\sqrt{2\pi t}} x e^{-\frac{x^2}{2t}}\,dx = 0$$

$$m_2(H(t,\cdot)) = \int_{-\infty}^{+\infty} \frac{1}{\sqrt{2\pi t}} x^2 e^{-\frac{x^2}{2t}}\,dx = t .$$

Now consider the initial vaue problem for the heat equation, our solution procedure yields $u(t,x) = H(t,\cdot) * f(x)$, and the resulting heat distribution $u(t,x)\,dx$ has moments which are given by

$$m_k(u(t,\cdot)) = \int_{-\infty}^{+\infty} x^k u(t,x)\,dx = \iint x^k \frac{1}{\sqrt{2\pi t}} e^{-\frac{(x-x')^2}{2t}} f(x')\,dx'dx .$$

Proposition 3.8. The first two moments of the solution $u(t,x)$ are conserved;

$$m_0(u(t,\cdot)) = m_0(f) , \qquad m_1(u(t,\cdot)) = m_1(f) .$$

To deduce the evolution properties of the higher moments of $u(t,x)\,dx$ we will derive further elementary properties of the Fourier transform.

Proposition 3.9. For sufficiently well behaved functions $g(x)$, the Fourier transform has the property that

$$\mathcal{F}(x^k g(x)) = (i\partial_\xi)^k \hat{g}(\xi) ,$$

$$\int_{-\infty}^{+\infty} g(x)\,dx = \sqrt{2\pi}\hat{g}(0) .$$

Proof. This first statement is essentially dual to that of Proposition 2.3. Observe by integrations by parts that

$$\int e^{-i\xi x}\big(x^k g(x)\big)\,dx = \int \big((i\partial_\xi)^k e^{-i\xi x}\big)g(x)\,dx = (i\partial_\xi)^k \int e^{-i\xi x}g(x)\,dx \ ,$$

which is the first statement of the proposition. To show the second statement,

$$\int g(x)\,dx = \int e^{-i\xi x}g(x)\,dx\big|_{\xi=0}= \sqrt{2\pi}\hat{g}(0) \ .$$

Hypotheses on the function $g(x)$ are necessary in order to justify the integrations by parts and the limits. \square

We use this information in order to compute moments; since

$$\widehat{x^k u}(t,\xi) = (i\partial_\xi)^k \hat{u}(t,\xi) = \sqrt{2\pi}(i\partial_\xi)^k\big(\hat{H}(t,\xi)\hat{f}(\xi)\big) \ ,$$

therefore

$$m_k(u(t,\cdot)) = \int x^k u(t,x)\,dx = \sqrt{2\pi}\big((i\partial_\xi)^k\hat{u}(t,\xi)\big)\big|_{\xi=0}$$
$$= 2\pi\big((i\partial_\xi)^k\hat{H}(t,\xi)\hat{f}(\xi)\big)\big|_{\xi=0} \ .$$

In particular for $k=0$,

$$m_0(u(t,\cdot)) = 2\pi\hat{H}(t,0)\hat{f}(0) = \sqrt{2\pi}\hat{f}(0) = m_0(f) \ ,$$

which gives the first statement of Proposition 3.8. For $k=1$,

$$m_1(u(t,\cdot)) = 2\pi i\partial_\xi\big(\hat{H}(t,\xi)\hat{f}(\xi)\big)\big|_{\xi=0}$$
$$= 2\pi i\big(\partial_\xi\hat{H}(t,\xi)\hat{f}(\xi) + \hat{H}(t,\xi)\partial_\xi\hat{f}(\xi)\big)\big|_{\xi=0}$$
$$= 2\pi i\hat{H}(t,0)\partial_\xi\hat{f}(\xi)\big|_{\xi=0}= m_1(f) \ .$$

This proves the second statement of Proposition 3.8, for initial data with finite zeroth and first moments, at least. The general case is now clear;

$$m_k(u(t,\cdot)) = 2\pi(i\partial_\xi)^k\big(\hat{H}(t,\xi)\hat{f}(\xi)\big)|_{\xi=0}$$
$$= 2\pi i^k \sum_{j=0}^{k} \binom{k}{j} \big(\partial_\xi^j\hat{H}(t,\xi)\partial_\xi^{k-j}\hat{f}(\xi)\big)|_{\xi=0}$$
$$= \sum_{\substack{j=0 \\ j \text{ even}}}^{k} \binom{k}{j} m_j(H(t,\cdot))m_{k-j}(f) \ .$$

We used the Leibnitz product rule for for differentiation in the second line, and in the third line we used that a odd moments of the heat kernel are zero, as the kernel itself is an even function of x.

A property of solutions of the heat equation, related to that of conservation of heat as in Theorem 3.7, is that the evolution has a certain contraction property on a number of common spaces of functions.

Proposition 3.10. Let $u(t,x)$ solve the heat equation (3.1) with initial data $f \in L^2(\mathbb{R}^1)$. Then the L^2-norm of $u(t,\cdot)$ is a decreasing function of t;
$$\|u(t,\cdot)\|_{L^2} \leq \|f\|_{L^2} \ .$$

Proof. Compute the time derivative of the norm;
$$\partial_t \|u(t,\cdot)\|_{L^2}^2 = \partial_t \int u^2(t,x)\,dx$$
$$= \int 2u(t,x)\partial_t u(t,x)\,dx = \int 2u(t,x)\tfrac{1}{2}\partial_x^2 u(t,x)\,dx$$
$$= -\int |\nabla u(t,x)|^2\,dx \leq 0 \ .$$

Thus we find that
$$\|u(t,\cdot)\|_{L^2}^2 - \|f\|_{L^2}^2 = \int_0^t \partial_t \|u(s,\cdot)\|_{L^2}^2\,ds \leq 0 \ .$$

One needs to revisit this calculation in order to justify the integration by parts. $\qquad\square$

We have already seen that the setting of $L^1(\mathbb{R}^1)$ functions is sometimes more natural for the heat equation than that of $L^2(\mathbb{R}^1)$. It turns out that time evolution by heat flow is also a contraction in $L^1(\mathbb{R}^1)$.

Proposition 3.11. Let $f \in L^1(\mathbb{R}^1)$ and let $u(t,x)$ solve the heat equation with initial data f. Then $\|u(t,\cdot)\|_{L^1}$ is a nonincreasing function of t;
$$\|u(t,\cdot)\|_{L^1} \leq \|f\|_{L^1} \ .$$

Proof. By nonincreasing we mean that the norm in question could stay the same or it could decrease in time, in any case it cannot increase. The easy case is for $f \in L^1$ to be of one sign; say for convenience that $f(x) \geq 0$. The the maximum principle implies that $u(t,x) \geq 0$ as well, so that
$$\partial_t \int |u(t,x)|\,dx = \partial_t \int u(t,x)\,dx$$
$$= \int \partial_t u(t,x)\,dx = \int \tfrac{1}{2}\partial_x^2 u(t,x)\,dx = 0 \ ,$$

and the L^1-norm is unchanged by the flow. However when the initial data $f(x)$ changes sign, the L^1-norm will in fact be decreasing in time. To show this, decompose the initial data $f(x) = f_+(x) - f_-(x)$, into respectively its positive and negative parts. Both $f_\pm(x) \geq 0$, and furthermore they have

essentially disjoint support; $\{f_+ \neq 0\} \cap \{f_- \neq 0\} = \emptyset$. The L^1-norm of f is then the sum of the L^1-norms; indeed

$$\int |f(x)| \, dx = \int (f_+(x) + f_-(x)) \, dx = \int_{\mathrm{supp}(f_+)} f_+ \, dx + \int_{\mathrm{supp}(f_-)} f_- \, dx \ .$$

The previous result can now be applied to the two initial data, respectively f_+ and f_-,

$$\|u_+(t, \cdot)\|_{L^1} = \|f_+\|_{L^1} \ , \qquad \|u_-(t, \cdot)\|_{L^1} = \|f_-\|_{L^1} \ .$$

The solution is obtained from the sum, $u(t, x) = u_+(t, x) - u_-(t, x)$, however

Figure 2. Decomposition of initial data into positive $(f_+(x))$ and negative $(-f_-(x))$ components, and their subsequent evolution under heat flow, respectively $u_+(t, x)$ and $u_-(t, x)$.

the maximum principle applies, so that as long as neither of f_\pm is zero almost everywhere, then $\mathrm{supp}(u_+) = \mathrm{supp}(u_-) = \mathbb{R}^1$. We therefore have the estimate

$$\|u(t, \cdot)\|_{L^1} = \|u_+ - u_-\|_{L^1}$$
$$\leq \|u_+\|_{L^1} + \|u_-\|_{L^1} = \|f_+\|_{L^1} + \|f_-\|_{L^1} = \|f\|_{L^1} \ .$$

Since we are assuming that both u_+ and u_- are not zero, then there must be some cancellation in the inequality of the second line, and hence the inequality is in fact strict. $\qquad \qquad \qquad \qquad \qquad \qquad \qquad \qquad \square$

3.5. The heat equation in \mathbb{R}^n

Most of the results of this chapter hold in general for the heat equation posed in higher dimensional space \mathbb{R}^n, for any dimension n. The heat equation is

$$(3.6) \qquad\qquad \partial_t u = \tfrac{1}{2} \Delta u \ , \qquad t \in \mathbb{R}^1_+ \ , \quad x \in \mathbb{R}^n$$
$$u(0, x) = f(x) \ .$$

For initial data $f(x)$ we follow the procedure of Section 3.1 and use the Fourier transform, this time in \mathbb{R}^n;

$$\hat{f}(\xi) = \frac{1}{\sqrt{2\pi}^n} \int_{\mathbb{R}^n} e^{-i\xi \cdot y} f(y)\, dy := \mathcal{F}f(\xi),$$

where both ξ and y are in \mathbb{R}^n and where their Euclidian inner product is given by $\xi \cdot y = \sum_{j=1}^n \xi_j y_j$. The inverse transform is similarly give by

$$f(x) = \frac{1}{\sqrt{2\pi}^n} \int_{\mathbb{R}^n} e^{i\xi \cdot x} \hat{f}(\xi)\, d\xi := \mathcal{F}^{-1}\hat{f}(x) ,$$

and the Plancherel identity holds for $f(x) \in L^2(\mathbb{R}^n)$;

$$\|f\|^2_{L^2(\mathbb{R}^n_x)} = \|\hat{f}\|^2_{L^2(\mathbb{R}^n_\xi)} .$$

A solution $u(t,x)$ of (3.6) has Fourier transform that satisfies the parametrized family of ODEs

$$\frac{d}{dt}\hat{u} + \tfrac{1}{2}|\xi|^2 \hat{u} = 0$$

which has solution $\hat{u}(t,\xi) = e^{-\frac{1}{2}|\xi|^2 t}\hat{f}(\xi)$ analogous to our previous expression. As we did in (3.2), the heat kernel is given by a Gaussian integral

$$(3.7) \quad H(t, x-y) = \frac{1}{(2\pi t)^n} \int_{\mathbb{R}^n} e^{i\xi \cdot (x-y)} e^{-\frac{1}{2}|\xi|^2 t}\, d\xi = \frac{1}{\sqrt{2\pi t}^n} e^{-\frac{1}{2}\frac{|x-y|^2}{t}} .$$

Thus a solution to (3.6) is given by convolution with the heat kernel

$$(3.8) \qquad u(t,x) = \int_{\mathbb{R}^n} H(t, x-x') f(x')\, dx' .$$

The heat kernel gives rise to a probability measure that is important for Brownian motion in \mathbb{R}^n,

$$dP_t(x) = \frac{1}{\sqrt{2\pi t}^n} e^{-\frac{1}{2}\frac{|x|^2}{t}}\, dx$$

which is invariant under Brownian scaling and which has total measure $\int dP_t(x) = 1$, as one can check.

3.6. Entropy

The interpretation of nonnegative and normalized solutions of the heat equation as probability distributions has been discussed in Section 3.4. Associated with such probability measures are a variety of concepts that concern the *entropy* of a measure. Given a density $f \in L^1(\mathbb{R}^n)$ with $f(x) \geq 0$ and $\|f\|_{L^1} = 1$, the entropy is defined as

$$(3.9) \qquad S(f) := \int_{\mathbb{R}^n} f(x) \log(f(x))\, dx .$$

If $f(x)$ is taken as initial data for the heat equation, the entropy of the solution evolves monotonically in time.

Proposition 3.12. Suppose that $f(x) \geq 0$ is taken as initial data for the heat equation, then the solution $u(t,x)$ given by (3.8) satisfies

$$\frac{d}{dt}S(u(t,\cdot)) \leq 0 \ .$$

Proof. Unless $f(x) = 0$ we know by the maximum principle that $u(t,x) > 0$, and hence the entropy $S(u(t,\cdot))$ is at least defined. Its time evolution can be expressed by

$$\frac{d}{dt}\int_{\mathbb{R}^n} u(t,x) \log(u(t,x))\, dx = \int_{\mathbb{R}^n} \partial_t u \, \log(u)\, dx + \int_{\mathbb{R}^n} u \, \frac{\partial_t u}{u}\, dx$$

$$= \int_{\mathbb{R}^n} \tfrac{1}{2}\Delta u \, \log(u)\, dx + \int_{\mathbb{R}^n} \tfrac{1}{2}\Delta u\, dx$$

$$= -\frac{1}{2}\int_{\mathbb{R}^n} \nabla u \cdot \frac{\nabla u}{u}\, dx = -\frac{1}{2}\int_{\mathbb{R}^n} \frac{|\nabla u|^2}{u}\, dx \leq 0 \ .$$

Therefore it is a nonincreasing quantity associated with heat flow. □

In the proof one identifies the rate of entropy increase as being

(3.10) $$\tfrac{1}{2}\int_{\mathbb{R}^n} \frac{|\nabla u|^2}{u}\, dx \ ,$$

and as we have shown that the quantity $S(u(t,\cdot))$ is decreasing, by mathematics tradition we have evidently chosen the opposite sign in the definition (3.9) from that in practice in physics. The entropy is not guaranteed to be finite for any choice of $f \in L^1(\mathbb{R}^n)$, but if it is initially so then it will remain finite for $u(t,\cdot)$ for all future $t > 0$.

There are other quantities that are studied in relation to the concept of entropy. One is the *relative entropy* of one probability distribution with respect to another. Suppose that $u(x)$ and $e(x)$ are densities of two probability measures, the relative entropy of $dP_1(x) = u(x)dx$ with respect to $dP_2(x) = e(x)dx$ is defined to be

$$S(u|e) := \int_{\mathbb{R}^n} u(x) \log\left(\frac{u(x)}{e(x)}\right) dx \ .$$

Note that there is an asymmetry between the roles of u and e. Suppose that $u(t,x)$ is a solution of the heat equation, and that $e(t,x) = H(t,x)$ is given by the heat kernel (3.7). The change in time of the relative entropy is then expressed as

$$\frac{d}{dt}\int_{\mathbb{R}^n} u \log \frac{u}{e}\, dx = \int_{\mathbb{R}^n} \partial_t\big(u\log(u) - u\log(e)\big)\, dx \ .$$

The first term of the RHS we know from (3.10). The second term evolves as follows

$$\frac{d}{dt}\int_{\mathbb{R}^n} u\log(e)\,dx = \int_{\mathbb{R}^n} \partial_t u\log(e) + u\frac{\partial_t e}{e}\,dx = \int_{\mathbb{R}^n} \tfrac{1}{2}\Delta u\log(e) + u\frac{\tfrac{1}{2}\Delta e}{e}\,dx$$

$$= -\int_{\mathbb{R}^n} \tfrac{1}{2}\nabla u\cdot\frac{\nabla e}{e} + \tfrac{1}{2}\nabla\left(\frac{u}{e}\right)\cdot\nabla e\,dx = -\int_{\mathbb{R}^n} \nabla u\cdot\frac{\nabla e}{e} - \tfrac{1}{2}u\frac{|\nabla e|^2}{e^2}\,dx.$$

Since $e(t,x) = H(t,x)$ the heat kernel, the latter quantity is explicit;

$$\frac{\nabla e}{e} = -\frac{x}{t}\ .$$

We can therefore compute that

$$\int_{\mathbb{R}^n} \nabla u\cdot\frac{\nabla e}{e}\,dx = -\int_{\mathbb{R}^n} \nabla u\cdot\frac{x}{t}\,dx = \frac{n}{t}\int_{\mathbb{R}^n} u\,dx\ ,$$

and furthermore

$$\int_{\mathbb{R}^n} -\tfrac{1}{2}u\frac{|\nabla e|^2}{e^2}\,dx = -\int_{\mathbb{R}^n} \tfrac{1}{2}u\frac{|x|^2}{t^2}\,dx = -\frac{1}{2t^2}\int_{\mathbb{R}^n} |x|^2 u(t,x)\,dx\ .$$

This latter is the variance of the probability distribution $dP_1 = u(t,x)dx$, which from Section 3.4 we know satisfies

$$\partial_t\int_{\mathbb{R}^n} |x|^2 u\,dx = \tfrac{1}{2}\int_{\mathbb{R}^n} |x|^2\Delta u\,dx = \tfrac{1}{2}\int_{\mathbb{R}^n} \Delta(|x|^2)\,u\,dx = n\int_{\mathbb{R}^n} u(t,x)\,dx\ .$$

Since by Proposition 3.8 the moment $m_0(u(t,\cdot)) = m_0(f)$ is a constant, a conserved quantity, we then have that

$$-\int_{\mathbb{R}^n} \nabla u\cdot\frac{\nabla e}{e} - \tfrac{1}{2}u\frac{|\nabla e|^2}{e^2}\,dx = -\frac{n}{t}\int_{\mathbb{R}^n} u\,dx + \left(\frac{n}{2t}\int_{\mathbb{R}^n} u\,dx + \frac{1}{2t^2}\int_{\mathbb{R}^n} |x|^2 f(x)\,dx\right)\ .$$

Putting these together, we have a quite explicit form for the evolution of the relative entropy $S(u|e)$, namely

$$(3.11)\qquad \frac{d}{dt}S(u|e) = -\tfrac{1}{2}\int_{\mathbb{R}^n} \frac{|\nabla u|^2}{u}\,dx - \frac{n}{2t}m_0(f) - \frac{1}{t^2}m_2(f)\ .$$

3.7. Gradient flow

The last section of the chapter has to do with an interpretation of the heat equations as a gradient flow for the *energy functional*

$$(3.12)\qquad\qquad E(u) = \frac{1}{4}\int |\nabla u|^2\,dx\ .$$

To illustrate gradient flow with a finite dimensional example, let

$$e(v)\ :\ \mathbb{R}^d \to \mathbb{R}$$

be a C^1 function of $v \in \mathbb{R}^d$. Its gradient $\nabla e(v)$ (defined in terms of the Euclidian inner product on \mathbb{R}^d) is given by the formula

$$\frac{d}{d\sigma}\Big|_{\sigma=0} e(v + \sigma V) = \langle \nabla e(v), V \rangle .$$

The (negative) gradient flow of e is the solution map of the ordinary differential equation

$$\dot{v} = -\nabla e(v) .$$

A basic property of gradient flow is that the function $e(v)$ is decreasing along trajectories, indeed

$$\frac{d}{dt} e(v(t)) = \langle \nabla e(v), \dot{v}(t) \rangle = -\langle \nabla e(v), \nabla e(v) \rangle = -\|\nabla e(v)\|^2 \leq 0 .$$

Such flows play a role in Morse theory, among many other things.

The heat equation defines a flow in space of functions. Using a similar calculation, we can identify this as a gradient flow for the energy functional $E(u)$.

$$\frac{d}{d\sigma}\Big|_{\sigma=0} E(u + \sigma w) = \frac{d}{d\sigma}\Big|_{\sigma=0} \frac{1}{4} \int |\nabla u + \sigma w|^2 \, dx$$

$$= \frac{d}{d\sigma}\Big|_{\sigma=0} \frac{1}{4} \int |\nabla u|^2 + 2\sigma \nabla u \cdot \nabla w + \sigma^2 |\nabla w|^2 \, dx$$

$$= \tfrac{1}{2} \int \nabla u \cdot \nabla w \, dx .$$

In order to describe this quantity in terms of the L^2 inner product one integrates by parts;

$$\frac{d}{d\sigma}\Big|_{\sigma=0} E(u + \sigma w) = -\int \tfrac{1}{2} \Delta u \, w \, dx ,$$

which identifies $\mathrm{grad} E(u) = -\tfrac{1}{2}\Delta u$. The (negative) gradient flow is therefore

$$\partial_t u = -\mathrm{grad} E(u) = \tfrac{1}{2}\Delta u ,$$

which is precisely the heat equation (1.8).

Exercises: Chapter 3

Exercise 3.1. This problem concerns the semigroup property of the solution process for the heat equation. Show that the heat kernel satisfies the identity

$$H(t, x) = \int_{-\infty}^{+\infty} H(t - s, x - x') H(x', s) \, dx' , \quad \forall 0 < s < t .$$

Now show that the heat operator satisfies the property that for all $0 < s < t$

$$\mathbb{H}(t) = \mathbb{H}(t - s)\mathbb{H}(s) .$$

Conclude that the formula (3.4) holds for the one parameter family of solution operators $\{\mathbb{H}(t)\}_{t \in \mathbb{R}_+^1}$ of the heat equation.

Exercise 3.2. Justify on a rigorous level of analysis the exchange of integrations in the proof of Proposition 3.4(iii), therefore completing the rigorous proof of the proposition's three parts.

Exercise 3.3. Solve the following initial value problems for the heat equation in explicit terms.

(1) $f(x) = x$.

(2) $f(x) = x^2$

(3) $f(x) = 0$ for $x < 0$, and $f(x) = 1$ for $x \geq 0$.

(4) $f(x) = e^{\alpha x}$

(5) $f(x) = \sin(kx)$

What is the asymptotic behavior of $u(t, x)$ as $t \to +\infty$. Does it affect the asymptotic behavior if $f(x) \notin L^1(\mathbb{R}^1)$?

Exercise 3.4 (*(method of images)*)**.** Derive the heat kernel and the solution method for the initial boundary value problem on $\{(t, x) : x > 0, t > 0\}$ in the various cases of the boundary conditions given below.

 1 Dirichlet boundary conditions:

$$u(t, 0) = 0 .$$

 2 Neumann boundary conditions

$$\partial_x u(t, 0) = 0 .$$

 3 Periodic boundary conditions over $0 \leq x < 2\pi$

$$u(t, x + 2\pi) = u(t, x) .$$

Exercise 3.5 (Tychonov - nonuniqueness of solutions of the heat equation.)**.**

Laplace's equation

Soap bubbles - surfaces of constant mean curvature supported by a slight pressure difference across the interface. Godunova Tatiana/iStock/Getty Images Plus

4.1. Dirichlet, Poisson and Neumann boundary value problems

The most commonly occurring form of problem that is associated with Laplace's equation is a boundary value problem, normally posed on a domain $\Omega \subseteq \mathbb{R}^n$. That is, Ω is an open set of \mathbb{R}^n whose boundary is smooth

enough so that integrations by parts may be performed, thus at the very least rectifiable. The most common boundary value problem is the *Dirichlet problem*:

$$(4.1) \qquad \Delta u(x) = 0 , \qquad x \in \Omega$$
$$u(x) = f(x) , \qquad x \in \partial\Omega .$$

The function $f(x)$ is known as the Dirichlet data; physically it corresponds to a density of charge dipoles fixed on the boundary $\partial\Omega$, whereupon the solution $u(x)$ corresponds to the resulting electrostatic potential. A function satisfying $\Delta u = 0$ is called *harmonic*, as we have stated in Chapter 1.

Perhaps the second most common problem is called the *Poisson problem*;

$$(4.2) \qquad \Delta u(x) = h(x) , \qquad x \in \Omega$$
$$u(x) = 0 , \qquad x \in \partial\Omega ,$$

for which the function $h(x)$ represents a distribution of fixed charges in the domain Ω , while the boundary $\partial\Omega$ is a perfect conductor. Again the solution $u(x)$ represents the resulting electrostatic potential. There are several other quite common boundary value problems that are similar in character to (4.1), for example the *Neumann problem*

$$(4.3) \qquad \Delta u(x) = 0 , \qquad x \in \Omega$$
$$\partial_N u(x) = g(x) , \qquad x \in \partial\Omega ,$$

where $N(x)$ is the outward unit normal vector to Ω and $\partial_N u(x) = \nabla u(x) \cdot N$. The solution corresponds to the electrostatic potential in Ω due to a charge density distribution on $\partial\Omega$. The *Robin problem*, or boundary value problem of the third kind, asks to find $u(x)$ such that

$$(4.4) \qquad \Delta u(x) = 0 , \qquad x \in \Omega$$
$$\partial_N u(x) - \beta u(x) = g(x) , \qquad x \in \partial\Omega ,$$

where β is a real constant, or possibly a real function of $x \in \Omega$. Often this problem is associated with an imposed impedance on the boundary.

4.2. Green's identities

Consider two function $u(x)$ and $v(x)$ defined on a domain $\Omega \subseteq \mathbb{R}^n$. Calculus identities for integrations by parts give the following formulae, which is known as *Green's first identity*

$$(4.5) \qquad \int_\Omega v\Delta u \, dx = - \int_\Omega \nabla v \cdot \nabla u \, dx + \int_{\partial\Omega} v\partial_N u \, dS_x .$$

The notation is that the differential of surface area in the integral over the boundary is dS_x. To ensure that the manipulations in this formula are valid, we take $\Omega \subseteq \mathbb{R}^n$ to be bounded, and ask that $u, v \in C^2(\Omega) \cap C^1(\overline{\Omega})$, that is,

all derivatives of u and v up to second order are continuous in the interior of Ω and at least their first derivatives have continuous limits on the boundary $\partial\Omega$.

Integrating again by parts (or alternatively using (4.5) in a symmetric way with the roles of u and v reversed) we obtain *Green's second identity*

$$(4.6) \qquad \int_\Omega v\Delta u\,dx - \int_\Omega \Delta v\,u\,dx = \int_{\partial\Omega} \left(v\partial_N u - \partial_N v\,u\right) dS_x \;.$$

for $u, v \in C^2(\Omega) \cap C^1(\overline{\Omega})$. The integrand of the integral over the boundary $\partial\Omega$ is the analog of the Wronskian in ODEs.

Considering the function v as a test function and substituting several astute choices for it into Green's identities, we obtain information about solutions u of Laplace's equation. First of all, let $v(x) = 1$, then (4.5) gives

$$\int_\Omega \Delta u\,dx = \int_{\partial\Omega} \partial_N u\,dS_x \;.$$

In case u is harmonic, then $\Delta u = 0$ and the LHS vanishes. This is a compatibility condition for boundary data $g(x) = \partial_N u$ for the Neumann problem.

Proposition 4.1. In order for the Neumann problem (4.3) to have a solution, the Neumann data $g(x)$ must satisfy

$$\int_{\partial\Omega} g(x)\,dS_x = \int_{\partial\Omega} \partial_N u(x)\,dS_x = 0 \;.$$

For a second choice, let $v(x) = u(x)$ itself. Then Green's first identity (4.5) is an 'energy' identity

$$(4.7) \qquad \int_\Omega |\nabla u(x)|^2\,dx + \int_\Omega u\Delta u\,dx = \int_{\partial\Omega} u\partial_N u\,dS_x \;.$$

One consequence of this is a uniqueness theorem.

Theorem 4.2. *Suppose that $u \in C^2(\Omega) \cap C^1(\overline{\Omega})$ satisfies the Dirichlet problem (4.1) with $f(x) = 0$, or the Poisson problem (4.2) with $h(x) = 0$, or the Neumann problem (4.3) with $g(x) = 0$. Then*

$$\int_\Omega |\nabla u(x)|^2\,dx = \int_{\partial\Omega} u\partial_N u\,dS_x = 0 \;.$$

Therefore $u(x) = 0$ in the case of the Dirichlet problem (4.3) and of the Poisson problem (4.2). In the case of the Neumann problem, the conclusion is that $u(x)$ is constant.

Proof. The identity (4.7) implies that

$$\int_\Omega |\nabla u(x)|^2\,dx = 0$$

in each of the three cases, which in turn implies that $\nabla u = 0$ almost everywhere in Ω. Therefore $u(x)$ must be constant as we have assumed that $u \in C^2(\Omega)$. In cases (4.1) and (4.2) this constant must vanish in order to satisfy the boundary conditions. In the case of the Neumann problem (4.3) we only conclude that $u(x)$ is constant. In this situation we conclude that the constant functions $u(x) \equiv C$ span the null space of the Laplace operator with Neumann boundary conditions. \square

The case of unbounded domains Ω is not too different, and a uniqueness result is the goal. One asks that solutions $u(x)$ are bounded and have the limit $u(x) = 0$ as x becomes unbounded.

4.3. Poisson kernel

This component of the course is dedicated to techniques based on the Fourier transform, For Laplace's equation we can do this directly only in particular cases, the most straightforward being that the domain $\Omega = \mathbb{R}^n_+ := \{x = (x_1, \ldots x_n) \in \mathbb{R}^n : x_n > 0\}$, the half-space, and this is the situation that we will discuss. It would also be possible to directly use Fourier series to solve Laplace's equation on the disk $\mathbb{D}^2 := \{x \in \mathbb{R}^2 : |x| < 1\}$, or the polydisc $\mathbb{D}^{2n} := \{z = (x_1, \ldots x_n, y_1, \ldots y_n) \in \mathbb{R}^{2n} : (x_j^2 + y_j^2) < 1, j = 1, \ldots n\}$. We will however stick with the half space \mathbb{R}^n_+.

The Dirichlet problem (4.1) on \mathbb{R}^n_+ is to solve

$$(4.8) \qquad \Delta u(x) = 0 , \qquad x = (x_1, \ldots x_n) \in \mathbb{R}^n_+$$
$$u(x) = f(x') , \qquad x = (x', 0), \quad x' \in \mathbb{R}^{n-1} = \partial\mathbb{R}^n_+ .$$

It is implied that $u(x)$ and $\nabla u(x)$ tend to zero as $x_n \to +\infty$. For the special boundary data $f(x') = e^{i\xi' \cdot x'}$, with $\xi' \in \mathbb{R}^{n-1}$ there are explicit solutions

$$(4.9) \qquad\qquad u(x', x_n) = e^{i\xi' \cdot x'} e^{-|\xi'| x_n} ,$$

since

$$\Delta u(x', x_n) = \sum_{j=1}^{n-1} \partial_{x_j}^2 \left(e^{i\xi' \cdot x'} e^{-|\xi'| x_n} \right) + \partial_{x_n}^2 \left(e^{i\xi' \cdot x'} e^{-|\xi'| x_n} \right)$$

$$= \left(\sum_{j=1}^{n-1} -\xi_j'^2 + |\xi'|^2 \right) \left(e^{i\xi' \cdot x'} e^{-|\xi'| x_n} \right) = 0 .$$

The other possible solution is $e^{i\xi' \cdot x'} e^{+|\xi'| x_n}$ but this is ruled out by its growth as $x_n \to +\infty$. The Fourier transform allows us to decompose a general function $f(x')$ on the boundary (in $L^2(\mathbb{R}^{n-1})$ or perhaps in $L^1(\mathbb{R}^{n-1})$) into

a composite of complex exponentials

$$f(x') = \frac{1}{\sqrt{2\pi}^{n-1}} \int e^{i\xi'\cdot x'} \hat{f}(\xi')\, d\xi' \ .$$

By using (4.9) the solution $u(x)$ is expressed as a superposition

$$u(x) = \frac{1}{\sqrt{2\pi}^{n-1}} \int e^{i\xi'\cdot x'} e^{-|\xi'|x_n} \hat{f}(\xi')\, d\xi'$$

$$= \frac{1}{(2\pi)^{n-1}} \int \left(\int e^{i\xi'\cdot(x'-y')} e^{-|\xi'|x_n}\, d\xi' \right) f(y')\, dy'$$

$$(4.10) \qquad = \int D(x'-y', x_n) f(y')\, dy' \ .$$

The function $D(x', x_n)$ is called the Poisson kernel for \mathbb{R}^n_+ or the double layer potential, and the solution $u(x)$ is evidently given by convolution with $D(x', x_n)$. Evaluating the above Fourier integral expression (4.10) we get an explicit expression,

$$D(x', x_n) = \frac{1}{(2\pi)^{n-1}} \int e^{i\xi'\cdot x'} e^{-|\xi'|x_n}\, d\xi'$$

$$(4.11) \qquad = \frac{2}{\omega_n} \left(\frac{x_n}{(|x'|^2 + x_n^2)^{n/2}} \right) \ .$$

The second line of (4.11) will be verified later; the constant ω_n is the surface area of the unit sphere in \mathbb{R}^n.

Theorem 4.3. *The solution of the Dirichlet problem on \mathbb{R}^n_+ with data $f(x') \in L^2(\mathbb{R}^{n-1})$ is given by*

$$(4.12) \qquad u(x) = \int_{\mathbb{R}^{n-1}} D(x'-y, x_n) f(y')\, dy'$$

$$= \frac{1}{(2\pi)^{n-1}} \int_{\mathbb{R}^{n-1}} \left(\int_{\mathbb{R}^{n-1}} e^{i\xi'\cdot(x'-y')} e^{-|\xi'|x_n}\, d\xi' \right) f(y')\, dy'$$

For $x_n > 0$ this function is C^∞ (differentiable an arbitrary number of times).

Proof. For $x_n > 0$ both of the above integrals in (4.12) converge absolutely, as indeed we have

$$\int_{\mathbb{R}^{n-1}} \left| e^{i\xi'\cdot x'} e^{-|\xi'|x_n} \hat{f}(\xi') \right| d\xi' \le \|\hat{f}\|_{L^2(\mathbb{R}^{n-1})} \left(\int_{\mathbb{R}^{n-1}} e^{-2|\xi'|x_n}\, d\xi' \right)^{1/2} ,$$

(where we have used the Cauchy-Schwarz inequality and the Plancherel identity) and hence we also learn that the solution $u(x)$ has an upper bound in \mathbb{R}^n_+ which quantifies its decay rate in $x_n \to +\infty$. Namely

$$|u(x', x_n)| \le \left(\int_{\mathbb{R}^{n-1}} e^{-2|\xi'|x_n}\, d\xi' \right)^{1/2} \|\hat{f}\|_{L^2(\mathbb{R}^{n-1})} \le \frac{C}{|x_n|^{(n-1)/2}} \|f\|_{L^2(\mathbb{R}^{n-1})} \ .$$

Further derivatives of the expression (4.12) don't change the properties of absolute convergence of the integral for $x_n > 0$, and we verify that the function we have produced is indeed harmonic;

$$\Delta u(x) = \frac{1}{\sqrt{2\pi}^{n-1}} \int_{\mathbb{R}^{n-1}} \Delta\left(e^{i\xi'\cdot x'}e^{-|\xi'|x_n}\right)\hat{f}(\xi')\,d\xi' = 0\ .$$

The issue is whether the harmonic function $u(x', x_n)$ that we have produced converges to $f(x')$ as $x_n \to 0$, and in what sense. In this paragraph we will show that for every $x_n > 0$, $u(x', x_n)$ is an $L^2(\mathbb{R}^{n-1})$ function of the horizontal variables $x' \in \mathbb{R}^{n-1}$, and that $u(x', x_n) \to f(x')$ in the $L^2(\mathbb{R}^{n-1})$ sense as $x_n \to 0$. By Plancherel,

$$\|u(x', x_n) - f(x')\|_{L^2(\mathbb{R}^{n-1})} = \|e^{-|\xi'|x_n}\hat{f}(\xi') - \hat{f}(\xi')\|_{L^2(\mathbb{R}^{n-1})}\ .$$

Because $\|\hat{f}\|_{L^2} < +\infty$, for any $\delta > 0$ there is a (possibly large) $R > 0$ such that the integral

$$\int_{|\xi'|>R} |\hat{f}(\xi')|^2\,d\xi' < \delta\ .$$

We now estimate

$$\|u(x', x_n) - f(x')\|^2_{L^2(\mathbb{R}^{n-1})} = \|\left(e^{-|\xi'|x_n} - 1\right)\hat{f}(\xi')\|^2_{L^2(\mathbb{R}^{n-1})}$$

$$= \int_{|\xi'|\le R} \left|\left(e^{-|\xi'|x_n} - 1\right)\hat{f}(\xi')\right|^2 d\xi' + \int_{|\xi'|>R} \left|\left(e^{-|\xi'|x_n} - 1\right)\hat{f}(\xi')\right|^2 d\xi'$$

$$\le \left|e^{-Rx_n} - 1\right| \int_{|\xi'|\le R} |\hat{f}(\xi')|^2\,d\xi' + \delta\ .$$

The first term of the RHS vanishes in the limit as $\delta \to 0$. Since δ is arbitrary, we conclude that $u(x', x_n)$ converges to $f(x')$ as $x_n \to 0$ in the $L^2(\mathbb{R}^{n-1})$ sense, which is that the L^2 norm of their difference tends to zero. \square

4.4. Maximum principle

A property that is evident of the Poisson kernel is that for $x_n > 0$,

$$D(x' - y', x_n) = \frac{2}{\omega_n}\left(\frac{x_n}{(|x'|^2 + x_n^2)^{n/2}}\right) > 0\ .$$

Therefore whenever a solution of the Dirichlet problem (4.8) has the property that $f(x') \ge 0$, then

$$u(x) = \int_{\mathbb{R}^{n-1}} D(x' - y', x_n)f(y')\,dy' > 0\ ;$$

this follows from an argument that is very similar to the one we used for Theorem 3.5 on the heat equation.

Theorem 4.4. *Suppose that $f(x') \geq 0$, then for $x \in \mathbb{R}^n_+$ we have $u(x) \geq 0$, and in fact if at any point $x \in \mathbb{R}^n_+$ (meaning, with $x_n > 0$) it happens that $u(x) = 0$, then we conclude that $u(x) \equiv 0$ and $f(x') = 0$.*

From this result we have a comparison between solutions.

Corollary 4.5. *Suppose that $f_1(x') \leq f_2(x')$ for all $x' \in \mathbb{R}^{n-1}$. Then either*

$$u_1(x) = (D * f_1)(x) < u_2(x) = (D * f_2)(x)$$

on all of \mathbb{R}^n_+, or else $u_i(x) \equiv u_2(x)$ if equality holds at any point $x \in \mathbb{R}^n_+$. In particular if $f_1 = f_2$ then both $f_1 \leq f_2$ and $f_1 \geq f_2$, so that $u_1 \equiv u_2$.

This is our second encounter with the recurring theme in elliptic and parabolic PDEs of comparison and maximum principles. In the case of the Laplace's equation and other elliptic equations, closely analog results hold on essentially arbitrary domains as well, although the Poisson kernel is not in general so explicit and the proof is different. In our present setting, the form of the Poisson kernel gives us a lower bound on the decay rates of solutions $u(x', x_n)$ for large x_n.

Corollary 4.6. *Suppose that $f(x') \geq 0$ and that $A \subseteq \{x' : f(x') \geq \delta\}$ is a bounded set of positive measure $\mathrm{meas}(A) > 0$. Then*

$$u(x', x_n) \geq \frac{2}{\omega_n} \left(\frac{x_n}{\sup_{y' \in A}(|x' - y'|^2 + x_n^2)^{n/2}} \right) \delta \, \mathrm{meas}(A) \,,$$

and in particular solutions $u(x', x_n)$ that are positive cannot decay too rapidly as $x_n \to +\infty$.

Proof. Express the solution in terms of the Poisson kernel

$$u(x) = \int_{\mathbb{R}^{n-1}} D(x' - y', x_n) f(y') \, dy'$$

$$\geq \int_A D(x' - y', x_n) f(y') \, dy'$$

$$\geq \inf_{y' \in A} \left(D(x' - y', x_n) \right) \int_A f(y') \, dy' \,,$$

and of course

$$\int_A f(y') \, dy' \geq \delta \, \mathrm{meas}(A) \,,$$

while

$$\inf_{y' \in A} \left(D(x' - y', x_n) \right) \geq \left(\frac{x_n}{\sup_{y' \in A}(|x' - y'|^2 + x_n^2)^{n/2}} \right) \cdot$$

\square

4.5. Oscillation and attenuation estimates

Another principle exhibited by solutions of Laplace's equation is the property of attenuation of oscillatory data. This is a feature that is related to the interior regularity of elliptic equations. It also is very relevant to applications, such as to imaging strategies in electrical impedance tomography, which is a medical imaging technique where the idea is to use electrostatic potentials to probe the interior of a patient's body in real time.

Theorem 4.7. *Suppose that $f(x') \in L^2(\mathbb{R}^{n-1})$ is the Dirichlet data for (4.8) on \mathbb{R}^n_+, and suppose in addition that*

$$\text{dist}\big(\text{supp}(\hat{f}(\xi')), 0\big) > \rho .$$

Then the solution $u(x', x_n)$ decays as $x_n \to +\infty$ with the upper bounds

$$(4.13) \qquad |u(x', x_n)| \leq \frac{C}{|x_n|^{(n-1)/2}} e^{-\rho|x_n|} .$$

This estimate (4.13) gives an effective penetration depth of the solution $u(x)$ into the interior of the domain, in the situation in which the Dirichlet data $f(x')$ has no low frequency component.

Proof. Since $\text{dist}\big(\text{supp}(\hat{f}(\xi')), 0\big) > \rho$ there is a $\delta > 0$ such that $\inf_{\xi' \in \text{supp}(\hat{f})} > \rho(1 + \delta)$. Using the Fourier representation for $u(x)$,

$$u(x) = \frac{1}{\sqrt{2\pi}^{n-1}} \int_{\text{supp}(\hat{f})} e^{i\xi' \cdot x'} e^{-|\xi'|x_n} \hat{f}(\xi') \, d\xi' .$$

Therefore

$$|u(x', x_n)| \leq \frac{1}{\sqrt{2\pi}^{n-1}} \int_{\text{supp}(\hat{f})} \big|e^{-|\xi'|x_n} \hat{f}(\xi')\big| \, d\xi'$$

$$\leq \frac{1}{\sqrt{2\pi}^{n-1}} \int_{\text{supp}(\hat{f})} e^{-|\xi'|x_n(\frac{1}{1+\delta})} e^{-|\xi'|x_n(\frac{\delta}{1+\delta})} |\hat{f}(\xi')| \, d\xi'$$

$$\leq e^{-\inf_{\xi' \in \text{supp}(\hat{f})}(\frac{|\xi'|x_n}{1+\delta})} \frac{1}{\sqrt{2\pi}^{n-1}} \int_{\text{supp}(\hat{f})} e^{-|\xi'|x_n(\frac{\delta}{1+\delta})} |\hat{f}(\xi')| \, d\xi'$$

$$\leq e^{-\rho|x_n|} \left(\int |\hat{f}|^2 \, d\xi'\right)^{1/2} \left(\int e^{-|\xi'|x_n(\frac{2\delta}{1+\delta})} \, d\xi'\right)^{1/2} ,$$

where we have used the Cauchy-Schwarz inequality on the last line. We thus have the estimate on the decay of $u(x', x_n)$ for large x_n, namely

$$|u(x)| \leq \frac{C(\delta)}{|x_n|^{(n-1)/2}} e^{-\rho|x_n|} \|f\|_{L^2} .$$

\square

A similar bound holds for derivatives of $u(x)$ using the same lines of argument as in the proof above. This is again related to the interior regularity of solutions of elliptic equations. We will give a bound on multiple derivatives of $u(x)$. Using multiindex notation

$$\partial_x^\alpha u(x) = \partial_{x_1}^{\alpha_1} \ldots \partial_{x_n}^{\alpha_n} u(x) \ ,$$

and assuming the hypotheses on the support of the Dirichlet data $f(x)$ as in Theorem 4.7, one follows a similar argument as in the proof above to show that

$$|\partial_x^\alpha u(x', x_n)| \le e^{-\rho} \int \left(|\xi_1^{\alpha_1} \ldots \xi_{n-1}^{\alpha_{n-1}}||\xi'|^{\alpha_n}|\hat{f}(\xi')|e^{-|\xi'|x_n(\frac{\delta}{1+\delta})} \right) d\xi'$$

$$\le \frac{C(\delta, \alpha)}{|x_n|^{(n-1)/2+|\alpha|}} e^{-\rho|x_n|} \|f\|_{L^2} \ .$$

4.6. The fundamental solution

The Laplace operator is invariant under rotations, and one can imagine that solutions which are also rotationally invariant are of special interest. In polar coordinates (r, φ) in \mathbb{R}^n, where $r \in [0, +\infty)$ and $\varphi \in \mathbb{S}^{n-1}$ the Laplacian is expressed

$$(4.14) \qquad \Delta u = \partial_r^2 + \frac{n-1}{r}\partial_r u + \frac{1}{r^2}\Delta_\varphi u \ ,$$

where Δ_φ is the Laplace operator on the unit sphere $\mathbb{S}^{n-1} \subseteq \mathbb{R}^n$. A rotationally invariant solution $\Gamma(r)$ of Laplace's equation must satisfy

$$\partial_r^2 \Gamma + \frac{n-1}{r}\partial_r \Gamma = 0 \ ,$$

That is $\partial_r \Gamma = \frac{C}{r^{n-1}}$, which in turn implies that

$$\Gamma(r) = \frac{C}{2-n}\frac{1}{r^{n-2}} \ , \qquad n \ge 3$$

$$\Gamma(r) = C\log(r) \ , \qquad n = 2 \ .$$

The function $\Gamma(r)$ is harmonic for $0 < r < +\infty$ but singular for $r = 0$. It is called a *fundamental solution*, which will be explained by the following computation that uses Green's identities. Suppose that $u \in C^2(\Omega) \cap C^1(\partial\Omega)$ and consider $y \in \Omega$ a point inside the domain under consideration. Take $\rho > 0$ sufficiently small so that the ball $B_\rho(y) \subseteq \Omega$, as in the Figure 1. Using

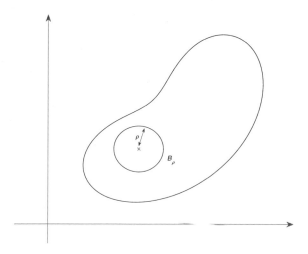

Figure 1. Domain Ω with a ball $B_\rho(y)$ excised.

Green's second identity (4.6) over the region $\Omega\backslash B_\rho(y)$ we have

$$(4.15) \qquad \int_{\Omega\backslash B_\rho(y)} \Gamma(|x-y|)\Delta u\,dx$$

$$= \int_{\partial\Omega}\left(\Gamma\partial_N u - \partial_N\Gamma u\right)dS_x + \int_{S_\rho(y)}\left(\Gamma\partial_N u - \partial_N\Gamma u\right)dS_x$$

$$+ \int_{\Omega\backslash B_\rho(y)}\Delta\Gamma\, u\,dx \ .$$

The fundamental solution Γ is harmonic in $\Omega\backslash B_\rho(y)$, the singularity at $x=y$ being inside $B_\rho(y)$, therefore that last term of the RHS is zero. The first term of the RHS is our usual boundary integral from (4.6). We are to calculate the second integral and its limit as $\rho \to 0$. On the sphere $S_\rho(y)$ we have $\Gamma(|x-y|) = \Gamma(\rho)$, while $\partial_N\Gamma(|x-y|) = -\partial_r\Gamma(\rho)$, the latter minus sign coming from the fact that the outward unit normal to $\Omega\backslash B_\rho(y)$ on $S_\rho(y)$ is pointing inwards towards y. Therefore

$$\int_{S_\rho(y)}\Gamma\partial_N u\,dS_x = \Gamma(\rho)\int_{S_\rho(y)}\partial_N u\,dS_x = -\Gamma(\rho)\int_{B_\rho(y)}\Delta u\,dx \ ,$$

and the limit of this quantity vanishes as $\rho \to 0$. Indeed, in case $n \geq 3$ then

$$(4.16) \qquad \lim_{\rho\to 0}\left|\Gamma(\rho)\int_{B_\rho(y)}\Delta u\,dx\right| \leq \lim_{\rho\to 0}\frac{C}{n-2}\frac{1}{\rho^{n-2}}\rho^n\|u\|_{C^2}$$

which vanishes like ρ^2 as $\rho \to 0$. The case $n = 2$ also vanishes in the limit, which involves $\log(\rho)$ instead. On the other hand the second term of (4.15) is

$$-\int_{S_\rho(y)} \partial_N \Gamma \, u \, dS_x = \frac{C}{\rho^{n-1}} \int_{S_\rho(y)} u \, dS_x \, ,$$

and as ρ tends to zero, by the continuity of $u(x)$ at $x = y$ this has the limit

$$(4.17) \qquad \lim_{\rho \to 0} \frac{C}{\rho^{n-1}} \int_{S_\rho(y)} u \, dS_x = \lim_{\rho \to 0} \frac{C}{\rho^{n-1}} \left(\frac{\omega_n}{\rho^{n-1}} u(y) \right) = C\omega_n u(y) \, ,$$

where the quantity ω_n is the surface area of the unit sphere $\mathbb{S}^{n-1} \subseteq \mathbb{R}^n$.

Theorem 4.8. *For $u \in C^2(\Omega) \cap C^1(\partial\Omega)$ and for $y \in \Omega$ we have the identity*

$$(4.18) \qquad \int_\Omega \Gamma(|x - y|)\Delta u(x) \, dx = C\omega_n u(y) + \int_{\partial\Omega} \left(\Gamma \partial_N u - \partial_N \Gamma \, u \right) dS_x \, .$$

Setting $C = \omega_n^{-1}$ we recover precisely the value of $u(y)$ with this identity. In fact this procedure need not be restricted to bounded domains Ω. If we specify that $u \in C^2(\mathbb{R}^n)$ is such that $\lim_{R \to +\infty} \int_{S_R(0)} (\Gamma \partial_N u - \partial_N \Gamma \, u) \, dS_x = 0$ for $y \in \mathbb{R}^n$ then the statement of Theorem 4.8 can be interpreted distributionaly in terms of the Dirac-δ function;

$$\Delta_x \Gamma(|x - y|) = \delta_y(x) \, .$$

We comment further that away from its pole the fundamental solution Γ is C^∞ smooth, in fact it is real analytic C^ω. The results of Theorem 4.8 can be used to deduce that a harmonic functions are C^∞, indeed even real analytic, in the interior of their domain of definition.

Theorem 4.9. *Let $u \in C^2(\Omega) \cap C^1(\partial\Omega)$ be a harmonic function in Ω, then in fact $u \in C^\omega$.*

Proof. For harmonic functions $u(x)$ the identity (4.18) reads

$$u(y) = \int_{\partial\Omega} \left(u \, \partial_N \Gamma - \partial_N u \, \Gamma \right) dS_x \, .$$

Since $y \in \Omega$ in this expression, while the boundary integral only involves $x \in \partial\Omega$, then $\mathrm{dist}(x, y)$ is bounded from below and the RHS clearly is a C^ω function of y, whence the result. \square

We may add any harmonic function $w(x)$ to the fundamental solution $\Gamma(|x - y|)$ and retain the above properties, as

$$\Delta_x(\Gamma + w) = \Delta_x \Gamma + \Delta_x w = \delta_y(x) \, .$$

In particular consider any ball $B_\rho(y) \subseteq \Omega$ within the domain of definition of a harmonic function $u(x)$. Use the quantity $\Gamma(|x-y|) - \Gamma(\rho)$ as a fundamental solution in (4.18) to find that

$$
u(y) = \int_{S_\rho(y)} \left(\Gamma(|x-y|) - \Gamma(\rho)\right) \partial_N u \, dS_x - \int_{S_\rho(y)} u \, \partial_r \Gamma \Big|_{r=\rho} dS_x
$$

$$
= \int_{S_\rho(y)} u(x) \frac{1}{\omega_n \rho^{n-1}} \, dS_x \ .
$$

This is a proof of the following result.

Theorem 4.10 (Gauss' law of arithmetic mean). *A harmonic function satisfies the integral identity*

$$
(4.19) \qquad u(y) = \frac{1}{\omega_n \rho^{n-1}} \int_{S_\rho(y)} u(x) \, dS_x = \frac{1}{\omega_n} \int_{v \in S_1(0)} u(y + \rho v) \, dS_v \ ,
$$

for all $B_\rho(y)$ contained in the domain of definition of u. An alternative version of this statement is that

$$
(4.20) \qquad\qquad u(y) = \frac{n}{\omega_n \rho^n} \int_{B_\rho(y)} u(x) \, dx \ .
$$

In words, this statement of this result is that a harmonic function $u(y)$ is equal to its average values over spheres $S_\rho(y)$ about y. This fact is consistent with discretizations of the Laplace operator in numerical simulations. For example, the simplest version of a finite difference approximation of the Laplacian at $y \in \mathbb{Z}^n$ is

$$
\Delta_h u(y) := \frac{1}{h^2} \left(\sum_{x \in \mathbb{Z}^n : |x-y|=1} u(x) - 2n u(y) \right) \ .
$$

A discrete harmonic function $\Delta_h u = 0$ explicitly satisfies the property that $u(y)$ is equal to the average of its values at the nearest neighbor points $|x-y| = 1$.

4.7. Maximum principle again

The maximum principle is a recurring theme in the theory of elliptic and parabolic PDEs. The result above of Gauss' law of arithmetic mean (4.19) allows us to discuss this sort of behavior of functions which are not even $C^2(\Omega)$, but merely continuous.

Definition 4.11. A function $u \in C(\Omega)$ is *subharmonic* in Ω when for all $y \in \Omega$ and all $B_\rho(y) \subseteq \Omega$, one has

$$
u(y) \le \frac{1}{\omega_n \rho^{n-1}} \int_{S_\rho(y)} u(x) \, dS_x \ .
$$

A function $u \in C(\Omega)$ is *superharmonic* in Ω when for all $y \in \Omega$ and all $B_\rho(y) \subseteq \Omega$ the opposite inequality holds,

$$u(y) \geq \frac{1}{\omega_n \rho^{n-1}} \int_{S_\rho(y)} u(x)\, dS_x \; .$$

This nomenclature is motivated by the fact that the graph of a subharmonic function lies beneath the graph of the harmonic function with the same boundary values on $\partial\Omega$, as we will show below. Similarly, superharmonic functions lie above harmonic functions sharing their boundary values. Furthermore, if we also knew that $u \in C^2(\Omega)$ then the inequality

$$\Delta u(x) \geq 0 \;, \qquad \bigl(\text{ respectively } \Delta u(x) \leq 0 \bigr) \;,$$

implies that $u(x)$ is subharmonic (respectively, superharmonic).

It turns out that subharmonic functions $u \in C(\Omega)$ satisfy the maximum principle, a statement that substantially lessens the necessary hypotheses for the result, and which proves to be a very useful principle in nonlinear problems and in other generalizations of Laplace's equation.

Theorem 4.12. *Let Ω be a bounded domain and suppose that $u \in C(\overline{\Omega})$ is subharmonic. Then*

(4.21)
$$\max_{x \in \overline{\Omega}}(u(x)) = \max_{x \in \partial\Omega}(u(x)) \;.$$

Furthermore, if Ω is connected then either for all $x \in \Omega$ we have

(4.22)
$$u(x) < \max_{x \in \partial\Omega}(u(x)) \;,$$

or else, if at some point $x \in \Omega$ equality holds, then $u(x)$ is necessarily a constant function $u(x) \equiv M := \max_{x \in \partial\Omega}(u(x))$. This latter result is known as the strong maximum principle.

If $u(x)$ is superharmonic then $-u(x)$ is subharmonic, and therefore u satisfies a *minimum principle*. A corollary of Theorem 4.12 is that harmonic functions, which are both sub- and superharmonic, satisfy upper and lower estimates in the supremum norm. Namely, if $u(x)$ is harmonic in Ω and $u(x) = f(x)$ for $x \in \partial\Omega$, then

$$\min_{x \in \partial\Omega}(f(x)) \leq u(x) \leq \max_{x \in \partial\Omega}(f(x))$$

for all $x \in \overline{\Omega}$.

Proof. We will give two proofs of this theorem, for the methods are interesting in their own right. Firstly, we will give a proof of the weak maximum principle, which is that of statement (4.21), under the stronger hypothesis that $u(x) \in C^2(\Omega) \cap C(\Omega)$. As a preliminary step, start with the case in which strict inequality holds; $\Delta u(x) > 0$ in Ω. Suppose that at some point

$x_0 \in \Omega$ the function $u(x)$ achieves its maximum, $u(x_0) = \max_{x \in \overline{\Omega}}(u(x))$. Then $\nabla u(x_0) = 0$ and the Hessian matrix of u satisfies

$$H(u) = \left(\partial_{x_j} \partial_{x_\ell} u(x_0) \right)_{j\ell=1}^n \leq 0 \ .$$

However this contradicts the fact that u is subharmonic, indeed

$$\Delta u(x) = \mathrm{tr}\big(H(u) \big) > 0 \ .$$

Hence no such maximum point can exist in Ω, and this argument even rules out local maxima. For the general case where we assume that $\Delta u \geq 0$ in Ω, consider the subharmonic function $v(x) = u(x) + \varepsilon |x|^2$, which satisfies $\Delta v(x) = \Delta u(x) + 2\varepsilon n > 0$. Therefore v satisfies the hypotheses of the first case, from which we conclude

$$\max_{x \in \overline{\Omega}}(u(x)) \leq \max_{x \in \overline{\Omega}}(u(x) + \varepsilon |x|^2)$$
$$= \max_{x \in \partial\Omega}(u(x) + \varepsilon |x|^2) \leq \max_{x \in \partial\Omega}(u(x)) + \varepsilon \max_{x \in \partial\Omega}(|x|^2) \ .$$

Since Ω is bounded, $\max_{x \in \partial\Omega}(|x|^2)$ is finite, and since ε is arbitrary, we have shown that

$$\max_{x \in \overline{\Omega}}(u(x)) \leq \max_{x \in \partial\Omega}(u(x)) \ .$$

The advantage of this proof is that it generalizes to many other elliptic equations, including

$$\sum_{j\ell=1}^n a^{j\ell}(x) \partial_{x_j} \partial_{x_\ell} u + \sum_{j=1}^n b^j(x) \partial_{x_j} u = 0 \ ,$$

where the matrices $(a^{j\ell}(x))_{j\ell=1}^n$ are positive definite.

The second proof is more specific to Laplace's equation, using Gauss' law of arithmetic mean. Consider Ω a domain which is connected, $u(x)$ a subharmonic function, and set $M := \sup_{x \in \Omega}(u(x))$. Decompose the domain into two disjoint subsets,

$$\Omega = \{x \in \Omega \, : \, u(x) = M\} \cup \{x \in \Omega \, : \, u(x) < M\} := \Omega_1 \cup \Omega_2 \ .$$

Since $u(x) \in C(\Omega)$, then Ω_2 is open as a subset of Ω because an inequality is an open condition. The claim is that the set Ω_1 is also open in Ω, which we will prove using the property of subharmonicity. Therefore, because of the fact of being connected, either $\Omega = \Omega_2$ and $\Omega_1 = \emptyset$, whereupon strict inequality holds throughout Ω. Or else $\Omega = \Omega_1$ and $\Omega_2 = \emptyset$, in which case $u(x) = M$ a constant.

To prove the claim above that Ω_1 is open, consider $x_0 \in \Omega_1$ and refer to Gauss' law of mean on all sufficiently small spheres $S_\rho(x_0)$ about x_0 which

lie in Ω. We have that

$$0 \leq \frac{1}{\omega_n \rho^{n-1}} \int_{|x-x_0|=\rho} u(x) - u(x_0) \, dS_x \; .$$

The integrand is nonpositive because $u(x) \leq M = u(x_0)$ in Ω. But the integrand cannot be negative anywhere near x_0 either, for that would violate the above inequality. Therefore we must have $S_\rho(x_0) \subseteq \Omega_1$ for all sufficiently small ρ, which is the statement that Ω_1 is open. ☐

4.8. Green's functions and the Dirichlet – Neumann operator

As we observed in Section 4.6 we may add any harmonic function to the fundamental solution $\Gamma(|x-y|)$ and retain the property that $\Delta(\Gamma + w) = \delta_y$. This is useful because the fundamental solution $\Gamma(|x-y|)$ doesn't satisfy the proper Dirichlet boundary conditions on domains Ω, with the only exception being the case $\Omega = \mathbb{R}^n$. Thus we may add a function $w(x,y) \in C^2(\Omega \times \Omega)$ that satisfies

$$\Delta_x w(x,y) = 0 \text{ for } x \in \Omega \; ,$$
$$w(x,y) = -\Gamma(|x-y|) \text{ for } x \in \partial\Omega \; .$$

The function $w(x,y)$ is harmonic in $x \in \Omega$ and depends parametrically on $y \in \Omega$. Then

$$G(x,y) := \Gamma(|x-y|) + w(x,y)$$

is still a fundamental solution in the distributional sense (4.18), meaning that $\Delta_x G(x,y) = \delta_y(x)$. Furthermore $G(x,y) = 0$ for $x \in \partial\Omega$, and therefore

$$u(x) := \int_\Omega G(x,y) h(y) \, dy$$

satisfies

$$\Delta_x u(x) = \Delta_x \int_\Omega G(x,y) h(y) \, dy$$
$$= \Delta_x \int_\Omega \Gamma(|x-y|) h(y) \, dy + \int_\Omega \Delta_x w(x,y) h(y) \, dy = h(x) \; .$$

It also satisfies Dirichlet boundary conditions; indeed for $x \in \partial\Omega$

$$u(x) = \int_\Omega G(x,y) h(y) \, dy = 0 \; .$$

The function $G(x,y)$ is called the *Green's function* for the domain Ω; it is the integral kernel of the solution operator \mathbf{P} for the Poisson problem (4.2),

$$(4.23) \qquad u(x) = \int_\Omega G(x,y) h(y) \, dy := \mathbf{P}h(x) \; .$$

While it is usually not possible to have explicit formulae for the Green's function $G(x,y)$ for a general domain, it is straightforward for the domain consisting of the half space \mathbb{R}^n_+. Let $y = (y', y_n) \in \mathbb{R}^n_+$ so that $y_n > 0$, denote the point that is its reflection through the boundary $\{x_n = 0\}$ by $y^* := (y', -y_n) \in \mathbb{R}^n_-$. The function $w(x,y) = -\Gamma(|x - y^*|)$ satisfies the property that it is harmonic in \mathbb{R}^n_+ (since its singularity at $x = y^*$ is in $\mathbb{R}^n_- 0$), and $\Gamma(|x - y^*|) = \Gamma(|x - y|)$ when $x = (x', 0) \in \partial\mathbb{R}^n_+$. This gives rise to the following expression for the Green's function for the domain \mathbb{R}^n_+:

$$(4.24) \qquad G(x,y) = \Gamma(|x - y|) - \Gamma(|x - y^*|)$$

$$= \frac{1}{(2 \quad n)\omega_n}\left(\frac{1}{(|x' \quad y'|^2 \mid (x_n \quad y_n)^2)^{(n-2)/2}}\right.$$

$$\left. - \frac{1}{(|x' - y'|^2 + (x_n + y_n)^2)^{(n-2)/2}}\right),$$

when $n \geq 3$. When $n = 2$ then

$$(4.25) \qquad G(x,y) = \frac{1}{4\pi}\log\left(\frac{(x_1 - y_1)^2 + (x_2 - y_2)^2}{(x_1 - y_1)^2 + (x_2 + y_2)^2}\right).$$

This procedure is similar to the method of images, as one can see. Actually, in two dimensions there is a connection with the theory of complex variables; because of the Riemann mapping theorem there is an expression for the Green's function for arbitrary simply connected domains in terms of the formula (4.25) and the Riemann mapping of the domain to the upper half plane \mathbb{R}^2_+.

Although it is not so evident from the way we constructed the Green's function for a domain Ω, the Green's function has the symmetry that $G(x,y) = G(y,x)$. This reflects the property of the Laplace operator with Dirichlet boundary conditions being a self-adjoint operator[1]. This property can be verified explicitly for the Green's functions for the upper half-space upon inspecting the formulae in (4.24) and (4.25).

The Poisson kernel: The Green's function $G(x,y)$ is the integral kernel for the solution of the Poisson problem (4.2), but it also is relevant for the Dirichlet problem (4.1). Let $u \in C^2(\Omega) \cap C^1(\overline{\Omega})$ be harmonic. Then by Green's identities

$$0 = \int_\Omega G(x,y)\Delta u(x)\,dx$$

$$= u(y) + \int_{\partial\Omega}\big(G(x,y)\partial_N u(x) - \partial_{N_x}G(x,y)u(x)\big)\,dS_x\ .$$

[1]Technically, the Laplace operator is a symmetric operator which is self-adjoint when restricted to an appropriate subspace $H^1_0(\Omega) \subseteq L^2(\Omega)$

Using the fact that $G(x,y) = 0$ for $x \in \partial\Omega$ we deduce that

$$(4.26) \qquad u(y) = \int_{\partial\Omega} u(x)\partial_{N_x}G(x,y)\, dS_x$$

$$= \int_{\partial\Omega} f(x)\partial_{N_x}G(x,y)\, dS_x := \mathbf{D}f(y)\,,$$

where $f(x)$ is the Dirichlet data for $u(x)$ on the boundary $\partial\Omega$. One may check that in the case of \mathbb{R}^n_+ this is indeed the formula for the Poisson kernel (4.11), namely that $-\partial_{x_n}G(x,y)\big|_{y_n=0} = D(x'-y',x_n)$.

There is a related expression for the analog of the Green's function for the Neumann problem, choosing another function $w(x,y)$ which is harmonic in x, and forming the fundamental solution

$$N(x,y) = \Gamma(|x-y|) + w(x,y)\,.$$

If $w(x,y)$ is chosen so that $\partial_N\Gamma(|x-y|) = -\partial_N w(x,y)$ for all $x \in \partial\Omega$, then the function $N(x,y)$ is the integral kernel for the solution operator of the Neumann problem (4.3). That is, the analog of the formula (4.26) holds. On general domains, given Neumann data $g(x)$ such that $\int_{\partial\Omega} g(x)\, dS_x = 0$, then

$$(4.27) \qquad u(y) = -\int_{\partial\Omega} N(x,y)\partial_N u(x)\, dS_x$$

$$= -\int_{\partial\Omega} N(x,y)g(x)\, dS_x := \mathbf{S}g(y)\,,$$

analogous to (4.26), as one shows with a calculation using Green's second identity. In the case that $\Omega = \mathbb{R}^n_+$ the choice is that $w(x,y) = \Gamma(|x-y^*|)$, and

$$(4.28) \qquad N(x,y) = \Gamma(|x-y|) + \Gamma(|x-y^*|)$$

$$= \frac{1}{(2-n)\omega_n}\Big(\frac{1}{(|x'-y'|^2+(x_n-y_n)^2)^{(n-2)/2}}$$

$$+ \frac{1}{(|x'-y'|^2+(x_n+y_n)^2)^{(n-2)/2}}\Big)\,,$$

when $n \geq 3$. When $n = 2$ then
$$(4.29)$$
$$N(x,y) = \frac{1}{4\pi}\log\Big(\big((x_1-y_1)^2+(x_2-y_2)^2\big)\big((x_1-y_1)^2+(x_2+y_2)^2\big)\Big)\,.$$

Setting $x_n = 0$ this gives the single layer potential

$$(4.30) \qquad S(x'-y',y_n) = \frac{2}{(2-n)\omega_n}\Big(\frac{1}{(|x'-y'|^2+y_N^2)^{(n-2)/2}}\Big)\,,$$

with which one solves the Neumann boundary value problem with data $g(x)$, namely

$$u(y) = \int_{x' \in \mathbb{R}^{n-1}} S(x' - y', x_n) g(x') \, dx' := \mathbf{S}g(x) \ .$$

The Dirichlet – Neumann operator: Given Dirichlet data on the boundary of a domain Ω, it is often the most important part of the solution process for $u(x)$ of the Dirichlet problem to recover the normal derivatives of the solution $\partial_N u(x)$ on the boundary. For Ω a conducting body this would be the map from applied voltage $u(x) = f(x)$ on $\partial\Omega$ to the resulting current $\partial_N u(x) = g(x)$ across the boundary. This map can be expressed in terms of the Green's function, in particular using the Poisson kernel we can express the solution to the Dirichlet problem

$$u(y) = \int_{\partial\Omega} (N_x \cdot \nabla_x) G(x, y) f(x) \, dS_x \ .$$

Therefore we have an expression for its normal derivative on $\partial\Omega$, namely
(4.31)
$$(N_y \cdot \nabla_y) u(y) \Big|_{y \in \partial\Omega} = \int_{\partial\Omega} (N_x \cdot \nabla_x)(N_y \cdot \nabla_y) G(x, y) f(x) \, dS_x := \mathbf{G}f(y) \ ,$$

where \mathbf{G} is the Dirichlet – Neumann operator for the domain Ω. There is symmetry in the exchange of x with y in the integrand of (4.31), from which we deduce that the Dirichlet – Neumann operator is self-adjoint[2]; $\mathbf{G}^T = \mathbf{G}$.

Recall the energy identity for a harmonic function $u(x)$,

$$(4.32) \quad 0 \leq \int_\Omega |\nabla u(x)|^2 \, dx = \int_{\partial\Omega} u(x) \partial_N u(x) \, dS_x = \int_{\partial\Omega} f(x)(\mathbf{G}f)(x) \, dS_x \ .$$

This is to say that the operator \mathbf{G} is nonnegative definite as well as being self-adjoint. The formula (4.32) also exhibits the relation between the Dirichlet integral of a harmonic function over a domain Ω and the boundary integral over $\partial\Omega$ involving the Dirichlet – Neumann operator.

It is useful to work this out on the domain \mathbb{R}^n_+. The solution to the Dirichlet problem for \mathbb{R}^n_+ is given in (4.12) in terms of the Fourier transform of the Poisson kernel;

$$u(x) = \frac{1}{\sqrt{2\pi}^{n-1}} \int_{\mathbb{R}^{n-1}} e^{i\xi' \cdot x'} e^{-|\xi'|x_n} \hat{f}(\xi') \, d\xi' \ .$$

Recall that $\widehat{\frac{1}{i}\partial_{x_j} u}(\xi) = \xi_j \hat{u}(\xi)$, which motivates the notation for differential operators that $D_j = \frac{1}{i}\partial_{x_j}$ and the definition of a general Fourier multiplier

[2]Analogous to the case above, technically the operator \mathbf{G} is symmetric on $C^1(\partial\Omega)$, and is self-adjoint on an appropriate subspace $H^{1/2}(\partial\Omega) \subseteq L^2(\partial\Omega)$

operator

$$\big(m(D')f\big)(x') = \frac{1}{\sqrt{2\pi}^{\,n-1}} \int_{\mathbb{R}^{n-1}} e^{i\xi'\cdot x'} m(\xi')\hat{f}(\xi')\,d\xi'$$

$$= \frac{1}{(2\pi)^{n-1}} \iint_{\mathbb{R}^{n-1}\times\mathbb{R}^{n-1}} e^{i\xi'\cdot(x'-y')} m(\xi') f(y')\,d\xi' dy' \ .$$

In these terms the harmonic extension $u(x)$ of the boundary conditions $f(x')$ can be written as

$$u(x) = e^{-x_n|D'|} f(x') := (\mathbf{D}f)(x', x_n) \ .$$

The operator \mathbf{D} extends the Dirichlet data $f(x')$ to a harmonic function $u(x) = \mathbf{D}f(x', x_n)$ in the upper half space \mathbb{R}^n_+. This is an interpretation of the formula (4.12) which uses a Fourier integral expression for the Poisson kernel.

Differentiating (4.12) with respect to x_n and evaluating the result on the boundary $\{x_n = 0\}$, the Dirichlet – Neumann operator has a related Fourier integral expression, namely

$$(4.33) \qquad \mathbf{G}f(x') = -\partial_{x_n}\big|_{x_n=0}\Big(\frac{1}{\sqrt{2\pi}^{\,n-1}} \int_{\mathbb{R}^{n-1}} e^{i\xi'\cdot x'} e^{-|\xi'|x_n} \hat{f}(\xi')\,d\xi'\Big)$$

$$= \big(|D'|f\big)(x') \ .$$

Finally, the Dirichlet integral can be expressed in terms of Fourier multipliers, using that

$$\partial_{x'}u(x', x_n) = \frac{1}{\sqrt{2\pi}^{\,n-1}} \int_{\mathbb{R}^{n-1}} e^{i\xi'\cdot x'} i\xi' e^{-|\xi'|x_n} \hat{f}(\xi')\,d\xi' \ ,$$

$$\partial_{x_n}u(x', x_n) = \frac{1}{\sqrt{2\pi}^{\,n-1}} \int_{\mathbb{R}^{n-1}} e^{i\xi'\cdot x'} |\xi'| e^{-|\xi'|x_n} \hat{f}(\xi')\,d\xi' \ .$$

Therefore

$$\int_{\mathbb{R}^n_+} |\nabla u(x)|^2\,dx = \int_0^{+\infty}\Big(\int_{\mathbb{R}^{n-1}} |i\xi'\hat{f}(\xi')|^2 e^{-2|\xi'|x_n} + |\xi'|^2|\hat{f}(\xi')|^2 e^{-2|\xi'|x_n}\,d\xi'\Big)dx_n \ ,$$

where we have used the Plancherel identity on the hyperplanes $\{(x', x_n) : x_n = \text{Constant}\}$. Thus

$$\int_{\mathbb{R}^n_+} |\nabla u(x)|^2\,dx = \int_{\mathbb{R}^{n-1}} 2|\xi'|^2|\hat{f}(\xi')|^2\Big(\int_0^{+\infty} e^{-2|\xi'|x_n}\,dx_n\Big)d\xi$$

$$= \int_{\mathbb{R}^{n-1}} f(x')\big(|D'|f(x')\big)\,dx' \ .$$

4.9. Hadamard variational formula

It is rare to have such explicit formulae as (4.10) for the Dirichlet problem
or (4.33) for the Dirichlet Neumann operator as is the case for the domain
\mathbb{R}^n_+. More often one considers general domains, with less explicit solution
procedures, so that it is reasonable to think to develop more general methods
in order to understand the solution operators. In particular, it is relevant
to ask whether the Green's function or the Poisson kernel vary continuously
under perturbation of the domain. For the Dirichlet problem there is an
elegant idea due originally to Hadamard, to describe the Taylor expansion
of the Green's function with respect to variations of the domain itself. We
will describe this idea in a specific case, namely in terms of the Poisson kernel
$\partial_N G(x', y)$ for domains which are perturbations of the upper half space \mathbb{R}^n_+.

Consider $\eta(x') \in C^1(\mathbb{R}^{n-1})$, whose graph defines the boundary of a
domain $\Omega(\eta) = \{(x', x_n) \in \mathbb{R}^n : x_n > \eta(x')\}$. In this notation $\Omega(0) =
\mathbb{R}^n_+$. The domain $\Omega(\eta)$ has its Green's function $G_{\Omega(\eta)}(x', y)$, from which we
obtain the Poisson kernel $\partial_N G_{\Omega(\eta)}(x', y) := D_{\Omega(\eta)}(x', y)$. The solution to the
Dirichlet problem with Dirichlet data is thus given by the integral operator

$$u(x) = \mathbf{D}_{\Omega(\eta)} f(x) = \int_{\mathbb{R}^{n-1}} D_{\Omega(\eta)}(x', y) f(y) \, dS_y \, ,$$

where $dS_y = \sqrt{1 + |\nabla\eta|^2} dy'$. From (4.12) we see that $\mathbf{D}_{\Omega(0)} = e^{-x_n|D'|}$, a
Fourier multiplier operator. In general $u(x) = \mathbf{D}_{\Omega(\eta)} f(x)$ is the bounded
harmonic extension to the domain $\Omega(\eta)$ of the boundary data $f(x)$ defined
on $\partial\Omega(\eta) = \{(x', x_n) : x_n = \eta(x')\}$. The solution operator $\mathbf{D}_{\Omega(\eta)}$ clearly
depends upon the domain given by $\eta(x')$ in a nonlinear, global and possibly
complicated way. The Hadamard variational formula expresses the deriv-
ative of the operator $\mathbf{D}_{\Omega(\eta)}$ with respect to variations of η, giving a linear
approximation to changes of the Green's function under perturbation of the
domain.

Definition 4.13. Let $\mathbf{D}(\eta)$ be a bounded linear operator from the space L^2
to L^2 that depends upon functions $\eta(x) \in C^1$. The bounded linear operator
$\mathbf{A}(\eta)$ is the *Fréchet derivative* of $\mathbf{D}(\eta)$ with respect to $\eta(x)$ at the point
$\eta = 0$ if it satisfies

$$\mathbf{A}(\lambda\eta) = \lambda\mathbf{A}(\eta) \quad \forall \lambda \in \mathbb{R}$$
$$\|(\mathbf{D}(\eta)f - \mathbf{D}(0)f) - \mathbf{A}(\eta)f\|_{L^2} \leq C|\eta|^2_{C^1}\|f\|_{L^2} \, .$$

The notation that is used for the *variation*, or linear approximation, to $\mathbf{D}(\eta)$
is that $\mathbf{A}(\eta) = \delta\mathbf{D}(\eta)\big|_{\eta=0}$. This definition can of course be adapted to the
more general situation of the operators $\mathbf{D}(\eta)$ mapping f in a Banach X to
a Banach space Y, for η varying over a neighborhood of a third Banach
space Z.

Without actually proving that $\mathbf{D}(\eta)$ is analytic with respect to $\eta \in C^1$ (which it is), we will derive a formula for the Fréchet derivative of $\mathbf{D}(\eta)$ for the domain that is the upper half space, for small $|\eta|_{C^1}$. A standard harmonic function on \mathbb{R}^n_+, and indeed on any of the domains $\omega(\eta)$, is of course $\varphi_k(x) = e^{ik \cdot x'} e^{-|k|x_n}$ for each parameter $k \in \mathbb{R}^{n-1}$ fixed. Therefore

$$\mathbf{D}(0)\big(e^{ik \cdot x'}\big) = e^{ik \cdot x'} e^{-|k|x_n} = e^{-x_n|D'|} e^{ik \cdot x'} \ .$$

Given one of the domains $\Omega(\eta)$, the boundary values of $\varphi_k(x)$ on $\partial\Omega(\eta)$ are $e^{ik \cdot x'} e^{-|k|\eta(x')}$, therefore for $x_n > \eta(x')$ we know that

$$\mathbf{D}(\eta)\big(e^{ik \cdot x'} e^{-|k|\eta(x')}\big) = e^{ik \cdot x'} e^{-|k|x_n} \ .$$

Thus taking any point $(x', x_n) \in \Omega(0) \cap \Omega(\eta)$,

$$0 = \mathbf{D}(\eta)\big(e^{ik \cdot x'} e^{-|k|\eta(x')}\big) - \mathbf{D}(0)\big(e^{ik \cdot x'}\big)$$
$$= \mathbf{D}(\eta)\big((1 - \eta(x')|k| + \tfrac{1}{2}\eta^2(x')|k|^2 + \ldots)e^{ik \cdot x'}\big) - \mathbf{D}(0)\big(e^{ik \cdot x'}\big) \ .$$

This is to say that

$$(4.34) \qquad \mathbf{D}(\eta)\big((e^{ik \cdot x'}) - \mathbf{D}(0)\big(e^{ik \cdot x'}\big) - \mathbf{D}(\eta)\big(\eta(x')|k|e^{ik \cdot x'}\big)$$
$$= \mathbf{D}(\eta)\big((\tfrac{1}{2}\eta^2(x')|k|^2 + \ldots)e^{ik \cdot x'}\big) \ .$$

The facts are that the operator $\mathbf{D}(\eta)$ does have a Fréchet derivative $\mathbf{A}(\eta)$ at $\eta = 0$, and that the RHS is bounded by $C|\eta|^2_{C^1}|k|^2$ for small $|\eta|_{C^1}$. This allows us to compute $\mathbf{A}(\eta)$ from (4.34). Namely,

$$\mathbf{D}(\eta)(e^{ik \cdot x'}) - \mathbf{D}(0)(e^{ik \cdot x'}) = \mathbf{D}(0)\big(\eta(x')|D'|e^{ik \cdot x'}\big) + \mathcal{O}(|\eta|^2_{C^1}) \ ,$$

from which we read that

$$\mathbf{A}(\eta)e^{ik \cdot x'} = \mathbf{D}(0)\big(\eta(x')|D'|e^{ik \cdot x'}\big) = e^{-x_n|D'|}\big(\eta(x')|D'|\big)e^{ik \cdot x'} \ .$$

In other words, $\partial_\eta \mathbf{D}(\eta)\big|_{\eta=0} f = \mathbf{A}(\eta)f = e^{-x_n|D'|}\big(\eta(x')|D'|f\big)(x)$.

Now consider the Dirichlet – Neumann operator $\mathbf{G}(\eta)$ on domains $\Omega(\eta)$ which are perturbations of $\Omega(0) = \mathbb{R}^n_+$, and its Fréchet derivative at $\eta = 0$. Recall that

$$\mathbf{G}(\eta)f(x') = N_x \cdot \nabla u(x)\big|_{x_n=\eta(x')} \ ,$$

where $u(x)$ is the bounded harmonic extension of the Dirichlet data $f(x')$ to the domain $\Omega(\eta)$. Using again the family of harmonic functions $\varphi_k(x) = e^{ik \cdot x'} e^{-|k|x_n}$ we compute its boundary values $f(x')$ and its normal derivative $N_x \cdot \nabla\varphi_k(x)$ on $\{x_n = \eta(x')\}$:

$$f(x') = e^{ik \cdot x'} e^{-|k|\eta(x')} = \big(1 - \eta(x')|k| + \mathcal{O}(|\eta|^2_{C^1})\big)e^{ik \cdot x'}$$
$$(4.35) \qquad \mathbf{G}(\eta)f(x') = N_x \cdot \nabla\varphi_k(x)$$
$$= \frac{1}{\sqrt{1 + |\nabla\eta|^2}}(\partial_{x'}\eta, -1) \cdot (ik, -|k|)\nabla\varphi_k(x)\big|_{x_n=\eta(x')} \ .$$

The Dirichlet – Neumann operator is not bounded on L^2, but it is bounded from $H^1(\mathbb{R}^{n-1})$ to L^2, as can be seen by its expression (4.33) as a Fourier multiplier when $\Omega = \mathbb{R}^n_+$. We seek the linear approximation to it among domain perturbations $\Omega(\eta)$ at the point $\eta = 0$. To calculate $\mathbf{B}(\eta) = \delta\mathbf{G}(\eta)\big|_{\eta=0} := \partial_\eta\mathbf{G}(\eta)\big|_{\eta=0}$, compare the first two terms of of the LHS with the RHS of (4.35) in powers of η:

$$\mathbf{G}(\eta)f(x') = \big(\mathbf{G}(0) + \mathbf{B}(\eta)\big)e^{ik\cdot x'} + \mathbf{G}(0)\big(-\eta(x')|k|e^{ik\cdot x'}\big)$$
$$= |D'|e^{ik\cdot x'} + \mathbf{B}(\eta)e^{ik\cdot x'} - |D'|\big(\eta(x')|D'|e^{ik\cdot x'}\big)$$

which is the LHS, and where the RHS is

$$N_x \cdot \nabla\varphi_k(x) = |k|e^{ik\cdot x'} + \partial_{x'}\eta(x')\cdot ik\, e^{ik\cdot x'} - |k|^2 e^{ik\cdot x'} + \mathcal{O}(|\eta|^2_{C^1})$$
$$= |D'|e^{ik\cdot x'} + \partial_{x'}\big(\eta(x')\partial_{x'}\, e^{ik\cdot x'}\big) + \mathcal{O}(|\eta|^2_{C^1})\ .$$

Equating these expressions, solving for $\mathbf{B}(\eta)$, and applying the operators to a general $f(x')$ rather than the particular family of functions $e^{ik\cdot x'}$, we obtain

(4.36) $\mathbf{B}(\eta)f(x') = \partial_{x'}\big(\eta(x')\partial_{x'}f(x')\big) + |D'|\big(\eta(x')|D'|f(x')\big)\ .$

Notice the symmetry under adjoints that is evident in this expression for $\mathbf{B}(\eta)$, reflecting the self-adjoint property of the Dirichlet – Neumann operator itself.

Exercises: Chapter 4

Exercise 4.1. Derive the expression (4.11) for the case $n = 2$ from the Fourier integral, and show that $\omega_2 = 2\pi$. *Hint:* Complex variables techniques would be useful.

Derive the expression (4.11) in the general case for $n \geq 3$ and show that ω_n is the surface area of the unit sphere $\mathbb{S}^{n-1} \subseteq \mathbb{R}^n$. *Hint:* A good starting place would be to adapt the method of images to the situation.

Exercise 4.2. In the case $n = 2$ the fundamental solution has the property that $\Delta\Gamma(|x - y|) = \delta_y(x)$. Show this by proving that the limit of the expression in (4.16) vanishes, and that the limit in (4.17) holds.

Exercise 4.3. Prove the second version of the Gauss' law of arithmetic mean (4.20).

Exercise 4.4. Prove that a function $u(x) \in C^2(\Omega)$ that satisfies

(4.37) $\Delta u \geq 0$

is subharmonic in Ω in the sense of Definition 4.11. Prove that if $u(x) \in C^2(\Omega)$ is subharmonic then it satisfies the inequality (4.37).

Exercise 4.5. Show that the Green's function $G(x, y)$ on a domain $\Omega \subseteq \mathbb{R}^n$ satisfies the property of symmetry $G(x, y) = G(y, x)$. Conclude that the resulting operator Δ^{-1} with Dirichlet boundary conditions is self-adjoint on $L^2(\Omega)$.

Exercise 4.6. Derive the Green's function and the Poisson kernel for the disk $B_R(0) \subseteq \mathbb{R}^n$.

Exercise 4.7. For simply connected domains Ω in \mathbb{R}^2 describe the Green's function in terms of the Riemann map of Ω to \mathbb{R}^2_+.

Exercise 4.8. Derive the variational formula of Hadamard for general (smooth) domains Ω, in a series of steps. Can we give a simple proof in an easy case?.

Properties of the Fourier transform

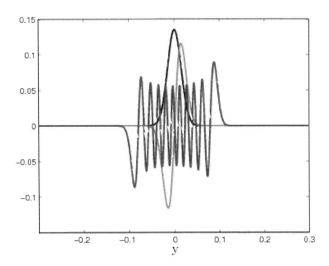

Figure 1. Three Hermite functions. Image from *W. Craig, P. Guyenne, C. Sulem, The surface signature of internal waves, The Journal of Fluid Mechanics, Volume 710, 10 November 2012, pages 277–303.* Reproduced with permission.

The purpose of this section is to raise our level of sophistication of the analysis of the Fourier transform, and to make up our backlog of analytic justification of our work in the previous several sections. The Fourier transform plays a very important role in analysis, and for this reason it has been

thoroughly analyzed from many points of view, by many people in many different settings. We will work through the bodies of two of the principal settings in this subsection, the ones most important to analysis and PDE. The cases are

(1) Hilbert spaces: covered in Section 5.1.

(2) Schwartz class: covered in Section 5.2.

5.1. Hilbert spaces

Definition 5.1. The usual Hilbert space for us is $L^2(\mathbb{R}^n)$, which consists of the square-integrable measurabe functions on \mathbb{R}^n;

$$L^2(\mathbb{R}^n) = \{f(x) \text{ Lebesgue measurable in } \mathbb{R}^n, \int_{\mathbb{R}^n} |f(x)|^2 dx < +\infty\}.$$

Proposition 5.2 (Elementary properties of $L^2(\mathbb{R}^n)$). (1) The space of functions $L^2(\mathbb{R}^n)$ is a linear space, namely if $f, g \in L^2$, then this implies that $\alpha f + \beta g \in L^2$.

(2) The topology on $L^2(\mathbb{R}^n)$ is given by a norm, which is homogenous of degree 1.

$$\|f\|_{L^2} = \left(\int_{\mathbb{R}^n} |f(x)|^2 \, dx\right)^{1/2}$$
$$\|\alpha f\|_{L^2} = |\alpha| \|f\|_{L^2}, \quad \|f\|_{L^2} = 0 \Leftrightarrow f = 0.$$

(3) The norm satisfies the triangle (or Minkowski) inequality:

$$\|f + g\|_{L^2} \leq \|f\|_{L^2} + \|g\|_{L^2}.$$

(4) The linear space $L^2(\mathbb{R}^n)$ is *complete* with respect to the norm

$$\|f\|_{L^2} = (\int_{\mathbb{R}^n} |f(x)|^2 dx|)^{\frac{1}{2}}.$$

That is, if $\{f_n\}_{n=1}^{\infty} \subseteq L^2(\mathbb{R}^n)$ is a Cauchy sequence of functions, then there exists a limit function $f(x) \in L^2(\mathbb{R}^n)$ such that $f_n(x) \to_{L^2} f(x)$ (meaning $\|f_n(x) - f(x)\|_{L^2} \to 0$).

(5) Furthermore, the norm on $L^2(\mathbb{R}^n)$ is given by an inner product:

(5.1) $\langle f, g \rangle = \int f(x)\overline{g(x)} \, dx, \qquad \langle f, f \rangle = \|f\|_{L^2}^2.$

The inner product satisfies the Schwartz inequality:

$$|\langle f, g \rangle| \leq \|f\|_{L^2} \|g\|_{L^2}.$$

(6) The "dual space", or space of bounded linear functionals on $L^2(\mathbb{R}^n)$, is $L^2(\mathbb{R}^n)$ itself.

Definition 5.3 (Banach and Hilbert spaces). A linear space with a norm, which is complete, is a *Banach space*. A Banach space whose norm is given by an inner product is a *Hilbert space*.

Our favourite Hilbert space $L^2(\mathbb{R}^n)$ has its inner product defined in (5.1). One reason that $L^2(\mathbb{R}^n)$ is a natural setting for the Fourier transform is that it is preserved under the transform. In \mathbb{R}^n, we define the transform as follows:

$$\hat{f}(\xi) = \frac{1}{\sqrt{2\pi}^n} \int_{\mathbb{R}^n} e^{-i\xi \cdot x} f(x)dx = (\mathcal{F}f)(\xi) .$$

Theorem 5.4. *The Fourier transform is an isometry of $L^2(\mathbb{R}^n)$. That is,* $\|f\|_{L^2(\mathbb{R}^n_x)} = \|\hat{f}\|_{L^2(\mathbb{R}^n_\xi)}$, *or stated in other words,*

$$\int_{\mathbb{R}^n_x} |f(x)|^2 \, dx = \int_{\mathbb{R}^n_\xi} |\hat{f}(\xi)|^2 \, d\xi .$$

This equality between the L^2 norms of a function and its Fourier transform is known as the Plancherel identity; it is a general fact about the Fourier transform that holds in many settings. The proof of Theorem 5.4 is deferred until the end of our discussion of Schwartz class.

Other examples of Hilbert spaces and Banach spaces as tools of analysis include the following:

(1) Sobolev spaces $H^s(\mathbb{R}^n)$ (Hilbert spaces based on L^2 norms):

$$H^s(\mathbb{R}^n) = \{f(x) : \sum_{0 \le |\alpha| \le s} \left(\int |\partial_x^\alpha f(x)|^2 \, dx \right)^{\frac{1}{2}} < +\infty\} .$$

This is a *scale of spaces*, which are nested in terms of decreasing index s: $H^s \subseteq H^{s-1} \subseteq \cdots \subseteq L^2(\mathbb{R}^n)$.

(2) L^p spaces (Banach spaces):

$$L^p(\mathbb{R}^n) = \{f(x) : \left(\int_{\mathbb{R}^n} |f(x)|^p \, dx \right)^{\frac{1}{p}} < +\infty\} .$$

For $p = \infty$ the space of bounded measurable functions on \mathbb{R}^n is denoted by $L^\infty(\mathbb{R}^n)$, and has a norm given by

$$\|f\|_{L^\infty} := \sup_{x \in \mathbb{R}^n} |f(x)| .$$

(3) Sobolev spaces $W^{s,p}(\mathbb{R}^n)$ (Banach spaces modeled on L^p norms):

$$W^{s,p}(\mathbb{R}^n) = \{f(x) : \sum_{0 \le |\alpha| \le s} \left(\int |\partial_x^\alpha f(x)|^p \, dx \right)^{\frac{1}{p}} < +\infty\} .$$

(4) Schauder spaces $C^{s,\gamma}(\Omega)$ (Banach spaces modeled on C^0 norms):

$$C^{s,\gamma}(\Omega) = \{f(x) \,:\, \sup_{x\in\Omega} |\partial_x^\alpha f(x)| < +\infty \;\forall|\alpha| \le s$$

$$\text{and } \forall|\alpha| = s, \;\; \sup_{x,y\in\Omega, x\neq y} \frac{|\partial_x^\alpha f(x) - \partial_x^\alpha f(y)|}{|x-y|^\gamma}\} < +\infty\} \,.$$

The space of Lipschitz functions is in this class, namely $f(x) \in Lip(\mathbb{R}^n) = C^{0,1}(\mathbb{R}^n)$ when

$$|f(x) - f(y)| \le C|x-y| \,, \qquad \text{for all} \quad x,y \in \mathbb{R}^n \,.$$

The many relationships of inclusion among these spaces, and their associated inequalities of norms, are important information for the analysis of PDE. A principal one that is very often used in PDEs is the Sobolev Embedding Theorem. A version of this result is as follows:

Theorem 5.5 (Sobolev embedding). *If $f(x) \in H^s(\mathbb{R}^n)$ for a Sobolev index $s > \frac{n}{2}$ then*

$$|f(x)|_{L^\infty} \le C_n \|f\|_{H^s} \,.$$

In other words $H^s \subseteq L^\infty$ for $s > \frac{n}{2}$, and there is a bound on the inclusion operator $\iota : H^s \to L^\infty$ given by the constant C_n.

Proof. Consider the value of $f(x)$ at an arbitrary point of \mathbb{R}^n,

$$|f(x)| = \Big|\frac{1}{\sqrt{2\pi}^n} \int_{\mathbb{R}^n} e^{i\xi\cdot x}\hat{f}(\xi)\,d\xi\Big|$$

$$= \Big|\frac{1}{\sqrt{2\pi}^n} \int_{\mathbb{R}^n} e^{i\xi\cdot x}\frac{1}{(1+|\xi|^2)^{\frac{s}{2}}}(1+|\xi|^2)^{\frac{s}{2}}\hat{f}(\xi)\,d\xi\Big| \,.$$

Using the Cauchy – Schwarz inequality on this last expression

$$(5.2) \qquad |f(x)| \le \frac{1}{\sqrt{2\pi}^n}\Big(\int\frac{1}{(1+|\xi|^2)^s}\,d\xi\Big)^{\frac{1}{2}}\Big(\int(1+|\xi|^2)^s|\hat{f}(\xi)|^2\,d\xi\Big)^{\frac{1}{2}} \,.$$

By the binomial theorem

$$\Big(\int(1+|\xi|^2)^s|\hat{f}(\xi)|^2\,d\xi\Big)^{\frac{1}{2}} = \Big(\sum_{j=0}^s\int\binom{s}{j}|\xi|^{2j}|\hat{f}(\xi)|^2\,d\xi\Big)^{\frac{1}{2}}$$

$$= \Big(\sum_{j=0}^s\int\binom{s}{j}|\nabla^j f(x)|^2\,dx\Big)^{\frac{1}{2}} \le C\|f\|_{H^s} \,,$$

where we have used the Plancherel identity for $f(x)$ and its derivatives in the last line. This holds of course for any integer s. It remains to bound the RHS of (5.2);

$$\Big(\int\frac{1}{(1+|\xi|^2)^s}\,d\xi\Big)^{\frac{1}{2}} = \Big(\int_{\mathbb{S}^{n-1}}\int_0^{+\infty}\frac{1}{(1+r^2)^s}r^{n-1}\,dr\,dS_\varphi\Big)^{\frac{1}{2}} \,,$$

and if $s > \frac{n}{2}$ then this quantity is finite, which finishes the proof. □

5.2. Schwartz class

This linear space of functions was introduced by Laurent Schwartz (Ecole Polytechnique - Paris) in order to embody a very convenient class of functions with which to work; for which one can integrate by parts and interchange integrations with differentiations with impunity. Colloquially, $f(x)$ is a Schwartz class function if it is infinitely differentiable, and if it decays along with all of its derivatives as $|x| \to \infty$ faster than any polynomial.

Definition 5.6 (Schwartz class). The Schwartz class consists of those functions $f(x)$ defined over \mathbb{R}^n such that for all α, β,

$$\sup_{x \in \mathbb{R}^n} |x^\alpha \partial_x^\beta f(x)| < +\infty.$$

It is clearly a linear space of functions and is denoted by \mathcal{S}.

Recall our previously introduced notation that is a convenient device for multivariable objects; the quantities α, β are multi-indices, $\alpha = (\alpha_1, \alpha_2, ..., \alpha_n)$, $\beta = (\beta_1, \beta_2, ..., \beta_n)$, with each $\alpha_i, \beta_j \in \mathbb{N}$. Thus, we have $|\alpha| = |\alpha_1| + \cdots + |\alpha_n|$ so that $x^\alpha = x_1^{\alpha_1} x_2^{\alpha_2} \ldots x_n^{\alpha_n}$ a monomial of degree $|\alpha|$ and $\partial_x^\beta = \partial_{x_1}^{\beta_1} \partial_{x_2}^{\beta_2} \ldots \partial_{x_n}^{\beta_n} = \Pi \partial_{x_j}^{\beta_j}$ a differential operator of order $|\beta|$.

With this notation, many combinatorially complex objects can be written very conveniently. For example, Taylor series in n dimensions can be stated

$$f(x) \sim \sum_\alpha \frac{1}{\alpha!} \partial_x^\alpha f(y)(x-y)^\alpha$$

with $\alpha! = \alpha_1! \alpha_2! \ldots \alpha_n!$.

Here are several examples of particular functions, where we can compare their properties of smoothness and decay in $x \in \mathbb{R}^n$ to those of Schwartz class:

$$f(x) = e^{-\frac{x^2}{2}} \in \mathcal{S} \ ,$$

$$f(x) = (1 + |x|^2)^{-\frac{b}{2}} \notin \mathcal{S} \text{ but } f(x) \in L^2(\mathbb{R}^n) \text{ for } b > n/2 \ ,$$

$$f(x) = e^{-|x|} \notin \mathcal{S} \text{ for a different reason } .$$

The space C_0^∞ of infinitely differentiable functions with compact support is a subset of \mathcal{S} as a subspace, $C_0^\infty \subseteq \mathcal{S}$, and the space C^∞ of bounded infinitely differentiable functions contains Schwartz class; $\mathcal{S} \subseteq C^\infty$. The space $C^\omega(\mathbb{R}^n)$ of bounded *real analytic function* on \mathbb{R}^n (the restriction to $x \in \mathbb{R}^n$ of functions that are analytic in a neighborhood of $\mathbb{R}^n \subseteq \mathbb{C}^n$) is a subset of C^∞, but not every C^∞ function is analytic.

The topology of \mathcal{S} is defined using a countable family of seminorms

$$\|f\|_{\alpha,\beta} = \sup_{x \in \mathbb{R}^n} |x^\alpha \partial_x^\beta f(x)| \ .$$

That is to say, a sequence $\{f_n(x)\}_{n=1}^\infty$ converges to $f(x)$ if and only if for all multi-indices α, β the seminorms

$$\|f_n - f\|_{\alpha,\beta} = \sup_x |x^\alpha \partial_x^\beta (f_n(x) - f(x))| \to 0$$

with $n \to \infty$. No uniformity in α, β is implied, however. Some functional analytic remarks are in order at this point. The space \mathcal{S} is a linear space, but not a Banach space, and there is no way to describe this sense of convergence by using a norm. It is, however, a metric space, with the distance between two points given by

$$\rho(f,g) = \sum_{\alpha,\beta} \frac{1}{2^{n(|\alpha|+|\beta|)}} \frac{\|f-g\|_{\alpha,\beta}}{1 + \|f-g\|_{\alpha,\beta}} \ ,$$

and it is complete with respect to this metric. Clearly $\{f_n(x)\}_{n=1}^\infty$ converges in \mathcal{S} to $f(x)$ if and only if $\rho(f_n, f) \to 0$ if and only if all $\|f_n - f\|_{\alpha,\beta} \to 0$ as $n \to \infty$. The notation for limits of sequences of functions in this Schwartz class sense is to write $\mathcal{S} - \lim f_n = f$. Metric spaces such as this one whose topology is given by a countable family of semi-norms are called *Fréchet spaces*.

Lemma 5.7 (technical lemma). This result quantifies the propertes of scaling limits of two objects, giving rise to well defined functionals on \mathcal{S}:

(i) Let $g \in \mathcal{S}$ with $g(0) = 1$. Then for all $f \in \mathcal{S}$,

$$\mathcal{S} - \lim_{\varepsilon \to 0} (g(\varepsilon x) f(x)) = f(x) \ .$$

(ii) Let $h(x) \in L^1(\mathbb{R}^n)$, with $\int h(x) dx = 1$, and suppose that $f(x)$ is bounded, and continuous at $x = 0$. Then

$$\lim_{\varepsilon \to 0} \int f(x) \frac{1}{\varepsilon} h(\frac{x}{\varepsilon}) dx = f(0) \ .$$

For $h(x) \in L^1 \mathbb{R}^n$, with $\int h(x)\, dx = 1$, the limit operation in (5.7) describes the approximation of the Dirac δ-function by rescaling a suitably normalized L^1 function $h(x)$.

Proof of Lemma 5.7(ii). By change of variables,

$$\int \frac{1}{\varepsilon^n} g(\frac{x}{\varepsilon})\, dx = \int g(x')\, dx' = 1 \ ,$$

with $x' = \frac{x}{\varepsilon}$. Given $\delta > 0$, choose $r > 0$ such that $|f(x) - f(0)| < \delta$ for all $|x| < r$. Then write

$$\int f(x)\frac{1}{\varepsilon}h(\frac{x}{\varepsilon})\,dx = \int f(0)\frac{1}{\varepsilon^n}h(\frac{x}{\varepsilon})\,dx + \int (f(x) - f(0))\frac{1}{\varepsilon^n}h(\frac{x}{\varepsilon})\,dx \ .$$

The first term is $f(0)$. Split the second term in two:

$$\left|\int_{|x|<r} (f(x) - f(0))\frac{1}{\varepsilon^n}h(\frac{x}{\varepsilon})\,dx\right| \le \delta\left|\int_{|x|<r}\frac{1}{\varepsilon^n}h(\frac{x}{\varepsilon})\,dx\right| \le \delta\|h\|_{L^1}$$

$$\left|\int_{|x|\ge r} (f(x) - f(0))\frac{1}{\varepsilon^n}h(\frac{x}{\varepsilon})\,dx\right| \le 2\sup_x |f(x)|\left|\int \frac{1}{\varepsilon^n}|h(\frac{x}{\varepsilon})|\,dx\right|$$

$$= 2\sup_x |f(x)|\int_{|x'|\ge\frac{r}{\varepsilon}}\frac{1}{\varepsilon^n}|h(x')||dx'|$$

and the RHS of the last term with r fixed tends to zero with $\varepsilon \to 0$. □

The proof of Lemma 5.7(i) appears in the exercises of this Chapter.

Corollary 5.8. The space $C_0^\infty \subseteq \mathcal{S}$ is a dense subspace of \mathcal{S}.

Proof. This uses Lemma 5.7: Take any $g \in C_0^\infty$ with $g(0) = 1$. Then for $f \in \mathcal{S}$ arbitrary,

$$g(\varepsilon x)f(x) \in C_0^\infty$$

and

$$\mathcal{S} - \lim_{\varepsilon\to 0}(g(\varepsilon x)f(x)) = f(x) \ .$$

□

The space of *distributions* is the space of continuous linear functionals on C_0^∞; $\mathcal{D}' = (C_0^\infty)'$, otherwise known as its dual space. The space of *tempered distributions* is the dual space of \mathcal{S}. Also, we write \mathcal{E}' for the dual space to C^∞, the space of bounded infinitely differentiable functions. Since $C_0^\infty \subseteq \mathcal{S} \subseteq C^\infty$, then $\mathcal{E} \subseteq \mathcal{S}' \subseteq \mathcal{D}'$.

The Fourier transform acts nicely on \mathcal{S}; for $f(x) \in \mathcal{S}$ define the Fourier transform as usual

$$\hat{f}(\xi) = \frac{1}{\sqrt{2\pi}^n}\int e^{-i\xi\cdot y}f(y)\,dy = \mathcal{F}(f)(\xi) \ .$$

One checks that this integral converges absolutely because $f(x) \in \mathcal{S}$; indeed

$$|e^{-i\xi\cdot x}f(x)| \le \|f\|_{N,0}\frac{1}{(1+|x|^2)^{\frac{N}{2}}} \ ,$$

and $N > n + 1$ will do for this. For Schwartz class $f(x)$ we may exchange integrations and differentiations as much as we wish, therefore the following list of properties holds for $\hat{f}(\xi)$.

Proposition 5.9 (Elementary properties of the Fourier transform on \mathcal{S}).
(1) $\widehat{\partial_x f}(\xi) = (i\xi)\hat{f}(\xi)$.

(2) $\widehat{xf}(\xi) = i\partial_\xi \hat{f}(\xi)$.

Notice the vectorial notation; x and $i\partial_\xi$ are vector operations.

Define two operations on functions: $\tau_h f(x) = f(x - h)$ (translations) and $(\sigma_\lambda f)(x) = f(\lambda x)$ (dilations).

(3) $\widehat{\tau_h f}(\xi) = e^{-ih\xi} \hat{f}(\xi)$ a *position boost*.

(4) $\widehat{e^{ihx} f}(\xi) = \hat{f}(\xi - h)$ a *momentum boost*.

(5) $\widehat{\sigma_\lambda f}(\xi) = \frac{1}{|\lambda|^n}\sigma_{(1/\lambda)}(\hat{f})(\xi) = \frac{1}{|\lambda|^n}\hat{f}(\xi/\lambda)$.

The principal reason why Schwartz class is well-suited for Fourier analysis is that it is invariant under the Fourier transform.

Theorem 5.10. *The Fourier transform maps \mathcal{S} onto itself; that is, whenever $f \in \mathcal{S}$, then $\hat{f} = \mathcal{F}(f) \in \mathcal{S}$.*

Proof. For $f(x) \in \mathcal{S}$, at the very least $\hat{f}(\xi)$ makes sense as a convergent integral. In order to check that $\hat{f}(\xi) \in \mathcal{S}$, we have to check that all of the seminorms are finite, which we do using the properties described in Proposition 5.9.

$$\|\hat{f}\|_{\alpha,\beta} = \sup_\xi |\xi^\alpha \partial_\xi^\beta \hat{f}(\xi)|$$

$$= \sup_\xi \left| \frac{1}{\sqrt{2\pi}^n} \int e^{-i\xi \cdot x} ((\tfrac{1}{i}\partial_x)^\alpha (\tfrac{1}{i}x)^\beta f(x))\, dx \right|.$$

This integrand is still bounded by $C_{\beta+N,\alpha}(1+|x|^2)^{-\frac{N}{2}}$, and hence the supremum over $\xi \in \mathbb{R}^n$ is finite. Furthermore, the Fourier transform is continuous on \mathcal{S}. Suppose that $\{f_n(x)\}_{n=1}^\infty$, and $f_n \underset{\mathcal{S}}{\to} f$. This implies that for each α, β,

$$\|\hat{f}_n - \hat{f}\|_{\alpha,\beta} = \sup_\xi \left| \frac{1}{\sqrt{2\pi}^n} \int e^{-i\xi \cdot x} ((\tfrac{1}{i}\partial_x)^\alpha (\tfrac{1}{i}x)^\beta (f_n(x) - f(x)))\, dx \right| \to 0$$

with $n \to \infty$ as well. Hence $\hat{f}_n(\xi) \underset{\mathcal{S}}{\to} \hat{f}(\xi)$, and therefore the mapping $\hat{f} : \mathcal{S} \to \mathcal{S}$ is continuous. \square

Finally we are prepared to prove the central theorem of Fourier inversion on \mathcal{S}.

Theorem 5.11 (Fourier inversion theorem on \mathcal{S}). *Suppose that $f \in \mathcal{S}$, then*

$$f(x) = \frac{1}{\sqrt{2\pi}^n} \int e^{i\xi \cdot x} \hat{f}(\xi)\, d\xi = \mathcal{F}^{-1}(\hat{f})(x) \ .$$

Proof. Lets first note that this works if $f(x)$ is a Gaussian. For $G(x) = \frac{1}{\sqrt{2\pi}^n} e^{-\frac{|x|^2}{2}}$ then $\hat{G}(\xi) = \frac{1}{\sqrt{2\pi}^n} e^{-\frac{|\xi|^2}{2}}$, by explicit calculation. One interpretation of this fact is that $G(x)$ is an eigenfunction of the Fourier transform, $\mathcal{F}(G) = G$, with eigenvalue 1. Now for the case of general $f(x) \in \mathcal{S}$, use properties given in Lemma (5.7),

$$f(0) = \lim_{\varepsilon \to 0} \int f(x) \frac{1}{\varepsilon^n} G(\frac{x}{\varepsilon})\, dx = \lim_{\varepsilon \to 0} \int f(x) \frac{1}{\varepsilon^n} \sigma_{\frac{x}{\varepsilon}}(G)\, dx$$

$$= \lim_{\varepsilon \to 0} \int f(x) \frac{1}{\varepsilon^n} \sigma_{\frac{x}{\varepsilon}}(\hat{G})\, dx = \lim_{\varepsilon \to 0} \int f(x) \widehat{\sigma_\varepsilon(G)}\, dx$$

$$= \lim_{\varepsilon \to 0} \int \hat{f}(\xi) \sigma_\varepsilon(G)(\xi)\, d\xi \ .$$

We have to verify the last step of this sequence of calculations.

Lemma 5.12. For $f, g \in \mathcal{S}$, then

$$\int f(x)\overline{\hat{g}(x)}dx = \int \hat{f}(\xi)\overline{g(\xi)}d\xi \ .$$

Proof of Lemma 5.12.

$$\int f(x) \frac{1}{\sqrt{2\pi}^n} \int e^{+i\xi \cdot x}\, dx\, \overline{g(\xi)}\, d\xi = \frac{1}{\sqrt{2\pi}^n} \int f(x) \int e^{+i\xi \cdot x}\, dx\, \overline{g(\xi)}\, d\xi$$

$$= \int (\hat{f}(\xi)\overline{g(\xi)})\, dx \ .$$

\square

Now apply (5.7) to the result. Since $G(\xi)\big|_{\xi=0} = \frac{1}{\sqrt{2\pi}^n}$;

$$f(0) = \lim_{\varepsilon \to 0} \int \hat{f}(\varepsilon) G(\varepsilon/\xi)\, d\xi = \frac{1}{\sqrt{2\pi}^n} \int \hat{f}(\xi)\, d\xi \ .$$

This recovers $f(0) = \frac{1}{\sqrt{2\pi}^n} \int \hat{f}(\xi)\, d\xi$. To generalize this procedure to cover all $x \in \mathbb{R}^n$ is in fact simple, again using the list of properties in Proposition 5.9:

$$f(x) = (\tau_{-x}f)(0) = \frac{1}{\sqrt{2\pi}^n} \int \mathcal{F}(\tau_{-x}f)(\xi)\, d\xi = \frac{1}{\sqrt{2\pi}^n} \int e^{i\xi \cdot x} \hat{f}(\xi)\, d\xi \ .$$

\square

We can finish this circle of ideas with a proof of the $L^2(\mathbb{R}^n)$ Fourier inversion theorem. We have shown that Schwartz class $\mathcal{S} \subseteq L^2(\mathbb{R}^n)$ is a dense subspace. The Lemma 5.12 states that for $f, g \in \mathcal{S}$, then

$$\langle f, \mathcal{F}^{-1}g \rangle = \langle \mathcal{F}f, g \rangle \ ,$$

where we also note that

$$(\mathcal{F}^{-1}g)(x) = \hat{g}(-\xi) \ .$$

Therefore for every $f \in \mathcal{S}$,

$$\|f\|_{L^2} = \langle f, \mathcal{F}^{-1}(\mathcal{F}f) \rangle$$
$$= \langle \mathcal{F}(f), \mathcal{F}(f) \rangle$$
$$= \|\hat{f}\|_{L^2}^2 .$$

so the Fourier transform acts on the the subspace $\mathcal{S} \subseteq L^2(\mathbb{R}^n)$ isometrically (in the sense of the L^2-norm). Since \mathcal{S} is dense, given an arbitrary $f \in L^2(\mathbb{R}^n)$, there is a sequence $f_n \to f$ in the $L^2(\mathbb{R}^n)$ sense of convergence, with $f_n \in \mathcal{S}$. Then we define

$$\mathcal{F}(f) - \lim_{n \to \infty} \mathcal{F}(f_n) .$$

Theorem 5.13 (of functional analysis). *: Suppose that an operator* \mathbf{T} *is defined on a dense subspace* $\mathcal{S} \subseteq \mathcal{B}$, *where* \mathcal{B} *is a Banach space, and it is bounded;* $\|\mathbf{T}f\|_{\mathcal{B}} \leq C\|f\|_{\mathcal{B}}$ *for all* $f \in \mathcal{S}$. *Then there exists a unique extension* $\mathbf{T}^{(1)}$ *of* \mathbf{T} *to all of* \mathcal{B}, *which is bounded with the same bound.*

Proof. For arbitrary $f \in \mathcal{B}$ consider a sequence $\{f_n\}_{n=1}^{\infty} \to f$, with $\{f_n\}_{n=1}^{\infty} \subseteq \mathcal{S}$. Then $\{f_n\}_{n=1}^{\infty}$ is Cauchy, and so is the sequence $\{\mathbf{T}f_n\}_{n=1}^{\infty}$ because

$$\|\mathbf{T}f_n - \mathbf{T}f_m\|_{\mathcal{B}} \leq C\|f_n - f_m\|_{\mathcal{B}} \to 0 .$$

Thus $\{\mathbf{T}f_n\}_{n=1}^{\infty}$ has a limit $g \in \mathcal{B}$, which we define to be $\mathbf{T}^{(1)}f := g$. The extension is clearly linear. It is also well-defined, for if $\{h_n\}_{n=1}^{\infty} \subseteq \mathcal{S}$ is another sequence such that $\{h_n\}_{n=1}^{\infty} \to f$, but $Th_n \to g_1$, then

$$\|g - g_1\|_{\mathcal{B}} = \lim_{n \to \infty} \|\mathbf{T}f_n - \mathbf{T}h_n\|_{\mathcal{B}} \leq C \lim_{n \to \infty} \|f_n - h_n\|_{\mathcal{B}} = 0 .$$

\square

The conclusion that is relevant to the Fourier transform is that \mathcal{F} restricted to \mathcal{S} (such that it has norm $\|\mathcal{F}f\|_{L^2} = \|f\|_{L^2}$ on \mathcal{S}) extends uniquely to $\mathcal{F}^{(1)}$ defined on all of $L^2(\mathbb{R}^n)$. Furthermore, this extension is an isometry of $L^2(\mathbb{R}^n)$, as for $\{f_n\}_{n=1}^{\infty} \subseteq \mathcal{S} \subseteq L^2(\mathbb{R}^n)$, with $f_n \to f$;

$$\|f\|_{L^2}^2 = \lim_{n \to \infty} \|f_n\|_{L^2}^2 = \lim_{n \to \infty} \|\hat{f}_n\|_{L^2}^2 = \|\mathcal{F}^{(1)}(f)\|_{L^2}^2 .$$

This completes the proof of Theorem 5.4. We will redefine the extension notation $\mathcal{F}^{(1)} := \mathcal{F}$ at this time, dropping the extra superscript. The statement is then that $\|f\|_{L^2} = \|\mathcal{F}f\|_{L^2}$ for all $f \in L^2$, which is the desired result.

To finish our remarks we should note that complex isometries \mathbf{U} have the property that $\mathbf{U}^* = \mathbf{U}^{-1}$; namely they are unitary operators. Lets verify this with the Fourier transform.

Definition 5.14. The adjoint \mathbf{T}^* of an operator \mathbf{T} on a Hilbert space H satisfies $\langle \mathbf{T}^* f, g \rangle = \langle f, \mathbf{T} g \rangle$ for all $f, g \in H$.

Applying this definition of the adjoint to \mathcal{F}, take any two $f, g \in L^2$. Then

$$
\int_{\mathbb{R}^n} g(\xi) \overline{\mathcal{F}(f)(\xi)} \, d\xi = \int_{\mathbb{R}^n} g(\xi) \overline{\frac{1}{\sqrt{2\pi}^n} \int e^{-i\xi \cdot x} f(x) \, dx} \, d\xi
$$

$$
= \int_{\mathbb{R}^n} \left(\int_{\mathbb{R}^n} \frac{1}{\sqrt{2\pi}^n} e^{i\xi \cdot x} g(\xi) \, d\xi \right) \overline{f(x)} \, dx
$$

$$
= \int_{\mathbb{R}^n} \mathcal{F}^{-1}(g)(x) \overline{(f(x))} \, dx \ ,
$$

which states that $\mathcal{F}^* = \mathcal{F}^{-1}$, as desired.

Exercises: Chapter 5

Exercise 5.1. Show that the Fourier transform preserves angles between vectors. For $f, g \in L^2$ then,

$$
Re\langle f, g \rangle = \|f\|_{L^2} \|g\|_{L^2} \cos \theta
$$

and

$$
Re\langle \hat{f}, \hat{g} \rangle = \|\hat{f}\|_{L^2} \|\hat{g}\|_{L^2} \cos \varphi \ .
$$

Show that $\theta = \varphi$.

Exercise 5.2. The $L^p(\Omega)$ norm for functions on a domain $\Omega \subseteq \mathbb{R}^n$ is defined as

$$
\|f\|_{L^p} = \left(\int_\Omega |f(x)|^p \, dx \right)^{1/p} \ ,
$$

for $1 \leq p < +\infty$. The Hölder inequality states that

$$
\left| \int_\Omega f(x) g(x) \, dx \right| \leq \|f\|_{L^p} \|g\|_{L^{p'}}
$$

where $\frac{1}{p} + \frac{1}{p'} = 1$ are dual indices. A special case for $p = p' = 2$ is the Cauchy – Schwarz inequality.

Give a proof of the Hölder inequality for the range of p, p' given above.

Exercise 5.3. This problem concerns the case of domains $\Omega = \mathbb{R}^n$ and of bounded domains $\Omega \subseteq \mathbb{R}^n$.

 (1) In the case of $\Omega = \mathbb{R}^n$, for which indices p and q does the following hold:

$$
L^p(\mathbb{R}^n) \subseteq L^q(\mathbb{R}^n) \ ?
$$

(2) In the case of bounded Ω, use the Hölder inequality to show that
$$L^p(\Omega) \subseteq L^q(\Omega) .$$
for $q \leq p$.

(3) In the case of bounded Ω, is it true that
$$L^\infty(\Omega) = \bigcap_{1 \leq p < +\infty} L^p(\Omega) .$$

Exercise 5.4. Prove the part (i) of the technical lemma 5.7 on Schwartz class functions. Namely show that for $g \in \mathcal{S}(\mathbb{R}^n)$ such that $g(0) = 1$, then for all $f \in \mathcal{S}(\mathbb{R}^n)$
$$\mathcal{S} - \lim_{\varepsilon \to 0} \big(g(\varepsilon x) f(x) \big) = f(x) .$$

Exercise 5.5. Give examples of non-analytic, C^∞ functions on \mathbb{R}^n.

Exercise 5.6. We have described the Fourier transform \mathcal{F} as a unitary operator on $L^2(\mathbb{R}^n)$. What are the eigenvalues and eigenfunctions $(\lambda_k, \psi_k(x))$ of this operator. For simplicity you may consider only the case $n = 1$. Note: this exercise is related to exercise 2.5 of Chapter 2.

Wave equations on \mathbb{R}^n

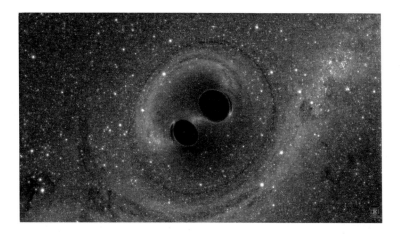

Numerical simulation of a merger of two black holes generating gravitational waves, similar to those observed by the LIGO detectors. Image Credit: SXS, the Simulating eXtreme Spacetimes (SXS) project (`http://www.black-holes.org`). Courtesy of Caltech/MIT/LIGO Laboratory.

Solutions of this equation describe the propagation of light, of sound waves in a gas or a fluid, of gravitational waves in the interstellar vacuum, and many other phenomena. It is one of my favourite equations. Posed in $\mathbb{R}^1_t \times \mathbb{R}^n_x$ the initial value problem, (or *Cauchy problem*), for the equation looks very similar to (2.10) of Chapter 2;

$$(6.1) \qquad \partial_t^2 u - \Delta u = 0, \qquad x \in \mathbb{R}^n, t \in \mathbb{R}^1 \ ,$$

with initial or Cauchy data for $u(x, t)$ given by

$$u(0, x) = f(x) , \qquad \partial_t u(0, x) = g(x) .$$

The given initial data $u(0, x) = f(x)$ is often referred to as the initial position or displacement of the field $u(t, x)$, while the data for $\partial_t u(0, x) = g(x)$ is called the initial momentum or velocity.

6.1. Wave propagator by Fourier synthesis

Assuming first that $f(x), g(x) \in \mathcal{S}$, we may take the Fourier transform of the equation to obtain

$$(6.2) \qquad \partial_t^2 \hat{u}(\xi, t) + |\xi|^2 \hat{u}(\xi, t) = 0 .$$

Solutions of this second order ODE are composed of linear combinations of $e^{\pm i|\xi|t}$; taking into account that $\hat{u}(\xi, 0) = \hat{f}(\xi)$ and $\partial_t \hat{u}(\xi, 0) = \hat{g}(\xi)$, we derive the expression

$$(6.3) \qquad \hat{u}(t, \xi) = \cos(|\xi|t)\hat{f}(\xi) + \frac{\sin(|\xi|t)}{|\xi|}\hat{g}(\xi) .$$

The inverse Fourier transform gives the solution

$$(6.4) \qquad u(t, x) = \frac{1}{\sqrt{2\pi}^n} \int e^{i\xi \cdot x} \left(\cos(|\xi|t)\hat{f}(\xi) + \frac{\sin(|\xi|t)}{|\xi|}\hat{g}(\xi) \right) d\xi .$$

we observe from (6.3) that $\hat{u}(t, \xi) \in \mathcal{S}(\mathbb{R}_x^n)$ for each time t, and therefore our solution given in (6.4) is Schwartz class as well. However this high level of smoothness is not at all necessary, and one notes that the expression (6.4) makes sense whenever $\hat{f}(\xi), \frac{\hat{g}(\xi)}{|\xi|} \in L^2(\mathbb{R}_x^n)$.

Theorem 6.1. *For $f, g \in \mathcal{S}$, the expression* (6.4) *gives a solution of the wave equation $u(t, x) \in \mathcal{S}(\mathbb{R}_x^n)$ for each time $t \in \mathbb{R}$. For $\hat{f}(\xi), \frac{\hat{g}(\xi)}{|\xi|} \in L^2(\mathbb{R}_x^n)$, then* (6.4) *gives a weak solution to the wave equation, in the sense that* (6.2) *is satisfied.*

One basic property satisfied by solutions of the wave equation is the principle of 'energy' conservation under time evolution. The energy of a solution is given by

$$(6.5) \qquad E(u) = \frac{1}{2} \int (\partial_t u(t, x))^2 + |\nabla_x u(t, x)|^2 \, dx .$$

Theorem 6.2. *For $(f, g) \in H^1(\mathbb{R}_x^n) \times L^2(\mathbb{R}_x^n)$ the energy* (6.5) *is conserved for solutions of the wave equation* (6.1).

Proof. Using the expression (6.3) for the Fourier transform of the solution, we give a similar formula for the vector $(\partial_x u(t,x), \partial_t u(t,x))^T$

$$\begin{pmatrix} \partial_x u(t,x) \\ \partial_t u(t,x) \end{pmatrix} = \frac{1}{\sqrt{2\pi}^n} \int e^{i\xi \cdot x} \begin{pmatrix} \cos(|\xi|t) & \frac{i\xi}{|\xi|}\sin(|\xi|t) \\ \frac{i\xi}{|\xi|}\sin(|\xi|t) & \cos(|\xi|t) \end{pmatrix} \begin{pmatrix} i\xi \hat{f}(\xi) \\ \hat{g}(\xi) \end{pmatrix} d\xi \ .$$

By inspection this is a well defined vector valued function in $[L^2(\mathbb{R}^n)]^{n+1}$ as long as $(\nabla_x f(x), g(x))^T \in [L^2(\mathbb{R}^n)]^{n+1}$, which it is by hypothesis. By the Plancharel identity

$$\|\partial_t u(x,t)\|_{L^2}^2 + \|\partial_x u(x,t)\|_{L^2}^2 = \| \begin{pmatrix} \cos(|\xi|t) & \frac{i\xi}{|\xi|} \\ \frac{i\xi}{|\xi|}\sin(|\xi|t) & \cos(|\xi|t) \end{pmatrix} \begin{pmatrix} i\xi \hat{f}(\xi) \\ \hat{g}(\xi) \end{pmatrix} \|_{L^2}^2$$

$$= \| \begin{pmatrix} i\xi \hat{f}(\xi) \\ \hat{g}(\xi) \end{pmatrix} \|_{L^2}^2 = \|\nabla_x f\|_{L^2}^2 + \|g\|_{L^2}^2 \ .$$

The second to last equality holds because the 2×2 matrix featured in this calculation is unitary. $\qquad\square$

An alternative proof works in the case that we also have $\partial_t^2 u, \Delta u \in L^2$, then for solutions of (6.1);

$$\frac{d}{dt}E(u) = \frac{1}{2}\int_{\mathbb{R}^n} 2\partial_t u \partial_t^2 u + 2\partial_x u \partial_t \partial_x u \, dx$$

$$= \int_{\mathbb{R}^n} \partial_t u \left(\partial_t^2 u - \Delta u\right) dx = 0 \ .$$

6.2. Lorentz transformations

Just as the Laplace operator $\Delta = \sum_{j=1}^n \partial_{x_j}^2$ is invariant under translations $x' = x + c$ and rotations $x' = Rx$, where $R^T = R^{-1}$, the wave operator or d'Alembertian

$$\Box = \partial_t^2 - \Delta = \partial_t^2 - \sum_{j=1}^n \partial_{x_j}^2$$

is invariant under a group of transformations of the space-time $\mathbb{R}_t^1 \times \mathbb{R}_x^n$ known as the Lorentz group. Elements of this transformation group are generated by the same rotations of \mathbb{R}_x^n as above, and *hyperbolic rotations* which involve time as well as space. Define a hyperbolic rotation in the (t, x_1) coordinate plane in $\mathbb{R}^2 \subseteq \mathbb{R}^{n+1}$ by

$$\begin{pmatrix} t' \\ x'_1 \end{pmatrix} = \begin{pmatrix} \cosh(\psi) & \sinh(\psi) \\ \sinh(\psi) & \cosh(\psi) \end{pmatrix} \begin{pmatrix} t \\ x_1 \end{pmatrix} = H(\psi) \begin{pmatrix} t \\ x_1 \end{pmatrix} \ .$$

One calculates that $\det(H(\psi)) = \cosh(\psi)^2 - \sinh(\psi)^2 = 1$ and that $H^{-1}(\psi) = H(-\psi)$. Vector fields in the (t, x_1) coordinate plane transform as follows

$$(6.6) \qquad \begin{pmatrix} \partial_t \\ \partial_{x_1} \end{pmatrix} = \begin{pmatrix} \cosh(\psi) & \sinh(\psi) \\ \sinh(\psi) & \cosh(\psi) \end{pmatrix} \begin{pmatrix} \partial_{t'} \\ \partial_{x'_1} \end{pmatrix} = H(\psi) \begin{pmatrix} \partial_{t'} \\ \partial_{x'_1} \end{pmatrix} .$$

The Lorentz group of transformations on the space-time $\mathbb{R}^1_t \times \mathbb{R}^n_x$ is generated by all spatial rotations R and by the hyperbolic rotations $H(\psi)$. It is a Lie group known as $SO(1, n)$. The set of space-time translations $(t', x') = (t + b, x + c)$ leave the wave equation invariant, and so do the elements of the Lorentz group.

Proposition 6.3. The Lorentz transformations leave the d'Alembertian operator invariant.

Proof. Since the group generators involving translations obviously leave the d'Alembertian invariant, and all spatial rotations R just involve the Laplacian, it suffices to check invariance under the hyperbolic rotations $H(\psi)$. Write the d'Alembertian operator using matrix notation

$$\Box u = (\partial_t^2 - \Delta)u = \begin{pmatrix} \partial_t \\ \partial_{x_1} \end{pmatrix}^T \begin{pmatrix} 1 & 0 \\ 0 & -I_{n \times n} \end{pmatrix} \begin{pmatrix} \partial_t \\ \partial_{x_1} \end{pmatrix} u .$$

Use the transformation rule (6.6) for vector fields to check the invariance of the d'Alembertian

$$\begin{pmatrix} \partial_{t'} \\ \partial_{x'_1} \end{pmatrix}^T \begin{pmatrix} H_{2\times2}^T & 0 \\ 0 & I_{(n-1)\times(n-1)} \end{pmatrix} \begin{pmatrix} 1 & 0 \\ 0 & -I_{n \times n} \end{pmatrix} \begin{pmatrix} H_{2\times2} & 0 \\ 0 & I_{(n-1)\times(n-1)} \end{pmatrix} \begin{pmatrix} \partial_{t'} \\ \partial_{x'_1} \end{pmatrix} .$$

The only nontrivial part of this matrix calculation is the upper right hand 2×2 block

$$H_{2\times2}^T \begin{pmatrix} 1 & 0 \\ 0 & -1 \end{pmatrix} H_{2\times2} = \begin{pmatrix} \cosh(\psi) & \sinh(\psi) \\ \sinh(\psi) & \cosh(\psi) \end{pmatrix} \begin{pmatrix} 1 & 0 \\ 0 & -1 \end{pmatrix} \begin{pmatrix} \cosh(\psi) & \sinh(\psi) \\ \sinh(\psi) & \cosh(\psi) \end{pmatrix}$$

$$= \begin{pmatrix} \cosh^2(\psi) - \sinh^2(\psi) & 0 \\ 0 & \sinh^2(\psi) - \cosh^2(\psi) \end{pmatrix} = \begin{pmatrix} 1 & 0 \\ 0 & -1 \end{pmatrix} ,$$

which is precisely to say that the d'Alembertian \Box is invariant under $H(\psi)$. This is the stated result. $\qquad\square$

The effects of the Lorentz transformation $H(\psi)$ on the time axis $\{x = 0\}$ are given by

$$x'_1 = \sinh(\psi)t , \qquad t' = \cosh(\psi)t ,$$

therefore their ratio

$$\frac{x'_1}{t'} = \tanh(\psi) := v$$

gives the velocity of the new frame of reference with respect to the old. We note that $|v| = |\tanh(\psi)| < 1$. In terms of v, the hyperbolic rotation can be written in a more familiar form

$$H = \begin{pmatrix} \frac{1}{\sqrt{1-|v|^2}} & \frac{-v}{\sqrt{1-|v|^2}} \\ \frac{-v}{\sqrt{1-|v|^2}} & \frac{1}{\sqrt{1-|v|^2}} \end{pmatrix} \, .$$

The coordinate plane $\{(0, 0, x_2, \ldots x_n)\}$ is invariant under $H(\psi)$, but the x_1-axis $\{(t, x_2, \ldots x_n) = 0\}$ is moved;

$$x'_1 = \cosh(\psi)x_1 \, , \qquad t' = \sinh(\psi)x_1 \, ,$$

so that the $\{t = 0\}$ coordinate plane is tilted in space-time as well, at slope

$$\frac{x'_1}{t'} = \coth(\psi)$$

A diagram of the new space-time coordinates under a hyperbolic rotation is as follows.

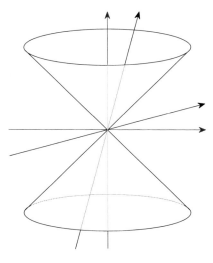

Figure 1. This is the image of the x_1 and t axes and the light cone, under a Lorentz transformation consisting of a hyperbolic rotation of the (t, x_1) coordinates.

The set that remains invariant under the transformations of the Lorentz group is the light cone itself. Setting $LC = \{t^2 - |x|^2 = 0\}$ this fact is checked as follows. Take $(t, x) \in LC$, then

$$\begin{pmatrix} t \\ x \end{pmatrix}^T \begin{pmatrix} 1 & 0 \\ 0 & -I_{n \times n} \end{pmatrix} \begin{pmatrix} t \\ x \end{pmatrix} = 0 \, .$$

Under a Lorentz transformation $L : (t, x) \mapsto (t', x')$ we have

$$\begin{pmatrix} t' \\ x' \end{pmatrix}^T \begin{pmatrix} 1 & 0 \\ 0 & -I_{n \times n} \end{pmatrix} \begin{pmatrix} t' \\ x' \end{pmatrix} = \begin{pmatrix} t \\ x \end{pmatrix}^T L^T \begin{pmatrix} 1 & 0 \\ 0 & -I_{n \times n} \end{pmatrix} L \begin{pmatrix} t \\ x \end{pmatrix} = 0 \,,$$

and as we have checked above,

$$L^T \begin{pmatrix} 1 & 0 \\ 0 & -I_{n \times n} \end{pmatrix} L = \begin{pmatrix} 1 & 0 \\ 0 & -I_{n \times n} \end{pmatrix} \,.$$

The geometric interpretation of these properties is that the matrix

$$g := \begin{pmatrix} 1 & 0 \\ 0 & -I_{n \times n} \end{pmatrix}$$

defines the Minkowski metric $ds^2 = (dt, dx_1, \ldots dx_n)^T g (dt, dx_1, \ldots dx_n)$ on the space-time $\mathbb{R}^1_t \times \mathbb{R}^n_x$, which we have just shown to be invariant under the Lorentz group.

The invariance of the wave equation under the Lorentz group of transformations was part of a paradox that physics faced towards the end of the 19^{th} century. As we have seen in (1.1), Maxwell's equations are intimately tied to the wave equation. While the equations of classical mechanics are invariant under the Galilean transformation group, the theory of electricity and magnetism is invariant under the Lorentz group, and these are incompatible. Compatibility was restored in 1905 when Einstein introduced the special theory of relativity. However this was a revolutionary change in our perception of the universe, for which many intuitive ideas about space-time had to be modified. One of these we have seen above; the action of a hyperbolic rotation transforms the plane $\{t = 0\}$ of spatial coordinates as well as the time axis. Since we think of the spatial coordinate plane as being the 'present' state of the universe, it is a new idea that there is no universally valid instant that can globally be considered to be the present, and that the sense of the present is relative to the frame of reference of the observer. The concept of simultaneity has to be sacrificed. In terms of the wave equation, any one of the hypersurfaces $\{t' = 0\}$ can be used as a Cauchy surface for initial data for the wave equation.

6.3. Method of spherical means

There is another method for representing the solution of the wave equation in n space dimensions (6.1), based on the spherical means that we have encountered in Chapter 4, in formula (4.19). Recall the elementary solution method in the case of spatial dimension $n = 1$, via the d'Alembert formula

$$u(t, x) = \tfrac{1}{2}(f(x + t) + f(x - t)) + \tfrac{1}{2} \int_{x-t}^{x+t} g(y) \, dy \,.$$

The goal of this section is to produce similar expressions for the solution of the wave equation in the case of higher space dimensions.

Definition 6.4. Given a function $h(x) \in C(\mathbb{R}^n)$, its *spherical mean* centered about the point $x \in \mathbb{R}^n$ is

$$(6.7) \qquad M(h)(x,r) := \frac{1}{\omega_n r^{n-1}} \int_{|x-y|=r} h(y)\,dS_y \ ,$$

the average of $h(x)$ over a sphere \mathbb{S}^{n-1} centered at x of radius r.

Recall that $\omega_n r^{n-1}$ is the surface area of the sphere \mathbb{S}^{n-1} of radius r in n dimensions. When $n=1$ the spherical mean of a function $f(x)$ is $M(f)(x,r) = \frac{1}{2}(f(x+r)+f(x-r))$, reminding one of the first term of the d'Alembert formula. Changing variables in the integral (6.7), $y \mapsto x + r\xi$, $\xi \in S_1(0)$, there is another useful expression for the spherical mean;

$$M(h)(x,r) = \frac{1}{\omega_n} \int_{|\xi|=1} h(x+r\xi)\,dS_\xi \ .$$

This expression is defined for $r \geq 0$, but it is clear from this second expression that $M(h)(x,r)$ is an even function of r;

$$M(h)(x,-r) = M(h)(x,r) \ .$$

Lemma 6.5 (Darboux equation). Given $h \in C^2(\mathbb{R}^n)$ then

$$\Delta_x M(h)(x,r) = \left(\partial_r^2 + \frac{n-1}{r}\partial_r\right) M(h)(x,r) \ ,$$

a formula that relates the Laplace operator of $M(h)$ in the n-dimensional x variables to an operator involving only one dimensional r derivatives.

Proof. The Darboux equation follows from a calculation using multivariate calculus. First take one derivative;

$$\partial_r M(h)(x,r) = \frac{1}{\omega_n} \int_{|\xi|=1} \partial_r h(x+r\xi)\,dS_\xi$$
$$= \frac{1}{\omega_n} \int_{|\xi|=1} \sum_{j=1}^n \partial_{x_j} h(x+r\xi)\xi_j\,dS_\xi \ ,$$

and we notice that $\sum_{j=1}^n \partial_{x_j} h(x+r\xi)\xi_j = \nabla h \cdot N$, the outwards normal derivative of h on the unit sphere. Continue this line of calculation using

Green's theorem;

$$\frac{1}{\omega_n}\int_{|\xi|=1}\sum_{j=1}^n \partial_{x_j}h(x+r\xi)\xi_j\,dS_\xi = \frac{1}{\omega_n}\int_{|\xi|<1}r\Delta_x h(x+r\xi)\,d\xi$$

$$= \frac{1}{\omega_n r^{n-1}}\Delta_x \int_{|x-y|<r} h(y)\,dy$$

$$= \frac{1}{\omega_n r^{n-1}}\Delta_x \Big(\int_0^r \int_{|x-y|=\rho} h(y)\,dS_y\,d\rho\Big)$$

$$= \frac{1}{r^{n-1}}\Delta_x \Big(\int_0^r \rho^{n-1}M(h)(x,\rho)\,d\rho\Big)\ .$$

The second step is to take a second derivative, after multiplying through by r^{n-1};

$$\partial_r\big(r^{n-1}\partial_r M(h)(x,r)\big) = \partial_r\Big(\Delta_x \int_0^r \rho^{n-1}M(h)(x,\rho)\,d\rho\Big)$$

$$= \Delta_x\big(r^{n-1}M(h)(x,r)\big)\ .$$

Therefore

(6.8)
$$\Delta_x M(h)(x,r) = \frac{1}{r^{n-1}}\partial_r\big(r^{n-1}\partial_r M(h)(x,r)\big)$$

$$= \big(\partial_r^2 + \frac{n-1}{r}\partial_r\big)M(h)(x,r)\ ,$$

which is the result of the lemma. □

Proposition 6.6. (i) For $h(x)\in C(\mathbb{R}^n)$ the value of $h(x)$ at any $x\in\mathbb{R}^n$ can be recovered from its spherical means;

$$h(x) = \lim_{r\to 0} M(h)(x,r) = M(h)(x,0)\ .$$

(ii) Additionally, for $h(x)\in C^2(\mathbb{R}^n)$

$$\partial_r M(h)(x,0) = \lim_{r\to 0}\frac{r}{\omega_n}\int_{|\xi|<1}h(x+r\xi)\,d\xi = 0\ .$$

Formulae involving spherical means can be used to give an expression for the solution of the wave equation. Suppose that $u(t,x)$ is a solution of the Cauchy problems for the wave equation (6.1). Then its spherical mean $M(u)(t,x,r)$ satisfies an auxiliary equation in the reduced space-time variables $(t,r)\in\mathbb{R}^2$. Specifically, define

$$M(u)(t,x,r) = \frac{1}{\omega_n}\int_{|\xi|=1}u(t,x+r\xi)\,dS_\xi\ .$$

Taking time derivatives and using that $u(t,x)$ is a solution of (6.1), one obtains

$$\partial_t^2 M(u)(t,x,r) = \frac{1}{\omega_n} \int_{|\xi|=1} \partial_t^2 u(t, x + r\xi) \, dS_\xi$$

$$= \frac{1}{\omega_n} \int_{|\xi|=1} \Delta_x u(t, x + r\xi) \, dS_\xi = \Delta_x M(u)(t,x,r) \ .$$

Now use the Darboux equation of Lemma 6.5

$$(6.9) \qquad \partial_t^2 M(u)(t,x,r) = \left(\partial_r^2 + \frac{n-1}{r} \partial_r \right) M(u)(t,x,r) \ ,$$

a partial differential equation in the two variables $(t,r) \in \mathbb{R}^2$. This is the *Euler – Poisson – Darboux* equation.

The wave equation in \mathbb{R}^3: The equation (6.9) is normally posed as an initial value problem

$$(6.10) \quad \partial_t^2 M(u)(t,x,r) = \left(\partial_r^2 + \frac{n-1}{r} \partial_r \right) M(u)(t,x,r)$$

$$M(u)(0,x,r) = M(f)(x,r) \ , \qquad \partial_t M(u)(0,x,r) = M(g)(x,r) \ .$$

The precise methods and the character of the solution depend quite a bit on the the spatial dimension under consideration. The most straightforward case is in dimension $n = 3$. In the Euler – Poisson – Darboux equation (6.10) use the substitution $M(u)(t,x,r) \mapsto rM(u)(t,x,r)$, giving

$$\partial_t^2 \big(rM(u)(t,x,r) \big) = r \left(\partial_r^2 + \frac{2}{r} \partial_r \right) M(u)(t,x,r) = \partial_r^2 \big(rM(u)(t,x,r) \big) \ .$$

Therefore the function $v(t,r) = rM(u)(t,x,r)$ is a solution of the wave equation in one dimension, and the variable x is relegated to the role of a parameter. The solution is given by the d'Alembert formula

$$v(t,r) = rM(u)(t,x,r)$$

$$= \tfrac{1}{2} \big((r+t)M(f)(x, r+t) + (r-t)M(f)(x, r-t) \big)$$

$$+ \tfrac{1}{2} \int_{r-t}^{r+t} \rho M(g)(x, \rho) \, d\rho \ .$$

Since $M(f)(x,r)$ and $M(g)(x,r)$ are even functions under $r \mapsto -r$, then $rM(f)(x,r)$ and $rM(g)(x,r)$ are odd, therefore we may rewrite the above expression, dividing through by r;

$$M(u)(t,x,r) = \frac{1}{2r} \big((t+r)M(f)(x, t+r) - (t-r)M(f)(x, t-r) \big)$$

$$+ \frac{1}{2r} \int_{t-r}^{t+r} \rho M(g)(x, \rho) \, d\rho \ .$$

We have used the fact that $\int_{t-r}^{r-t} \rho M(g)(x,\rho)\, d\rho = 0$ which holds because $rM(g)(x,r)$ is odd. Taking the limit as $r \to 0$, we recover a representation for the solution $u(t,x)$.

Theorem 6.7 (Kirchhoff's formula). *When $n = 3$ the solution to the wave equation* (6.1) *is given by the expression*

$$(6.11) \qquad u(t,x) = \partial_t\big(tM(f)(x,t)\big) + tM(g)(x,t) \,,$$

which is well defined as long as $f(x) \in C^1(\mathbb{R}^3)$ and $g(x) \in C(\mathbb{R}^3)$.

However it is quite explicit to see that in terms of pointwise regularity, the solution is in general less smooth than the initial data, for the Kirchhoff formula depends upon the the derivative of $f(x)$. Specifically, carrying out the differentiation in (6.11) we obtain

$$u(t,x) = \frac{1}{4\pi t^2} \int_{|x-y|=t} \big(tg(y) + f(y) + t\nabla f(y) \cdot \frac{x-y}{|x-y|}\big)\, dS_y \,.$$

Corollary 6.8. Given initial data $g(x) \in C^2(\mathbb{R}^3)$ and $f(x) \in C^3(\mathbb{R}^3)$ then the spherical means solution given in (6.11) is a *classical* solution $u(t,x) \in C^2(\mathbb{R}^1_t \times \mathbb{R}^3_x)$.

This loss of differentiability for $n \geq 2$, due to focusing effects, is the topic of Problem 6.1. In contrast, when solutions are viewed in the sense of the Sobolev spaces H^s through the energy, there is no loss visible;

$$E(u)(t) = \int \tfrac{1}{2}(\partial_t u)^2 + \tfrac{1}{2}|\nabla_x u|^2\, dx = \int \tfrac{1}{2}g^2 + \tfrac{1}{2}|\nabla_x f|^2\, dx \,.$$

The Sobolev regularity of the solution is the same as the Sobolev regularity of the initial data.

The wave equation in \mathbb{R}^n for odd dimensions n: There are similar expressions for the solution of the wave equation for $x \in \mathbb{R}^n$, for odd dimensions, for $n \geq 3$. Returning to the Euler – Poisson – Darboux equation (6.9) for the n dimensional wave equation

$$\partial_t^2 M(u) = \big(\partial_r^2 + \frac{n-1}{r}\partial_r\big)M(u) \,,$$

we seek an algebraic reduction to the wave equation in two dimensions in the variables (t,r). This is able to be carried out in the odd dimensional case.

Proposition 6.9. Suppose that $k \geq 1$ is an integer and that $h = h(r) \in C^{k+1}(\mathbb{R}_+^1)$, then

$$\partial_r^2 \left(\frac{1}{r}\partial_r\right)^{k-1}\left(r^{2k-1}h\right) = \left(\frac{1}{r}\partial_r\right)^k\left(r^{2k}\partial_r h\right) ;$$

$$\left(\frac{1}{r}\partial_r\right)^{k-1}\left(r^{2k-1}h\right) = \sum_{j=0}^{k-1}\beta_j^k r^{j+1}\partial_r^j h .$$

with the combinatorial coefficients being $\beta_0^k = 1\cdot 3\cdot\ldots(2k-1)) := (2k-1)!!$.

Proof. An argument by induction will work. $\qquad\square$

The result is useful because we may set $n = 2k+1$ and take

$$v(t,x,r) := \left(\frac{1}{r}\partial_r\right)^{k-1}\left(r^{2k-1}M(u)\right)(t,x,r) ,$$

for a given solution $u(t,x)$ of (6.1). Then using the identities from Proposition 6.9

$$\partial_r^2 v = \partial_r^2\left(\frac{1}{r}\partial_r\right)^{k-1}\left(r^{2k-1}M(u)\right)$$
$$= \left(\frac{1}{r}\partial_r\right)^k\left(r^{2k}\partial_r M(u)\right)$$
$$= \left(\frac{1}{r}\partial_r\right)^{k-1}\left(r^{2k-1}\partial_r^2 M(u) + 2kr^{2k-2}\partial_r M(u)\right)$$
$$= \left(\frac{1}{r}\partial_r\right)^{k-1}\left(r^{2k-1}\left(\partial_r^2 M(u) + \frac{2k}{r}\partial_r M(u)\right)\right)$$
$$= \left(\frac{1}{r}\partial_r\right)^{k-1}\left(r^{2k-1}\partial_t^2 M(u)\right) = \partial_t^2 v(t,r) .$$

Therefore $v(t,x,r)$ is the quantity that satisfies the one dimensional wave equation in the variables (t,r), for which we can apply the d'Alembert formula.

$$v(t,x,r) = \tfrac{1}{2}\left(v(0,r+t) + v(0,r-t)\right) + \tfrac{1}{2}\int_{r-t}^{r+t}\partial_t v(0,x,\rho)\,d\rho ,$$

with initial data

$$v(0,x,r) = \left(\frac{1}{r}\partial_r\right)^{k-1}\left(r^{2k-1}M(f)\right)(x,r) ,$$
$$\partial_t v(0,x,r) = \left(\frac{1}{r}\partial_r\right)^{k-1}\left(r^{2k-1}M(g)\right)(x,r) .$$

One recovers the solution as a limit

$$(6.12) \qquad u(t,x) = \lim_{r \to 0} M(u)(t,x,r) = \lim_{r \to 0} \frac{v(t,x,r)}{\beta_0^k r}$$

$$= \frac{1}{(n-2)!!} \left[\partial_t \left(\frac{1}{t} \partial_t \right)^{(n-3)/2} \left(t^{n-2} M(f)(t,x) \right) \right.$$

$$\left. + \left(\frac{1}{t} \partial_t \right)^{(n-3)/2} \left(t^{n-2} M(g)(t,x) \right) \right] .$$

Theorem 6.10. *For n odd, and for $f \in C^{(n-1)/2}(\mathbb{R}^n)$ and $g \in C^{(n-3)/2}(\mathbb{R}^n)$ the solution formula (6.12) gives a classical solution to the wave equation in \mathbb{R}^n.*

It is interesting to quantify the possible loss of smoothness of the solution over the initial data, made clear by the formula (6.12). Indeed the reduction process from $M(u)$ to v involves $k-1 = (n-3)/2$ derivatives, and the limit involves one derivative, therefore in general the solution will be less regular than the initial data by $k = (n-1)/2$ many derivatives.

6.4. Huygens' principle

Huygens' principle is the expression of the principle of finite propagation speed, analogous to the case of the one-dimensional wave equation in section 2. This general form of Huygens' principle is valid for the wave equation in any space dimension, and for hyperbolic equations in general. The strong form of Huygens' principle says more than this; it is the property that solutions are supported precisely on the union of light cones which have their vertex on the support of the initial data. There is a difference in dimension concerning this strong form of the Huygens' principle; it holds for odd space dimensional problems, but not in even dimensions. We state it here for the case of three space dimensions.

Theorem 6.11. *Consider solutions to the wave equation for $x \in \mathbb{R}^3$, and assume that the Cauchy data $f(x)$ and $g(x)$ are compactly supported, such that $\mathrm{supp}(f) \cup \mathrm{supp}(g) \subseteq B_R(0)$. Then*

(1) (Huygens' principle). The solution $u(t,x)$ has its support within the bounded region $B_{R+|t|}(0)$;

$$\mathrm{supp}(u(t,\cdot)) \subseteq B_{R+|t|}(0) .$$

(2) (strong Huygens' principle). Additionally, for $|t| > R$, for any space-time point (t,x) in the region inside the light cones given by $\{(t,x) : |x| \leq R-|t|\}$, again the solution vanishes; $u(t,x) = 0$.

Proof. *(1). of Huygens' principle:* The result follows from the form of the Kirchhoff formula, which gives an expression for the solution $u(t,x)$ in terms

of spherical means over spheres of radius $|t|$ in the initial hyperplane plane $\{t = 0\}$, which are of the form $\{y : |x - y| = |t|\}$ (the intersection of the backwards light cone emanating from (t, x) and the Cauchy hypersurface). If $|x| > R + |t|$ then this sphere does not intersect $B_R(0)$, which contains the support of the initial data, and hence the solution at that space-time point vanishes.

(2). of the strong Huygens' principle: When $|t| > R$ and $|x| < |t| - R$, again the backwards light cone emanating from the point (t, x) does not intersect the support of the initial data, in this case because the sphere $\{y : |x - y| = |t|\}$ is too big and has passed outside of $B_R(0)$.

One notes that this proof is geometric, only depending upon the fact that the solution is represented as a spherical mean. Therefore the result holds for solutions of the wave equation in arbitrary odd dimensions, as exhibited in (6.12). □

In fact a more precise statement is true; at times $t > 0$ the solution $u(t, x)$ is supported within the region consisting of the union of light cones

$$LC_+(t, x) = \{(t, y) : t^2 - |y - x|^2 = 0, \, t > 0\}$$

whose vertices x lie in the set $\text{supp}(f) \cup \text{supp}(g)$. A space-time picture of the support of the solution is depicted in Fig. 2.

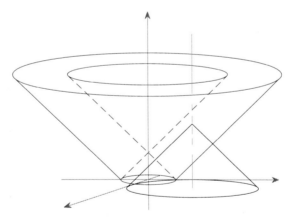

Figure 2. Space-time picture of the support of a solution. The vertical green line is the world line of a stationary observer.

The finite propagation speed property is sometimes known as the weak Huygens' principle, it is a central feature of hyperbolic equations. It implies that in particular a signal will travel with finite velocity. That is, for an observer standing still at point $x_0 \in \mathbb{R}^n$, $|x_0| > R$, the solution satisfies $u(x_0, t) = 0$ until $|x_0| - R < |t|$.

Corollary 6.12. If the initial data $f(x), g(x)$ vanish on $B_R(0)$, then the solution $u(t,x)$ must vanish on the cone $\{(t,x)\colon |x| < R - |t|\}$, $0 < |t| < R$. In particular if f, g are identically zero, then so will be $u(t,x)$.

Proof. This is a local uniqueness theorem. Suppose that $\text{supp}(f) \cup \text{supp}(g) \subseteq H_{a,v} = \{x \in \mathbb{R}^n \colon a \leq v \cdot x\}$ a half-space, then $\text{supp}(u(t,x)) \subseteq H_{a+|t|,v}$. Therefore no data in any of the enveloping half-space $H_{R-|t|,v}$, $|v| = 1$ to $B_{R-|t|}(0)$ can propagate into the cone pictured in Fig. 3. $\qquad\square$

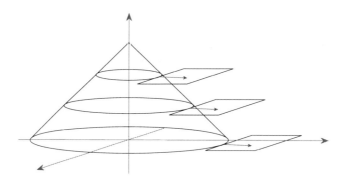

Figure 3. The cone of uniqueness.

Definition 6.13. (i) The *domain of influence* of a set $A \subseteq \mathbb{R}^n$ is the region in \mathbb{R}^{n+1} in which a solution $u(x,t)$ of the wave equation can be affected by data in A.

 (ii) The *domain of dependence* of a set $B \subseteq \mathbb{R}^{n+1}$ is the region $A \subseteq \mathbb{R}^n$ in which data can influence the solution in B.

The results of Theorem 6.17 and Corollary 6.12 imply the following pictures for the domains of influence and dependence of solutions of the wave equation, given respectively in Fig. 4 and Fig. 5.

6.5. Paley-Wiener theory

It is self-evident that the complex exponentials $e^{-i\xi \cdot x}$, with $\xi \in \mathbb{R}^n$ and $x \in \mathbb{R}^n$, extend as holomorphic functions $e^{-i\zeta \cdot x}$ for $\zeta \in \mathbb{C}^n$. More specifically to its character, the extension is defined over all of \mathbb{C}^n, meaning that is it is *entire*, and furthermore the extension has bounds on its growth at infinity of the form

$$|e^{-i\zeta \cdot x}| \leq e^{|x||im(\zeta)|}.$$

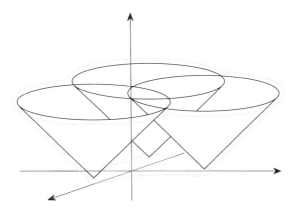

Figure 4. Domain of influence of the set $A \subseteq \mathbb{R}^n$.

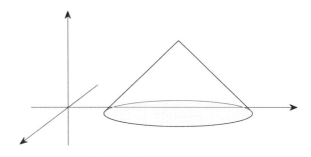

Figure 5. Domain of dependence of the point B.

Definition 6.14. An entire function $g(\zeta)$, $\zeta \in \mathbb{C}^n$, is of *exponential type R* if it satisfies the estimates

$$(6.13) \qquad (1 + |\zeta|^2)^{N/2} |g(\zeta)| \leq C_N e^{R|im(\zeta)|}$$

for all $N \in \mathbb{N}$.

Examples of the behavior are given by the Fourier transform. The complex exponential above is not strictly speaking of exponential type because it only satisfies (6.13) for the case $N = 0$. Another example of an entire function, which however is not of exponential type, is

$$g(\zeta) = e^{-\zeta^2/2} = e^{-\frac{1}{2}(\xi^2 - \eta^2) - i\xi\eta} \, ,$$

for $\zeta = \xi + i\eta \in \mathbb{C}$. Given any function $f \in \mathcal{S}$, we can express it's Fourier transform as a superposition of complex exponentials:

$$\hat{f}(\xi) = \frac{1}{\sqrt{2\pi}^n} \int_{\mathbb{R}^n} e^{-i\xi \cdot x} f(x) \, dx \;;$$

where each complex exponential extends to an entire function on \mathbb{C}^n but the function $\hat{f}(\xi)$ itself need not necessarily have a holomorphic extension off of the real subspace $\mathbb{R}^n \subseteq \mathbb{C}^n$ at all. However if a function $g(\xi)$ is such that $g(\xi) = \hat{f}(\xi)$ with $f(x) \in C_0^\infty(\mathbb{R}^n)$, in particular if $f(x)$ has compact support, then $g(\xi)$ does have an entire holomorphic extension.

Proposition 6.15. Suppose that $f \in C_0^\infty(\mathbb{R}^n)$, with $\mathrm{supp}(f) \subseteq \{x \in \mathbb{R}^n : |x| \leq R\}$. Then $\hat{f}(\xi) = g(\xi)$ extends to an entire function, which is of exponential type R.

Proof. For each $\zeta \in \mathbb{C}^n$, the integral

$$g(\zeta) = \frac{1}{\sqrt{2\pi}^n} \int_{B_R(0)} e^{-i\zeta \cdot x} f(x) dx$$

converges absolutely, uniformly over bounded sets of ζ. To check that $g(\zeta)$ is holomorphic we simply test the Cauchy-Riemann equations:

$$\partial_{\bar{\zeta}} g(\zeta) = \frac{1}{\sqrt{2}} (\partial_\xi + i\partial_\eta) g(\zeta) = \frac{1}{\sqrt{2\pi}^n} \int \partial_{\bar{\zeta}} (e^{-i\zeta \cdot x}) f(x) \, dx = 0 \;.$$

Lastly, for α a multi-index with $|\alpha| = N$, we need to estimate the integrals

$$\left| \zeta^\alpha \int_{\mathbb{R}^n} e^{-i\zeta \cdot x} f(x) dx \right| = \left| \int_{B_R(0)} e^{-i\zeta \cdot x} \left(\frac{1}{i} \partial_x \right)^\alpha f(x) dx \right|$$

$$\leq \int_{B_R(0)} e^{|x||im(\zeta)|} |\partial_x^\alpha f(x)| dx \leq C_{|\alpha|} e^{R|im(\zeta)|}.$$

\square

The content of Paley-Wiener theory is to say that the converse also holds.

Theorem 6.16 (Paley-Wiener). *Suppose that $g(\zeta)$ is an entire function of exponential type R. Then there is a function $f(x) \in C_0^\infty(\mathbb{R}^n)$ with $\mathrm{supp}(f) \subseteq B_R(0)$ such that*

$$g(\zeta) = \hat{f}(\zeta) = \frac{1}{\sqrt{2\pi}^n} \int e^{-i\zeta \cdot x} f(x) \, dx \;.$$

Proof. It is straightforward to restrict $g(\xi)$ to $\xi \in \mathbb{R}^n$, and define

$$f(x) = \frac{1}{\sqrt{2\pi}^n} \int_{\mathbb{R}^n} e^{i\xi \cdot x} g(\xi) d\xi.$$

Since $|g(\xi)| \leq C_N(1 + |\xi|^2)^{-N/2}$ as in (6.13), this integral is absolutely convergent. We may also take an arbitrary number of derivatives of $f(x)$

$$\partial_x^\beta f(x) = \frac{1}{\sqrt{2\pi}^n} \int_{\mathbb{R}^n} e^{i\xi \cdot x}(-i\xi)^\beta g(\xi)\, d\xi \ ,$$

and the integral remains absolutely convergent. Thus $f \in C^\infty(\mathbb{R}^n)$ and the question that remains has to do with its support.

Using that $g(\zeta)$ is holomorphic, consider deformations of the region of integration off of the real axis in the complex space \mathbb{C}^n,

$$\frac{1}{\sqrt{2\pi}^n} \int e^{i((\xi_1 + i\eta_1)x_1 + \xi' \cdot x')}g(\xi_1 + i\eta_1, \xi')\, d\xi_1 d\xi' \ ,$$

for $\eta_1 \in \mathbb{R}$. This is independent of η_1, as can be shown by Cauchy's theorem, taking the limit of an integral in $\zeta_1 = \xi_1 + i\eta_1$ over the countour given by Fig. 6. and letting $T \to +\infty$. The decay condition (6.13) assumes that there

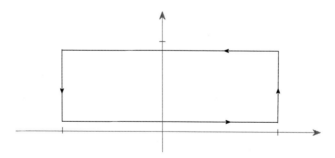

Figure 6. The contour

are no contributions from the boundaries $\xi_1 = \pm T$ in the limit. Repeating this argument in all variables, we show that for any desired $\eta \in \mathbb{R}^n$,

$$f(x) = \frac{1}{\sqrt{2\pi}^n} \int_{\mathbb{R}^n} e^{i(\xi + i\eta)\cdot x}g(\xi + i\eta)\, d\xi \ .$$

Now fix $x \neq 0$ in \mathbb{R}^n, and choose the particular $\eta = \lambda\frac{x}{|x|}$, with a real parameter $\lambda > 0$. Then

$$|f(x)| \leq \frac{1}{\sqrt{2\pi}^n} \left| \int_{\mathbb{R}^n} e^{i\xi \cdot x - \lambda|x|} g\left(\xi + i\lambda\frac{x}{|x|}\right) d\xi \right|$$

$$\leq \frac{1}{\sqrt{2\pi}^n} \int_{\mathbb{R}^n} e^{-\lambda|x|} \left| g\left(\xi + i\lambda\frac{x}{|x|}\right) \right| d\xi$$

$$\leq C_N \int_{\mathbb{R}^n} (1 + |\xi|^2)^{-N/2} e^{-\lambda|x| + \lambda R} d\xi.$$

Now suppose that $|x| > R$; as $\lambda \to +\infty$ the RHS tends to zero. Thus we have shown that $f(x) = 0$. This proves that indeed $\text{supp}(f) \subseteq B_R(0)$. \square

There is a similar theory for distributions of compact support, and their Fourier transforms as entire functions of exponential type; conversely if $g(\zeta)$ is an entire function which for some N satisfies the estimate

(6.14) $$|g(\zeta)| \leq C(1 + |\zeta|^2)^{N/2} e^{R|im(\zeta)|},$$

then there is a distribution $f \in \mathcal{D}'$, with $\text{supp}(f) \subseteq B_R(0)$ such that the (generalized) Fourier transform of f is g.

Hugens principle revisited: Returning to the discussion of solutions of the wave equation, our Fourier integral expression is that

$$u(x,t) = \frac{1}{\sqrt{2\pi}^n} \int e^{i\xi \cdot x} \left(\cos(|\xi|t)\hat{f}(\xi) + \frac{\sin(|\xi|t)}{|\xi|}\hat{g}(\xi) \right) d\xi .$$

Let us suppose that the initial data is of compact support:

$$\text{supp}(f) \cup \text{supp}(g) \subseteq B_R(0) = \{x \in \mathbb{R}^n : |x| < R\} .$$

Then by Proposition 6.15, both $\hat{f}(\xi)$ and $\hat{g}(\xi)$ extend to entire functions on \mathbb{C}^n, of exponential type R. Let us examine the Fourier transform of the solution

$$\hat{u}(\xi,t) = \cos(|\xi|t)\hat{f}(\xi) + \frac{\sin(|\xi|t)}{|\xi|}\hat{g}(\xi) .$$

The individual functions $\cos(\sqrt{\zeta^2}t)\hat{f}(\zeta)$ and $\frac{\sin(\sqrt{\zeta^2}t)}{\sqrt{\zeta^2}}\hat{g}(\zeta)$ are entire functions of $\zeta \in \mathbb{C}^n$, where we are using the notation that $\zeta^2 = \zeta_1^2 + \zeta_2^2 + \ldots + \zeta_n^2$, for $\zeta_j \in \mathbb{C}$. Furthermore,

$$\left| \cos(\sqrt{\zeta^2}t) \right| \leq e^{|im(\zeta)||t|}, \qquad \left| \frac{\sin(\sqrt{\zeta^2}t)}{\sqrt{\zeta^2}} \right| \leq e^{|im(\zeta)||t|},$$

therefore the two products $\cos(\sqrt{\zeta^2}t)\hat{f}(\zeta)$ and $\left(\sin(\sqrt{\zeta^2}t)/\sqrt{\zeta^2}\right)\hat{g}(\zeta)$ are of exponential type $(R + |t|)$. We can conclude that the solution $u(x,t)$ of the wave equation is the Fourier transform of an entire function of exponential

type $(R + |t|)$, and thus by the Paley–Wiener theorem the solution $u(x, t)$ has its support in the ball $B_{R+|t|}(0)$ of radius $R + |t|$.

Theorem 6.17 (Huygens' principle again). *Solutions of the wave equation* (6.1) *which start with initial data with support satisfying* $\mathrm{supp}(f) \cup \mathrm{supp}(g) \subseteq B_R(0)$ *satisfy at nonzero times* $t \in \mathbb{R}$

$$\mathrm{supp}(u(t, x)) \subseteq B_{R+|t|}(0).$$

6.6. Lagrangians and Hamiltonian PDEs

The wave equation can be derived from a Lagrangian, using a compelling analogy with classical mechanics. The *Lagrangian* function in the case of the wave equation (6.1) is defined by

$$(6.15) \qquad L := \int_{\mathbb{R}^n} \tfrac{1}{2}(\partial_t u)^2 - \tfrac{1}{2}|\nabla u|^2 \, dx \ .$$

This Lagrangian has an associated *action integral* given by

$$(6.16) \qquad S := \int_0^T \int_{\mathbb{R}^n} \tfrac{1}{2}(\partial_t u)^2 - \tfrac{1}{2}|\nabla u|^2 \, dx dt \ .$$

From the action the wave equation arises from the *principle of least action*, which dictates that the motion of a Lagrangian system is a stationary point of the action integral. A stationary point $u(t, x)$ of the action over the time interval $0 \leq t \leq T$ satisfies $\delta S = 0$ for all admissible variations $v(t, x) = \delta u(t, x)$, where $\delta u(t, x)$ denotes a small but arbitrary variation of the function $u(t, x)$. Admissible variations are smooth, and are such that $v(0, x) = v(T, x) = 0$, so that $u(t, x)$ and $u(t, x) + v(t, x)$ have the same initial and final states over the time interval $[0, T]$. In the case of the wave equation, a stationary point of the action satisfies

$$\delta S = \int_0^T \int_{\mathbb{R}^n} \partial_t u \partial_t v - \nabla_x u \cdot \nabla_x v \, dx dt$$

$$= -\int_0^T \int_{\mathbb{R}^n} (\partial_t^2 u - \Delta u) v \, dx dt + \int_{\mathbb{R}^n} \partial_t u v \, dx \Big|_{t=0}^T \ .$$

From the assumption that $v(0, x) = v(T, x) = 0$, the last term of the RHS vanishes. The conclusion is that, because $v(t, x)$ is otherwise arbitrary, we must have that

$$\partial_t^2 u - \Delta u = 0 \ .$$

These are the *Euler–Lagrange* equations for the action (6.16). Notice that the principle of stationary action allows us to give an initial *position* $u(0, x) = f(x)$ but does not allow for setting the initial *momentum* $\partial_t u(0, x) = g(x)$, so it is not in fact compatible with the initial value problem. Nonetheless the principle of least action, or more generally of stationary

action, remains a guiding principle for many equations in physics, while on a rigorous mathematical level the principle remains a formal one in this and other cases.

A Lagrangian L and subsequently an action integral S can be defined for more general systems, indeed this is how wave equations are derived in most problems in physics. Consider the more general Lagrangian

$$(6.17) \qquad L = \int_{\mathbb{R}^n} \tfrac{1}{2}\dot{u}^2 - G(u, \nabla_x u) \, dx$$

whose associated action is given by

$$S = \int_0^T \int_{\mathbb{R}^n} \tfrac{1}{2}\dot{u}^2 - G(u, \nabla_x u) \, dx dt \ .$$

Suppose that the field $u(t,x)$ is a stationary point of the action;

$$\begin{aligned}
0 = \delta S &= \frac{d}{d\varepsilon}\Big|_{\varepsilon=0} \int_0^T \int_{\mathbb{R}^n} \tfrac{1}{2}(\partial_t u + \varepsilon \partial_t v)^2 - G(u + \varepsilon v, \nabla_x(u + \varepsilon v)) \, dx dt \\
&= \int_0^T \int_{\mathbb{R}^n} \partial_t u \partial_t v - \partial_{\nabla u} G(u, \nabla_x u) \cdot \nabla_x v - \partial_u G(u, \nabla_x u) v \, dx dt \\
&= \int_0^T \int_{\mathbb{R}^n} \big[-\partial_t^2 u + \nabla_x \cdot \partial_{\nabla u} G(u, \nabla_x u) - \partial_u G(u, \nabla_x u) \big] v \, dx dt \\
&\quad + \int_{\mathbb{R}^n} \partial_t u v \, dx \Big|_{t=0}^{T} \ .
\end{aligned}$$

The notation is that the nonlinear function $G = G(u, V)$ depends upon the variables u as well as the n components of $V = \nabla u$. The notation for its partial derivatives is that $\partial_{\nabla u} G(u, \nabla_x u) = \partial_V G(u, V)|_{V = \nabla_x u}$. The final term vanishes because $v(t, x)$ is an admissible variation. Since v is otherwise arbitrary, the field $u(t, x)$ must satisfy the Euler – Lagrange equations

$$\partial_t^2 u - \nabla_x \cdot \partial_{\nabla u} G(u, \nabla_x u) + \partial_u G(u, \nabla_x u) = 0 \ .$$

This is a hyperbolic equation if the matrix of partial derivatives of G with respect to the variables V is positive definite. In the example of the wave equation, $G(u, \nabla u) = \tfrac{1}{2}|\nabla u|^2$, and $\partial_{\nabla u}^2 G = I$.

There is a compelling analogy with classical mechanics in this formal treatment of field theories. To continue the analogy, given a Lagrangian $L(\dot{u}, u)$, there is a transformation of the Euler – Lagrange equations to a Hamiltonian system, in our case to a system of Hamiltonian PDEs. This is illustrated in the example Lagrangian

$$(6.18) \qquad L = \int_{\mathbb{R}^n} \tfrac{1}{2}(\dot{u})^2 - G(\nabla_x u) \, dx \ ,$$

where for clarity we have simplified the Lagrangian (6.17) above. The action integral is as before

$$S = \int_0^T L\, dt,$$

and as above the principle of stationary action gives the Euler – Lagrange equations

(6.19) $$-\partial_t \delta_{\dot{u}} L + \delta_u L = 0 \; ,$$

where $\delta_u L = \nabla_x \cdot \partial_{\nabla_u} G(\nabla_x u)$ and $\delta_{\dot{u}} L = \dot{u}$. In general a Lagrangian may depend explicitly on time $L(\dot{u}, u, t)$, but in many cases, such as the one at hand, it describes a physical process whose properties do not change with time, and it does not. In this situation, the Euler – Lagrange equations exhibit a conservation law. This can be seen from the following computation:

$$\frac{d}{dt} L = \int \left(\delta_{\dot{u}} L\, \ddot{u} + \delta_u L\, \dot{u} \right) dx = \int \left(\delta_{\dot{u}} L\, \ddot{u} + \partial_t(\delta_{\dot{u}} L)\, \dot{u} \right) dx$$

$$= \frac{d}{dt} \int \delta_{\dot{u}} L\, \dot{u}\, dx \; .$$

We used the Euler – Lagrange equations (6.19) in the last equality of the first line. Therefore the conservation law is evident, namely

(6.20) $$\frac{d}{dt} \left(\int \delta_{\dot{u}} L\, \dot{u}\, dx - L \right) = 0 \; .$$

In the example (6.18) this conservation law is

$$\frac{d}{dt} \int_{\mathbb{R}^n} \tfrac{1}{2} (\partial_t u)^2 + G(\nabla_x u)\, dx = 0 \; .$$

Definition 6.18. (i) Define the *Hamiltonian* of the system (6.19) by

$$H := \int \delta_{\dot{u}} L\, \dot{u}\, dx - L$$

(ii) The *conjugate momentum* of the field u is defined to be

$$p := \delta_{\dot{u}} L \; ,$$

giving $p = p(\dot{u}, u)$.

(iii) If the relationship between \dot{u} and p can be inverted to obtain $\dot{u} = \dot{u}(p, u)$, at least locally, then the mapping $\dot{u} \to p$ is called the *Legendre transform*. Using this mapping, we may rewrite the Hamiltonian

$$H = \int \dot{u}\, p\, dx - L = H(u, p) \; ,$$

in terms of the new Hamiltonian variables (u, p).

The Legendre transform offers an elegant way to transform a second order equation (in time) to a first order system of equations.

Theorem 6.19. *The Euler – Lagrange equations* (6.19) *for $u = u(t,x)$ are equivalent in the new variables $(u(t,x), p(t,x))$ to the system*

$$(6.21) \qquad\qquad \partial_t u = \delta_p H$$
$$\partial_t p = -\delta_u H \ .$$

The system of equation (6.21) is known as *Hamilton's canonical equations* for the evolution equations described by H.

Proof. The formal equivalence of (6.19) and (6.21) is a general fact. Firstly,

$$H = \int \dot{u}\, p\, dx - L \ ,$$

so that $\dot{u} = \delta_p H$. Secondly we note that $\delta_u H = -\delta_u L$, so that

$$\dot{p} = \frac{d}{dt}\left(\delta_{\dot{u}} L\right) = \delta_u L = -\delta_u H \ .$$

$\qquad\qquad\qquad\qquad\qquad\qquad\qquad\qquad\qquad\qquad\qquad\qquad\qquad$ \square

Exhibiting this transformation in the setting of the wave equation, we have

$$L = \int_{\mathbb{R}^n} \tfrac{1}{2}\dot{u}^2 - \tfrac{1}{2}|\nabla_x u|^2 \, dx \ ,$$

from which the Legendre transform gives $p = \delta_{\dot{u}} L = \dot{u}$. Then

$$H = \int \dot{u}\, p\, dx - L(u, \dot{u}) = \int \dot{u}^2 \, dx - L = \int \tfrac{1}{2}p^2 + \tfrac{1}{2}|\nabla_x u|^2 \, dx \ .$$

Hamilton's canonical equations are then

$$(6.22) \qquad\qquad \partial_t u = \delta_p H = p$$
$$\partial_t p = -\delta_u H = \Delta u \ ,$$

which is of course the wave equation presented as a first order system of equations. The energy functional $E(u)$ for the wave equation is the Hamiltonian $H(u,p)$ for the system.

Hamiltonian PDEs: The above formal exposition is a lead-in to study other PDEs that can be posed in the form of Hamiltonian systems. Consider systems of equations of the form

$$(6.23) \qquad\qquad \partial_t z = J \mathrm{grad}_z H \ ,$$

where z is a vector valued function in a Hilbert space \mathcal{H}, and the matrix $J = -J^T$ is skew symmetric on \mathcal{H}. The gradient $\mathrm{grad}_z H$ of a functional is defined using the inner product of \mathcal{H} in this way;

$$\delta_z H \cdot v = \frac{d}{ds}\Big|_{s=0} H(z + sv) := \langle \mathrm{grad}_z H, v\rangle_{\mathcal{H}} \ .$$

Rewriting the wave equation (6.22) as

$$(6.24) \qquad \partial_t \begin{pmatrix} u \\ p \end{pmatrix} = \begin{pmatrix} p \\ \Delta u \end{pmatrix} = \begin{pmatrix} 0 & I \\ -I & 0 \end{pmatrix} \begin{pmatrix} -\Delta u \\ p \end{pmatrix} := J\mathrm{grad}_{(u,p)} H \ ,$$

the wave equation takes this form, with $\mathcal{H} = L^2_u \oplus L^2_p$ and with

$$J := \begin{pmatrix} 0 & I \\ -I & 0 \end{pmatrix} \ .$$

We note that this matrix J satisfies $J = -J^T$ on \mathcal{H}.

Proposition 6.20 (Conservation of energy)**.** The Hamiltonian $H(u, p)$ is a conerved quantity for solutions of (6.24).

Proof. This can reasonably be called the law of conservation of energy as the Hamiltonian function is often, not always, the energy of the system being considered. The following classical calculation using the chain rule makes the assumption that solutions to (6.23) exist. Indeed from (6.23),

$$\frac{d}{dt} H(z(t)) = \langle \mathrm{grad}_z H, \dot{z} \rangle_\mathcal{H} = \langle \mathrm{grad}_z H, J\mathrm{grad}_z H \rangle_\mathcal{H} = 0 \ ,$$

where we have used the skew symmetry of the matrix J. $\qquad \square$

A number of other problems can be viewed as Hamiltonian systems in infinitely many variables. Several examples are:

1. Nonlinear wave equations. Hyperbolic equations of this form can be treated as Hamiltonian PDEs. Define the Hamiltonian to be

$$H(u, p) = \int_{\mathbb{R}^n} \tfrac{1}{2}p^2 + \tfrac{1}{2}|\nabla u|^2 + G(x, u) \, dx$$

then the gradient of H is given by

$$\mathrm{grad}H(u, p) = \begin{pmatrix} -\Delta u + \partial_u G(x, u) \\ p \end{pmatrix}$$

and therefore the equations of motion are posed as

$$\partial_t \begin{pmatrix} u \\ p \end{pmatrix} = J\mathrm{grad}H \ .$$

which is a first order system equivalent to the nonlinear wave equation

$$\partial_t^2 u = \Delta u - \partial_u G(x, u) \ .$$

2. Nonlinear Schrödinger equations. The Hamiltonian for this set of equations is in the form

$$H(\psi, \bar{\psi}) = \int \tfrac{1}{2}|\nabla \psi|^2 + Q(x, \psi, \bar{\psi}) \, dx \ ,$$

where $Q(x,\psi,\xi) : \mathbb{R}_x \times \mathbb{C}_\psi \times \mathbb{C}_\xi \to \mathbb{C}$ has the property that $Q(x,\psi,\bar\psi)$ is real valued. Then $\delta_{\bar\psi} H(\psi,\bar\psi) = -\frac{1}{2}\Delta_x\psi + \partial_{\bar\psi}Q$, and setting $J = iI$ (which is a nondegenerate, skew symmetric operator), then

$$\partial_t \psi = J\delta_{\bar\psi}H$$
$$= i(-\frac{1}{2}\Delta\psi + \partial_{\bar\psi}Q(x,\psi,\bar\psi)) \ .$$

When $Q = \pm|\psi|^4$ this equation is the well-known cubic nonlinear Schrödinger equation, where the $+$ sign is the defocusing case and the $-$ sign is the focusing case.

3. Korteweg-de Vries equation (KdV). This famous dispersive equation first arose in the 19^{th} century as a model of waves in the free surface of water in a canal. Currently it is used in modeling numerous phenomena including tsunami propagation. It is also well known as a PDE that is a completely integrable Hamiltonian system, where the study of the phase space of solutions has led to discoveries as far ranging as algebraic geometry and inverse spectral theory. The Hamiltonian is

$$H(q) = \int_{-\infty}^\infty \frac{1}{12}(\partial_x q)^2 + G(q)\,dx \ .$$

As above, the gradient of $H(q)$ is given by

$$\delta_q H = -\frac{1}{6}\partial_x^2 q + \partial_q G(q) \ .$$

Setting $J = \partial_x$, which again is a skew symmetric operator, we arrive at Hamilton's canonical equations in the form

$$\partial_t q = \partial_x(-\frac{1}{6}\partial_x^2 q + \partial_q G(q))$$
$$= -\frac{1}{6}\partial_x^3 q + G''(q)\partial_x q \ .$$

The most well-known versions of the KdV equation are when $G(q) = \frac{1}{3}q^3$, and when $G(q) = \frac{1}{4}q^4$.

Exercises: Chapter 6

Exercise 6.1. (Focusing singularity of solutions of the wave equation in \mathbb{R}^3 (d'après F. John)):

(i) Suppose that the initial data for the wave equation in three dimensions has spherically symmetric data;

$$f(x) = f(r) \ , \quad g(x) = g(r) \ , \qquad r^2 = x_1^2 + x_2^2 + x_3^2 \ .$$

Show that the general solution can be expressed as

$$u(t,r) = \frac{1}{r}\big(F(r+t) + G(r-t)\big)\,,$$

that is, it consists of an incoming wave and an outgoing wave.

(ii) With the special initial data $u(0,r)=0$, $\partial_t u(r) = g(r)$ with $g(r)$ an even function of r, then

$$u(t,r) = \frac{1}{2r}\int_{r-t}^{r+t} \rho g(\rho)\,d\rho\,.$$

(iii) Set the initial data to be

$$g(r) = 1\,,\quad 0 \le r < 1\,,\quad g(r) = 0\,, 1 \le r\,,$$

show that $u(t,r)$ is continuous for $|t|<1$ but at time $t=1$ it exhibits a jump discontinuity. This is due to the focusing of the singularity in $\partial_t u(0,r)$ given at $t=0$.

Exercise 6.2. This problem addresses the decay rate of solutions of the wave equation in \mathbb{R}^3. Suppose that the initial data $(f(x),g(x)) \in C^1(\mathbb{R}^3) \times C(\mathbb{R}^3)$ and that it is supported in the bounded set $B_1(0)$. By inspecting the Kirchhoff formula for the solution $u(t,x)$, show that

$$|u(t,x)| \le \frac{C}{|t|}$$

for some constant C, which can be quantified using $\|f\|_{C^1(\mathbb{R}^3)}$ and $\|g\|_{C(\mathbb{R}^3)}$.

Exercise 6.3. (Global existence with small initial data for certain nonlinear wave equations):

This question is to show that certain nonlinear wave equations possess smooth solutions for all $t \in \mathbb{R}$. This contrasts with other cases where solutions form singularities in finite time. Consider the equation

(6.25)
$$\partial_t^2 v - \Delta v + (\partial_t v)^2 - |\nabla v|^2 = 0$$
$$v(0,x) = f(x)\quad \partial_t v(0,x) = g(x)\qquad (f(x),g(x)) \in C^1(\mathbb{R}^3) \times C(\mathbb{R}^3)\,,$$

with f,g supported in a compact set.

(i) Setting $u = e^v - 1$, show that $u(t,x)$ satisfies the wave equation

$$\partial_t^2 u - \Delta u = 0$$
$$u(0,x) = e^{f(x)} - 1 := F(x)\quad \partial_t u(0,x) = g(x)e^{f(x)} := G(x)$$
$$(F(x),G(x)) \in C^1(\mathbb{R}^3) \times C(\mathbb{R}^3)\,.$$

Explain why (F,G) has compact suport.

(ii) Show that for sufficiently small $\|(F, \partial_x F, G)\|_C$, the solution $u(t, x)$ is bounded by

$$|u(t, x)| < 1 \ ,$$

using the result of Problem 2.

In this case the transformation $v \mapsto u$ is invertible for all $(t, x) \in \mathbb{R}^1_t \times \mathbb{R}^3_x$, giving rise to a global solution $v(t, x)$ of the equation (6.25).

Exercise 6.4. (method of decent for the wave equation for $x \in \mathbb{R}^2$):

(i) Show that if $x \in \mathbb{R}^3$ but the Cauchy data for the wave equation only depends upon (x_1, x_2), namely

(6.26) $f = f(x_1, x_2) \ , \qquad g = g(x_1, x_2) \ ,$

then the solution of the wave equation in $\mathbb{R}^1_t \times \mathbb{R}^3_x$ is also independent of x_3;

$$u = u(t, x_1, x_2) \ ,$$

and therefore $u(t, x_1, x_2)$ satisfies the wave equation in two space dimensions;

$$\partial_t^2 u - (\partial_{x_1}^2 + \partial_{x_2}^2) u = 0 \ .$$

(ii) Use the Kirchhoff formula to express the solution to the wave equation in \mathbb{R}^3 for data satisfying (6.26).

(iii) In the expression in (ii) reparametrize the spherical integrals by their projection onto the (x_1, x_2)-plane; *e.g.*

$$\int_{\mathbb{S}^2 : |x-y| = t} f(y) \, dS_y = \iint_{|(x_1 - y_1, x_2 - y_2)| < t} f(y_1, y_2) \sqrt{t^2 - ((x_1 - y_1)^2 + (x_2 - y_2)^2)} \, dy_1 dy_2 \ ,$$

which gives a general formula in \mathbb{R}^2 for the solution of the wave equation

$$\Box u = 0 \ .$$

(iv) Describe the nature of this solution in the case that the support of f and g as functions on \mathbb{R}^2 is compact, say supported in the ball $B_R(0) = \{|(x_1, x_2)| < R\}$. In particular comment on the Huygens' principle. Does the solution satisfy the strong form of Huygens' principle, and why? Describe what an observer sees as time progresses when they are situated farther than R from the origin.

Exercise 6.5. (The Cauchy problem for the wave equation in the Friedman – Robertson – Walker space-time):

The metric for a Friedman – Robertson – Walker (FRW) space-time is given in terms of the line element in the form

$$ds^2 = -dt^2 + S^2(t) d\sigma^2 \ , \quad S(0) = 0 \ ,$$

defined on the half space-time $\mathbb{R}^1_+ \times \mathbb{R}^3_x$, where $d\sigma^2 = dx_1^2 + dx_2^2 + dx_3^2$ is the Euclidian metric of each space-like hypersurface $\{(t, x) : t = \text{Const.}\} \simeq \mathbb{R}^3$.

This metric describes an emerging space-time from a Big Bang at $t = 0$. Changing time variable

$$\frac{dt}{d\tau} = S(\tau) = \tau^2$$

the metric becomes

$$ds^2 = S^2(\tau)(-d\tau^2 + d\sigma^2) .$$

Consider the wave equation on $\mathbb{R}^1_+ \times \mathbb{R}^3_x$ in this metric,

$$\Box u := \frac{1}{S^2}\partial_\tau^2 u + \frac{2\dot{S}}{S^3}\partial_\tau u - \frac{1}{S^2}\Delta_\sigma u = 0 .$$

Initial data is given on the Cauchy hypersurface $\{(\tau_0, x)\} \simeq \mathbb{R}^3$,

$$u(\tau_0, x) = g(x) , \quad \partial_\tau u(\tau_0, x) = h(x) .$$

(a) Make the change of variables

$$v(\tau, x) = \frac{1}{\tau}\partial_\tau(\tau^3 u)$$

show that $v(\tau, x)$ satisfies the usual wave equation in Minkowski space

$$\partial_t^2 v = \Delta_\sigma v \quad \tau > 0 .$$

Show that the initial data for v at $\tau = \tau_0 > 0$ is given by

$$\begin{cases} v(\tau_0, x) = 3\tau_0 g(x) + \tau_0^2 h(x) := \phi(x) \\ \partial_\tau v(\tau_0, x) = 3g(x) + \tau_0^2 \Delta g(x) + \tau_0 h(x) := \psi(x) . \end{cases}$$

Thus the solution can be given in terms of spherical means; state this expression for the solution.

(b) The inverse of the transformation is given by

$$\tau^3 u(\tau, x) = \int_0^{\tau - \tau_0} (r + \tau_0)v(r + \tau_0, x) \, dr + \tau_0^3 g(x) .$$

Assume (for simplicity) that $h(x) = 0$. Give an expression for $u(\tau, x)$ in terms of $g(x)$ using the spherical means expression for v and the above inverse.

(c) The above expression is for fixed $\tau_0 > 0$ defining the Cauchy surface, and it gives the solution at time $\tau > 0$. Now consider the solution expression at a fixed time $\tau > \tau_0$, and take the limit as $\tau_0 \to 0$. What do you get?

(d) Make a sketch of the light cone structure of this problem in the original variables (t, x).

Dispersion

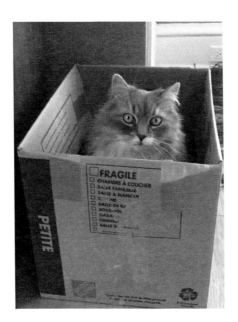

This image needs no caption.

7.1. Schrödinger's equation

The most common case of an evolution equation for which dispersion plays a role is the Schrödinger equation

$$(7.1) \qquad \frac{1}{i}\partial_t \psi = -\frac{1}{2}\Delta\psi \,, \qquad \psi : \mathbb{R}^1_t \times \mathbb{R}^n_x \to \mathbb{C} \,,$$

with prescribed initial data

$$\psi(0, x) = \psi_0(x) \in L^2(\mathbb{R}^n) \ .$$

In the quantum mechanical context the solution $\psi(t, x)$ is known as the *wave function* or the *complex probability amplitude*. The solution of (7.1) is straightforward via the Fourier transform,

$$\hat{\psi}(t, \xi) = (\mathcal{F}\psi)(t, \xi) = \frac{1}{\sqrt{2\pi}^n} \int e^{-i\xi \cdot x} \psi(t, x)\, dx \ ,$$

which then must satisfy the parameter family of ODEs

$$\frac{1}{i}\partial_t \hat{\psi} = \tfrac{1}{2}|\xi|^2 \hat{\psi} \ , \qquad \hat{\psi}(0, \xi) = \hat{\psi}_0(\xi) \ .$$

Thus

$$\hat{\psi}(t, \xi) = e^{i\frac{1}{2}|\xi|^2 t}\hat{\psi}_0(\xi) \ .$$

Reconstituting the wave function with the inverse Fourier transform gives the following expression of the solution

$$\psi(t, x) = \frac{1}{\sqrt{2\pi}^n} \int e^{i\xi \cdot x} e^{i\frac{1}{2}|\xi|^2 t}\hat{\psi}_0(\xi)\, d\xi$$

(7.2)
$$= \frac{1}{(2\pi)^n} \iint e^{i\xi \cdot (x-y)} e^{i\frac{1}{2}|\xi|^2 t}\psi_0(y)\, dy d\xi \ .$$

Proposition 7.1. Evaluation of the complex Gaussian integral in (7.2) gives the expression

$$\frac{1}{(2\pi)^n} \iint e^{i\xi \cdot (x-y)} e^{i\frac{1}{2}|\xi|^2 t}\, d\xi = \frac{1}{\sqrt{2\pi i t}^n} e^{-i\frac{|x-y|^2}{2t}} \ .$$

Thus the Fourier representation of the solution leads to the expression for the solution involving the Schrödinger kernel

(7.3)
$$\psi(t, x) = \int_{\mathbb{R}^n} \frac{1}{\sqrt{2\pi i t}^n} e^{-i\frac{|x-y|^2}{2t}} \psi_0(y)\, dy$$

$$:= \int_{\mathbb{R}^n} S(t, x - y)\psi_0(y)\, dy = \mathbf{S}(t)\psi_0(x) \ .$$

One notices formal similarities of the Schrödinger kernel with the heat kernel and its analogous representation of solutions of the heat equation. On the other hand, the presence of the complex unit i in the exponent changes radically the character of the Schrödinger kernel and the behavior of solutions. Indeed the heat kernel satisfies

$$H(t, x) = \frac{1}{\sqrt{2\pi t}^n} e^{-\frac{|x|^2}{2t}} \in \mathcal{S} \quad \forall t > 0 \ ,$$

and in particular for $t > 0$ the heat kernel $H(t,x)$ decays very rapidly as $|x| \to +\infty$ (faster than exponential decay). On the other hand

$$S(t,x) = \frac{1}{\sqrt{2\pi it}^n} e^{-\frac{i|x|^2}{2t}} \in C^\infty \quad \forall t \in \mathbb{R}$$

but it is not Schwartz class as it does not decay as $|x| \to +\infty$, rather it oscillates rapidly.

Theorem 7.2. (i) *For initial data $\psi_0(x) \in \mathcal{S}$ the solution expression (7.3) gives rise to an absolutely convergent integral, and for all $t \in \mathbb{R}^1$ $\psi(t,x) \in \mathcal{S}$.*
(ii) *For initial data $\psi_0(x) \in L^2(\mathbb{R}^n)$ then the expression (7.3) for the solution converges in the L^2 sense, and for all $t \in \mathbb{R}^1$ $\psi(t,x) \in L^2(\mathbb{R}^n)$.*

Proof. (i) The solution formula (7.3) is that

$$\psi(t,x) = \int_{\mathbb{R}^n} S(t,x-y)\psi_0(y)\,dy = \mathcal{F}^{-1}\big(e^{i\frac{1}{2}|\xi|^2 t}\hat{\psi}_0(\xi)\big)$$

which is the inverse Fourier transform of a Schwartz class function.
(ii) Again the solution formula gives us that

$$(7.4) \qquad \|\psi(t,\cdot)\|_{L^2}^2 = \int |\hat{\psi}(t,\xi)|^2\,d\xi = \int |e^{i\frac{1}{2}|\xi|^2 t}\hat{\psi}_0(\xi)|^2\,d\xi$$

$$= \int |\hat{\psi}_0(\xi)|^2\,d\xi = \|\psi_0\|_{L^2}^2\,.$$

This last fact, that the L^2 norm is preserved by the Schrödinger flow, is central to the interpretation of the wave function in quantum mechanics. \square

Consider initial data $\psi_0(x) \in L^2(\mathbb{R}^n)$, normalized to satisfy $\|\psi_0\|_{L^2} = 1$; this can be viewed as a rescaling of ψ_0 to lie on the unit sphere $\mathbb{S}_1^\infty \subseteq L^2$. Then the quantity

$$|\psi(t,x)|^2\,dx := dP_t(x)$$

is a time dependent probability distribution on $x \in \mathbb{R}^n$, with initial distribution

$$|\psi_0(x)|^2\,dx = dP_0(x)\,.$$

The interpretation of the wave function is that the probability of a quantum particle being in a (measurable) set A at time t is given by

$$P_t(A) = \int_A dP_t(x) = \int_A |\psi(t,x)|^2\,dx\,.$$

The normalization of the wave function implies that

$$P_t(\mathbb{R}^n) = \int_{\mathbb{R}^n} |\psi(t,x)|^2\,dx = \int_{\mathbb{R}^n} |\psi_0(x)|^2\,dx = 1\,.$$

Theorem 7.2, statement *(ii)* is the fact that the Schrödinger flow preserves probability. Comparing this with the heat equation, where the probability

measure in question is $dP_t(x) = u(t, x)\, dx$, which is a measure when $u_0(x) \geq 0$; under heat flow this sign condition and the L^1 norm of the solution are preserved.

Conservation laws. There are other conservation laws for solutions of Schrödinger's equations. The *kinetic energy* represented by the wave function is given by

$$E(\psi) := \int_{\mathbb{R}^n} \tfrac{1}{2} |\nabla \psi|^2 \, dx \; .$$

Expressing this in Fourier transform variables and using the Plancherel identity, it is straightforward to verify that solutions conserve (kinetic) energy (noting that no potential energy term is included in the equation (7.1)).

$$
\begin{aligned}
E(\psi(t, \cdot)) &= \int_{\mathbb{R}^n} \tfrac{1}{2} |\nabla \psi(t, x)|^2 \, dx = \int_{\mathbb{R}^n} \tfrac{1}{2} |\xi \hat{\psi}(t, \xi)|^2 \, dx \\
&= \int_{\mathbb{R}^n} \tfrac{1}{2} \left| \xi \left(e^{i\frac{1}{2}|\xi|^2 t} \hat{\psi}_0(\xi) \right) \right|^2 \, dx = E(\psi_0) \; .
\end{aligned}
$$

The probability distribution $dP_t(x)$ is called the *position distribution*. One can also study the *momentum distribution*

$$d\hat{P}_t(\xi) := |\hat{\psi}(t, \xi)|^2 \, d\xi \; ,$$

which has initial distribution $d\hat{P}_0(\xi) = |\psi_0(\xi)|^2 \, d\xi$. Again from the Plancherel identity

$$\int_{\mathbb{R}^n} d\hat{P}_t(\xi) = \int_{\mathbb{R}^n} |\hat{\psi}(t, \xi)|^2 \, d\xi = \int_{\mathbb{R}^n} |\psi(t, x)|^2 \, dx = \int_{\mathbb{R}^n} dP_0(x) \; ,$$

thus the total momentum probability, or the zeroth moment of $d\hat{P}_t(\xi)$ is preserved under Schrödinger evolution. Furthermore, all moments of the momentum distribution are preserved.

Theorem 7.3. *Given a Fourier multiplier operator $m(D)$,*

$$m(D)\psi(x) = \frac{1}{\sqrt{2\pi}^n} \int_{\mathbb{R}^n} e^{i\xi \cdot x} m(\xi) \hat{\psi}(\xi) \, d\xi \; .$$

All such quantities satisfy

$$\int_{\mathbb{R}^n} |m(D)\psi(t, x)|^2 \, dx = \int_{\mathbb{R}^n} |m(D)\psi_0(x)|^2 \, dx \; .$$

Therefore all moments of the momentum distribution are preserved under free Schrödinger flow.

Proof. The result follows from a calculation of the integrals in the statement of the theorem,

$$\int |m(D)\psi(t,x)|^2\, dx = \int |m(\xi)\hat\psi(t,\xi)|^2\, d\xi$$

$$= \int |m(\xi)\hat\psi_0(\xi)|^2\, d\xi = \int |m(D)\psi_0(x)|^2\, dx\ .$$

\square

It follows that all moments of the measure $d\hat P_t(x)$ are of this form,

$$\hat m(\psi(t,\cdot)) = \int \xi^k d\hat P_t(\xi) = \int \xi^k |\hat\psi(\xi)|^2\, d\xi = \int \xi^k d\hat P_0(\xi) = \hat m_k(\psi_0(\cdot))\ .$$

In particular, for $k = 2s$ these are Sobolev estimates of the solution

$$\hat m_{2s}(\psi(t,\cdot)) = \int |\xi^s \psi(t,\xi)|^2\, d\xi = \int |\partial_x^s \psi(t,x)|^2\, dx$$

$$= \int |\partial_x^s \psi_0(x)|^2\, dx = \hat m_{2s}(\psi_0)\ .$$

This leads to a natural question as to how the spatial moments of solutions of the Schrödinger equation behave. These are

$$m_k(\psi(t,x)) = \int_{\mathbb{R}^n} x^k d P_t(x) = \int_{\mathbb{R}^n} x^k |\psi(t,x)|^2\, dx\ .$$

It turns out that for $\psi_0 \in L^2(\mathbb{R}^n)$ the quantities $m_k(\psi(t,\cdot))$ are not necessarily bounded; see Exercise 7.2 in this section. This is in contrast to the recursive control of the moments of the analog probability measure given by the flow of the heat equation.

A second proof of the conservation law (7.4) for $\|\psi(t,\cdot)\|_{L^2}^2$ goes as follows. Take a domain $A \subseteq \mathbb{R}^n$, that is, an open subset with sufficiently smooth boundary. Then

$$\frac{d}{dt}\int_A \bar\psi\psi\, dx = \int_A \overline{\partial_t\psi}\psi + \bar\psi\partial_t\psi\, dx = \int_A \overline{\frac{1}{2i}\Delta\psi}\psi + \bar\psi\frac{1}{2i}\Delta\psi\, dx$$

$$= -\frac{1}{2i}\int_A \overline{\Delta\psi}\psi - \bar\psi\Delta\psi\, dx = \frac{1}{2i}\int_A \overline{\nabla\psi}\cdot\nabla\psi - \overline{\nabla\psi}\cdot\nabla\psi\, dx$$

$$+ \frac{1}{2i}\int_{\partial A}\left(-\psi\overline{\nabla\psi}\cdot N + \bar\psi\nabla\psi\cdot N\right) dS_A\ .$$

This calculation identifies the quantum mechanical flux $F(\psi)$ across the boundary ∂A as

$$F\cdot N = \frac{1}{2i}\left(-\psi\overline{\nabla\psi} + \bar\psi\nabla\psi\right)\cdot N\ .$$

Now let $A = \mathbb{R}^n$, we find that

$$\frac{d}{dt}\|\psi(t,\cdot)\|_{L^2}^2 = 0\ ,$$

hence $\|\psi(t,\cdot)\|_{L^2}^2 = \|\psi_0\|_{L^2}^2$ for all $t \in \mathbb{R}_t^1$. The advantage to this proof is that it is very general, and in particular it applies to the Schrödinger equation with potential

$$(7.5) \qquad \frac{1}{i}\partial_t\psi = -\tfrac{1}{2}\Delta\psi + V(x)\psi \,,$$

where $V(x)$ represents the interaction of the quantum particle in question with a background potential energy. Two examples that we have already discussed in Chapter 2 are the quantum harmonic oscillator and the hydrogen atom. The potential for the first is given by

$$V(x) = \tfrac{1}{2}|x|^2 \,.$$

For the second example let $x \in \mathbb{R}^3$; the potential energy given by the atomic nucleus of the hydrogen atom is given by

$$V(x) = -\frac{Z}{|x|} \,,$$

where $\psi(t,x)$ is the wave function of the electron.

7.2. Heisenberg uncertainty principle

Returning to the discussion of moments of a function $\psi(x) \in L^2$, we have defined the k^{th} spatial moments and momentum space moments as

$$m_k(\psi_0) = \int x^k|\psi_0(x)|^2\,dx \,, \qquad \hat{m}(\psi_0) = \int \xi^k|\hat\psi_0(\xi)|^2\,d\xi \,.$$

We have furthermore shown that the moments $m_0(\psi(t,\cdot))$ and $\hat{m}(\psi(t,\cdot))$ are constants of Schrödinger evolution. Introducing the Dirac *bra* and *ket* notation, the first moments of position and momentum of an arbitrary wave function $\psi(x)$ are

$$m_1(\psi) = \int_{\mathbb{R}^n} x|\psi(x)|^2\,dx = \langle\psi|x|\psi\rangle$$

$$\hat{m}_1(\psi) = \int \xi|\hat\psi(\xi)|^2\,d\xi = \int \overline{\psi}(x)\frac{1}{i}\partial_x\psi(x)\,dx = \langle\psi|\frac{1}{i}\partial_x|\psi\rangle \,.$$

Proposition 7.4. Under translation and change of phase, the wave function $\psi(x)$ may be adjusted so that $m_1(\psi) = 0 = \hat{m}_1(\psi)$.

Proof. Addressing first $m_1(\psi)$, change variables by translation $x \mapsto x'-x_0$, and denoting $\tau_{x_0}(\psi) := \psi(x-x_0)$

$$m_1(\psi) = \int x|\psi(x)|^2\,dx = \int (x'-x_0)|\psi(x'-x_0)|^2\,dx'$$

$$= m_1(\tau_{x_0}\psi) - x_0\,m_0(\tau_{x_0}\psi) \,.$$

Since $\psi \not\equiv 0$ then $m_0(\psi) = m_0(\tau_{x_0}\psi) \neq 0$, and thus we may choose

$$x_0 = -\frac{m_1(\psi)}{m_0(\psi)}$$

so that $m_1(\tau_{x_0}\psi) = 0$. Similarly, consider

$$\hat{m}_1(\psi) = \int \xi |\hat{\psi}|^2 \, d\xi = \int \bar{\psi}(x)\frac{1}{i}\partial_x\psi(x) \, dx \ .$$

Then with a change of phase

$$\hat{m}_1(e^{i\xi_0 \cdot x}\psi) = \int \overline{e^{i\xi_0 \cdot x}\psi(x)}\frac{1}{i}\partial_x\big(e^{i\xi_0 \cdot x}\psi(x)\big) \, dx$$

$$= \int \overline{\psi}(x)\frac{1}{i}\partial_x\psi(x) \, dx + \xi_0 \int \bar{\psi}\psi \, dx$$

$$= \hat{m}_1(\psi) + \xi_0\hat{m}_0(\psi) \ .$$

Again, one may choose ξ_0 so that $\hat{m}_1(e^{i\xi_0 \cdot x}\psi) = 0$. \square

The *variance* $\Delta_x(\psi)$ of a wave function quantifies its deviation from its mean value, which we can write as follows. Assume that $m_1(\psi) = 0 = \hat{m}_1(\psi)$, without loss of generality due to Proposition 7.4. Then we may write

$$m_2(\psi) = \int x^2|\psi(x)|^2 \, dx = \langle \psi|x^2|\psi\rangle = \Delta_x(\psi) \ ,$$

$$\hat{m}_2(\psi) = \int \Big|\frac{1}{i}\partial_x\psi\Big|^2 \, dx = \int \xi^2|\hat{\psi}(\xi)|^2 \, d\xi = \langle \hat{\psi}|\xi^2|\hat{\psi}\rangle = \Delta_\xi(\psi) \ .$$

Theorem 7.5 (Heisenberg uncertainty principle). *Consider a normalized* $\psi(x) \in B_1(0) \subseteq L^2$, *such that*

$$m_0(\psi) = 1 \ , \quad m_1(\psi) = 0 \ , \quad \hat{m}_1(\psi) = 0 \ .$$

Then there is a lower bound on the product of the variances; namely

(7.6) $$1 = m_0(\psi)^2 \leq 4m_2(\psi)\hat{m}_2(\psi) = 4\Delta_x(\psi)\Delta_\xi(\psi) \ .$$

In somewhat more generality the above inequality follows from the statement that for any $\psi \in L^2$ then

(7.7) $$\frac{1}{4}\|\psi\|_{L^2}^4 \leq \int x^2|\psi(x)|^2 \, dx \int \Big|\frac{1}{i}\partial_x\psi\Big|^2 \, dx \ .$$

Proof. We will prove (7.7). Assume that $\psi \in \mathcal{S}$ so that we may freely take derivatives and moments. Calculate the commutator

$$\Big[\frac{1}{i}\partial_x, x\Big]\psi = \frac{1}{i}\partial_x(x\psi) - x\frac{1}{i}\partial_x\psi = \frac{1}{i}\psi \ .$$

Using the commutator there is an identity

$$\frac{1}{i}\|\psi\|^2_{L^2} = \int \bar\psi\big(\big[\frac{1}{i}\partial_x,x\big]\psi\big)\,dx \quad = \int \overline{\frac{1}{i}\partial_x\psi}\,x\psi\,dx - \int \overline{x\psi}\,\frac{1}{i}\partial_x\psi\,dx\ .$$

Therefore

$$\int \bar\psi\big(\big[\frac{1}{i}\partial_x,x\big]\psi\big)\,dx = 2\mathrm{im}\int \overline{\frac{1}{i}\partial_x\psi}\,x\psi\,dx\ ,$$

and using the Cauchy – Schwartz inequality we have

$$\Big|\int \bar\psi\big(\big[\frac{1}{i}\partial_x,x\big]\psi\big)\,dx\Big| \le 2\Big(\int \big|\frac{1}{i}\partial_x\psi\big|^2\,dx\Big)^{1/2}\Big(\int x^2|\psi(x)|^2\,dx\Big)^{1/2}\ .$$

This is the desired inequality, for $\psi\in\mathcal{S}$ at least. The general case follows from the fact that $\mathcal{S}\subseteq L^2$ is a dense set. We may thus approach a general $\psi\in L^2$ by a sequence of Schwartz class approximates, in such a way that the LHS of (7.7) converges in the sense of L^2 (the RHS may well diverge, if for example our target L^2 function is not also H^1). □

7.3. Phase and group velocities

The majority of the problems that we have addressed so far in this course have been for constant coefficient PDE, which is to say that they are of the form

$$P(D)u = \sum_{|\alpha|\le m} p_\alpha D^\alpha u = 0$$

with $D=\frac{1}{i}\partial_x$ and $D^\alpha = \prod_{j=1}^{n} D_j^{\alpha_j} = (-i)^\alpha \prod_{j=1}^{n}\partial_{x_j}$. In particular the evolution equations have been posed as

$$(7.8)\qquad \partial_t u = P(D)u,$$
$$u(x,0)=u_0(x)\ .$$

The examples have been the Schrödinger equation

$$(7.9)\qquad P(D)u = \frac{i}{2}(\partial^2_{x_1}+\cdots+\partial^2_{x_n}) = -\frac{i}{2}|D|^2\ ,$$

the heat equation

$$(7.10)\qquad P(D)u = \frac{1}{2}\Delta = -\frac{1}{2}|D|^2\ ,$$

and the wave equation, for which we must write (7.8) as a system of PDE.

$$(7.11)\qquad \partial_t\begin{pmatrix}u\\p\end{pmatrix}=\begin{pmatrix}0&I\\\Delta&0\end{pmatrix}\begin{pmatrix}u\\p\end{pmatrix},$$

so that

$$P(D)=\begin{pmatrix}0&1\\-|D|^2&0\end{pmatrix}.$$

The method that we have used in each case is to take the Fourier transform of the equation (7.8),

$$(7.12) \qquad \partial_t \hat{u} = P(\xi)\hat{u},$$

and solve the resulting ODE which depends upon the parameter $\xi \in \mathbb{R}^n$;

$$(7.13) \qquad \hat{u}(\xi, t) = e^{P(\xi)t}\hat{u}_0(\xi).$$

Modulo questions of convergence, the solution should then be represented as a Fourier integral

$$(7.14) \qquad u(x, t) = \frac{1}{\sqrt{2\pi}^n} \int e^{i\xi \cdot x} e^{P(\xi)t}\hat{u}(\xi)d\xi.$$

The wave equation gives a good example of this method; in matrix form

$$P(\xi) = \begin{pmatrix} 0 & 1 \\ -|\xi|^2 & 0 \end{pmatrix} \text{ and } e^{P(\xi)t} = \begin{pmatrix} \cos(|\xi|t) & \frac{1}{|\xi|}\sin(|\xi|t) \\ -|\xi|\sin(|\xi|t) & \cos(|\xi|t) \end{pmatrix}.$$

Since the above sequence of calculation can be reproduced for any constant coefficient operator $P(D)$, we can imagine that the Fourier kernel $e^{P(\xi)t}$ of the solution operator cannot give rise to a well-defined distribution kernel in all case. There is however a simple criterion in the scalar case for guaranteeing that we can proceed in this fashion.

Definition 7.6. Suppose that the polynomial $iP(\xi)$ is real valued for all $\xi \in \mathbb{R}^n$, then $P(\xi)$ is said to be of *real type*, and

$$\omega(\xi) = iP(\xi)$$

is known as the *dispersion relation*.

The idea of a linear evolution equation with constant coefficient can be extended to more general operators which are defined in terms of Fourier multipliers which are symbols.

Definition 7.7. A Fourier multiplier $\omega(D)$ is called a *symbol* if $\omega(\xi) \in \mathbb{C}^\infty(\mathbb{R}^n \setminus \{0\})$ and there is an order m such that for all multi indices β,

$$|\partial_\xi^\beta \omega(\xi)| \leq C_\beta (1 + |\xi|^2)^{(m-|\beta|)/2}$$

A Fourier multiplier is *of real type* if $\omega(\xi)$ is real for all $\xi \in \mathbb{R}$.

Proposition 7.8. In case that $\omega(D)$ is a continuous Fourier multiplier of real type, then the initial value problem

$$(7.15) \qquad \partial_t u = -i\omega(D)u$$

is well-posed in $L^2(\mathbb{R}^n)$.

Proof. Well-posedness will mean in this context that if the initial data $u_0(x) \in L^2(\mathbb{R}^n)$, then there exists a solution $u(x,t)$ of (7.15) with the properties that for each $t \in \mathbb{R}$, $u(x,t) \in L^2(\mathbb{R}^n)$, and that $\lim_{t\to 0} \|u(x,t) - u_0(x)\|_{L^2(\mathbb{R}^n)} = 0$, which is to say that the solution is continuous in L^2. To show this, we will use the Fourier integral expression for a solution

$$(7.16) \qquad u(x,t) = \frac{1}{\sqrt{2\pi}^n} \int e^{i\xi \cdot x} e^{-i\omega(\xi)t} \hat{u}_0(\xi) d\xi.$$

Using again the Plancherel identity, $\|u(x,t)\|_{L^2(\mathbb{R}^n_x)} = \|e^{-i\omega(\xi)t} \hat{u}_0(\xi)\|_{L^2(\mathbb{R}^n_\xi)} = \|\hat{u}_0(\xi)\|_{L^2(\mathbb{R}^n_\xi)} = \|u_0\|_{L^2(\mathbb{R}^n_x)}$. The continuity in L^2 follows arguments that we have also seen before. $\qquad\square$

I want to talk in more detail about the character of solution, and in particular their long time asymptotic behavior, using an analysis of the Fourier integral representation (7.16) and the dispersion relation $\omega(\xi)$. For this analysis we ask that $\omega(\xi)$ be a symbol of real type. The Fourier integral represents the solution as a superposition of complex exponentials

$$u(x,t) = \frac{1}{(2\pi)^n} \int\int e^{i(\xi\cdot(x-y)-\omega(\xi)t)} u_0(y) dy d\xi$$
$$= \frac{1}{(2\pi)^n} \int\int e^{i(\xi\cdot\frac{(x-y)}{t}-\omega(\xi))t} u_0(y) dy d\xi.$$

Definition 7.9. (Kelvin) The *phase velocity* of the equation (7.15) is given by

$$\vec{c}_p = \omega(\xi)\frac{\xi}{|\xi|^2} \ ;$$

the *group velocity* is given by

$$\vec{c}_g = \partial_\xi \omega(\xi).$$

It is useful to describe the significance of these terms. Consider a complex exponential which solves the equation;

$$u(x,t) = e^{i(k\cdot x-\omega(k)t)} = e^{ik\cdot(x-\frac{\omega(k)}{|k|^2}kt)}.$$

Reading the exponent, we see that the loci of points in space-time along which the phase is constant lie on the rays $k\cdot(x-\frac{\omega(k)}{|k|^2}kt) = $ constant. That is, they move with velocity $\frac{\omega(k)}{|k|^2}k = \vec{c}_p(k)$. Taking the real (or imaginary) part of the solution, we see that this is the velocity of the peak or the trough of an individual oscillation.

Now consider a more distributed set of frequencies in the initial data, in the form of a wave packet. This is to say that we take data which decomposes into two features; a complex exponential and an envelope, where the envelope is slowly varying with respect to the oscillation of the complex

exponential factor. We claim that this wave packet will propagate with group velocity $\vec{c}_g(k)$. The dispersion relations and the phase and group velocities of several examples are as follows:

(1) The Schrödinger equation. $\omega(\xi) = \frac{1}{2}|\xi|^2$, $c_p = \frac{1}{2}\xi$, $c_g = \partial_\xi \omega = \xi$. The group velocity is twice the phase velocity.

(2) The wave equation. The matrix

$$P(\xi) = \begin{pmatrix} 0 & 1 \\ -|\xi|^2 & 0 \end{pmatrix}$$

has eigenvalues $\omega(\xi) = \pm|\xi|$. The phase and group velocity of each eigenvector of $P(\xi)$ coincide;

$$c_p = \frac{\pm\xi}{|\xi|} = c_g.$$

(3) The Airy equation (related to the KdV equation)

$$\partial_t u = \partial_x^3 u, \; P(D) = -iD^3.$$

The dispersion relation $\omega(\xi) = \xi^3$ has

$$c_p = \xi^2 \geq 0, \; c_g = 3\xi^2 = 3c_p.$$

(4) Free surface water waves. The dispersion relation is $\omega(\xi) = \sqrt{g|\xi|}$ in infinitely deep bodies of water. The parameter g is related to the acceleration of gravity and the density of water. Then

$$c_p = \frac{g}{|\xi|^{1/2}} \frac{\xi}{|\xi|}, \; c_g = \frac{g}{2|\xi|^{1/2}} \frac{\xi}{|\xi|}.$$

and c_g is slower than c_p. One can observe this relationship in the behavior of ripples in a basin of water.

7.4. Stationary phase

Starting with wave packet initial data, we can solve the equation (7.8) using Fourier integrals, giving the familiar expression

(7.17) $$u(x,t) = \frac{1}{\sqrt{2\pi}^n} \int e^{it(\frac{x\cdot\xi}{t} - \omega(\xi))} \hat{u}_0(\xi) d\xi.$$

Consider the data $\hat{u}_0(\xi)$ supported in $B_r(\xi^0)$, and taken any point $(x,t) \in \mathbb{R}^{n+1}$ such that for $\xi \in \text{supp}(\hat{u}_0(\cdot))$, $|\frac{x}{t} - \partial_\xi \omega(\xi)| > R$. Make use of the identity

$$e^{it(\frac{x\cdot\xi}{t} - \omega(\xi))} = \frac{-i(\frac{x}{t} - \partial_\xi \omega(\xi))}{t|\frac{x}{t} - \partial_\xi \omega(\xi)|^2} \cdot \partial_\xi \left(e^{it(\frac{x\cdot\xi}{t} - \omega(\xi))}\right)$$

in the expression (7.17), to rewrite it as

$$(7.18) \qquad u(x,t) = \frac{1}{\sqrt{2\pi}^n} \int \frac{-i(\frac{x}{t} - \partial_\xi \omega(\xi))}{t|\frac{x}{t} - \partial_\xi \omega(\xi)|^2} \cdot \partial_\xi(e^{it(\frac{x\cdot\xi}{t} - \omega(\xi))})\hat{u}_0(\xi)\, d\xi \ .$$

$$= \frac{1}{\sqrt{2\pi}^n} \int e^{it(\frac{x\cdot\xi}{t} - \omega(\xi))} \partial_\xi \cdot \left(\frac{i(\frac{x}{t} - \partial_\xi \omega(\xi))}{t|\frac{x}{t} - \partial_\xi \omega(\xi)|^2} \hat{u}_0(\xi) \right) d\xi \ .$$

The critical fact is that the denominator does not vanish on the support of the integrand, by the choice of $(x,t) \in \mathbb{R}^{n+1}$. Measuring the absolute value of the solution

$$|u(x,t)| \leq \frac{1}{\sqrt{2\pi}^n} \frac{1}{|t|} \int \left| \partial_\xi \cdot \left(\frac{i(\frac{x}{t} - \partial_\xi \omega(\xi))}{t|\frac{x}{t} - \partial_\xi \omega(\xi)|^2} \hat{u}_0(\xi) \right) \right| d\xi \ .$$

$$\leq \frac{C}{|t|} \int \left| \frac{1}{|\frac{x}{t} - \partial_\xi \omega(\xi)|} \partial_\xi \hat{u}_0(\xi) + \frac{\partial_\xi^2 \omega}{|\frac{x}{t} - \partial_\xi \omega(\xi)|^2} \hat{u}_0(\xi) \right| d\xi$$

$$\leq \frac{C_1}{R|t|} \ ,$$

For $R > 1$ at least. Thus the solution is shown to decay in time. Repeating the integration by parts that we performed above,

$$|u(x,t)| = \left| \frac{1}{\sqrt{2\pi}^n} \int e^{it(\frac{x\cdot\xi}{t} - \omega(\xi))} (i\partial_\xi \cdot \frac{i(\frac{x}{t} - \partial_\xi \omega(\xi))}{t|\frac{x}{t} - \partial_\xi \omega(\xi)|^2})^N \hat{u}_0(\xi)\, d\xi \right|$$

$$\leq \frac{C_N}{R^N |t|^N} \ ,$$

for large $|t|$. The picture of this is as follows

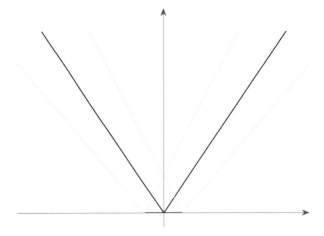

Figure 1. The channels travelled by wave packets with carrier oscillation k and k', respectively.

Theorem 7.10. *For initial data $u_0(x) \in \mathcal{S}$ such that $\text{supp}(\hat{u}_0(\xi)) \subseteq B_r(\xi^0)$, the solution $u(x,t)$ is also in \mathcal{S} for every t. Furthermore on the set $B = \{(x,t) : \inf_{\xi \in B_r(\xi_0)} |\frac{x}{t} - \partial_\xi \omega(\xi)| > R\}$ we have for all N*

$$|u(x,t)| \leq \frac{C_N}{R^N |t|^N}.$$

This is the statement that away from the rays of stationary phase $\{\frac{x}{t} - \partial_\xi \omega(\xi) = 0; \xi \in \text{supp}(\hat{u}_0(\cdot))\}$, the solution decays rapidly in space and time.

It may seem as though the above result only applies to quite special initial functions $u_0(x)$, but in fact it is rather generally applicable. Indeed we may furthermore decompose any initial data $u_0(x)$ into a sum of wave packets, through a partition of unity.

Lemma 7.11. *There exists $\{\chi_j(y)\}_{j \in \mathbb{Z}^n}$ a partition of unity of \mathbb{R}^n, with each $\chi_j(y) \in \mathbb{C}_0^\infty(\mathbb{R}^n)$ such that*

$$\text{supp}(\chi_j) \subseteq j + \frac{3}{2}Q, \quad \sum_{j \in \mathbb{Z}^n} \chi_j(y) = 1 \ ,$$

$$\chi_j(y) = 1 \text{ on } j + \frac{1}{2}Q,$$

where Q is the unit cube $\{y \in \mathbb{R}^n; -1 \leq y_j \leq 1, j = 1, ..., n\}$.

Proof. This can be constructed from a test function $\tilde{\chi}_0(y) \in \mathbb{C}_0^\infty$ which satisfies $\text{supp}(\tilde{\chi}_0) \subseteq \frac{3}{2}Q$, $\tilde{\chi}_0 \geq 0$ and $\tilde{\chi}_0(y) = 0$ for $y \in Q$. Set $\tilde{\chi}_j(y) = \tilde{\chi}_0(y-j)$ for all $j \in \mathbb{Z}^n$; it is supported in the cube $j + \frac{3}{2}Q$. We have finally to adjust the magnitude. But this is easy as we notice that for every $y \in m + Q$,

$$\sum_m \tilde{\chi}_m(y) = \sum_{|k-m|<2} \tilde{\chi}_k(y) > 0.$$

We can simply divide to get

$$\chi_j(y) = \frac{\tilde{\chi}_j(y)}{\sum_k \tilde{\chi}_k(y)}.$$

Notice that $\sum_{0<|k-m|<2} \tilde{\chi}_k(y) = 0$ for $|y-m| < \frac{1}{2}$, hence $\chi_m(y) = 1$ identically on $m + \frac{1}{2}Q$. \square

Theorem 7.12. *For initial data $u_0 \in L^2(\mathbb{R}^n)$, the solution $u(x,t)$ of (7.8) is in $L^2(\mathbb{R}^n)$. Furthermore the initial data can be decomposed into a superposition of compactly supported L^2 functions $\sum_{j \in \mathbb{Z}^n} (u_0)_j$ where each $(u_0)_j(x) \in L^2(j + \frac{3}{2}Q)$. The resulting solution is a superposition of wave packets $u_{jk}(x,t) \in \mathcal{S}$, each of which is asymptotically localized by Theorem 7.10 around the ray $\{\frac{x}{t} = \partial_\xi \omega(k)\}$.*

Proof. The initial data $u_0(x)$ can be decomposed into a sum of compactly supported L^2 functions using a partition of unity from Lemma 7.11;

$$u_0(x) = \sum_{j \in \mathbb{Z}^n} (u_0)_j(x) = \sum_{j \in \mathbb{Z}^n} (\chi_j u_0)(x) \ .$$

Secondly, we may decompose the Fourier transform $\widehat{(u_0)_j}$, using again a partition of unity from Lemma 7.11, with the result that $\widehat{(u_0)_j}\chi_k(\xi) \in C_0^\infty$. Therefore $\mathcal{F}^{-1}(\widehat{(u_0)_j}\chi_k(\xi)) \in \mathcal{S}$, with Fourier support localized in a cube $\frac{3}{2}Q + k \subseteq \mathbb{R}^n_\xi$. Theorem 7.10 applies to each component, which behaves as a wave packet, asymptotically being very well localized near rays determined by the relevant group velocity $\{\frac{x}{t} = \partial_\xi \omega(j)\}$. $\qquad\square$

Exercises: Chapter 7

Exercise 7.1. [Gaussian wave packets for the Schrödinger equation]

Exercise 7.2. [Which functions minimize the Heisenberg uncertainty principle?]

Exercise 7.3. [bounds on moments of the Schrödinger equation]

Exercise 7.4. [Kelvin ship wake problem]

Conservation laws and shocks

Shock waves in the interstellar medium in the Vela Constellation. Courtesy of Angus Lau, Y. Van, SS Tong /Jade Scope Observatory

8.1. First order quasilinear equations

This section is devoted to the study of nonlinear first order scalar equations and their solutions. We will focus on the case of one space and one time

127

dimension. The first example of an equation of this form is Burger's equation

$$(8.1) \qquad \partial_t u + u \, \partial_x u = 0 \ , \qquad x \in \mathbb{R}^1$$
$$u(0, x) = h(x) \ .$$

Nonlinear equations where the derivatives of the unknown function enter only linearly, as they do in (8.1) above, are called *quasilinear*. This equation is reminiscent of the PDEs that were studied in Chapter 2, of the form

$$\partial_t u + c \, \partial_x u = 0 \ ,$$

where c represents the speed of propagation. In quasilinear equations such as (8.1), the speed of propagation depends upon the unknown function $u(t, x)$, that is to say on the solution itself.

Equations of the general form of (8.1) are called *conservation laws*, which is explained as follows. In physical settings the function $u(t, x)$ represents the density of some quantity (such as of a gas, or a concentration of a component of a fluid). A second function $f = f(u)$ represents the *flux* of this quantity, which is assumed to depend upon the density u itself. Then the law of conservation of quantity dictates that over any interval $[a, b) \subseteq \mathbb{R}^1$

$$(8.2) \qquad \partial_t \left(\int_a^b u(t, x) \, dx \right) + f(u(t, b)) - f(u(t, a)) = 0 \ .$$

Namely, the total quantity contained in the interval $[a, b)$ changes in time t only through its flux out of the interval through the point $x = b$ and through its flux into the interval through the point $x = a$.

If $f(u(t, x))$ is differentiable at all $x \in [a, b)$, (8.2) can be rewritten as

$$0 = \partial_t \left(\int_a^b u(t, x) \, dx \right) + \left(\int_a^b \partial_x f(u) \, dx \right)$$
$$= \left(\int_a^b \partial_t u(t, x) + \partial_x f(u) \, dx \right) \ .$$

Of course if $u(t, \cdot) \in C^1(\mathbb{R}^1)$ then for any interval $[a, b)$ this holds, therefore $u(t, x)$ satisfies the PDE

$$\partial_t u + \partial_x f(u) = 0 \ ,$$

which is to say

$$(8.3) \qquad \partial_t u + f'(u) \partial_x u = 0 \ .$$

When the flux function is $f(u) = \frac{1}{2} u^2$ this equation is precisely Burger's equation (8.1).

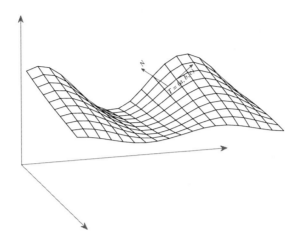

Figure 1. A solution to (8.5) as a graph $(t, x, u(t, x) \subseteq (t, x, z)$.

General first order quasilinear equations. When the initial data is smooth enough, $u(0, x) = h(x) \in C^1(\mathbb{R}^1)$, one solves these equations locally in time by first order methods, consisting of integrating along characteristics. The *characteristic equations* for Burger's equation are

$$\frac{dt}{ds} = 1 \ , \quad \frac{dx}{ds} = z \ , \quad \frac{dz}{ds} = 0 \ .$$

These characteristic ODEs can be solved explicitly,

$$(8.4) \qquad s = t \ , \quad z(s) = z(0) \ , \quad x(s) = x(0) + sz \ .$$

This merits an explanation; we will give an interpretation in geometric terms of first order quasilinear equations in general, and their associated characteristic ODEs. The general quasilinear equation when $(t, x) \in \mathbb{R}^2$ is

$$(8.5) \qquad a(t, x, u)\partial_t u + b(t, x, u)\partial_x u = c(t, x, u) \ .$$

A solution $u(t, x)$ is presented as a graph $(t, x, u(t, x)$ in $(t, x, z) \subseteq \mathbb{R}^3$, whose normal is

$$N = (-\partial_t u, -\partial_x u, 1) \ .$$

The coefficients of the equation (8.5) are interpreted as a vector field $T = (a(t, x, z), b(t, x, z), c(t, x, z))$ in $(t, x, z) \in \mathbb{R}^3$ (the *characteristic vector field*), and the equation (8.5) is the geometrical statement that

$$N \cdot T = 0 \ .$$

This implies that the integral curves $(t(s), x(s), z(s))$ (the *characteristic curves*) of the characteristic vector field

$$(8.6) \qquad \frac{dt}{ds} = a(t, x, z) \ , \quad \frac{dx}{ds} = b(t, x, z) \ , \quad \frac{dz}{ds} = c(t, x, z)$$

lie on the graph $z = u(t, x)$. A solution to (8.5) is given as the union
of a parameter family of such characteristic curves. This family is locally
specified by a condition that the characteristic curves pass through another
given curve $\Gamma = (T(\beta), X(\beta), Z(\beta))$. In the above case of an initial value
problem (8.1) this is the curve $\Gamma = (0, \beta, h(\beta))$, for $\beta \in \mathbb{R}^1$. To ensure that
the solution surface is well defined, one requires that the tangent vectors
to the curve Γ and the tangent vectors to the characteristic curves (8.6)
at points on Γ are transversal, and that they locally span a tangent space
which itself is a graph over the coordinate plane (t, x). This is the condition
on the curve Γ that it be *noncharacteristic*. That is

$$\det \begin{pmatrix} a & b \\ \partial_\beta T & \partial_\beta X \end{pmatrix} \neq 0 \ .$$

In the case (8.1) and for the initial value problem this is to say that

$$\det \begin{pmatrix} 1 & z \\ 0 & 1 \end{pmatrix} \neq 0 \ ,$$

a condition which holds independently of the initial data $z = h(\beta)$.

Applying this construction to Burger's equation (8.4), we have derived
the solution in the form

(8.7) $u(t, x) = z(s, \beta) \ ,$

where $t = s \ , \quad x(s, \beta) = \beta + sz \ , \quad z(s, \beta) = h(\beta) \ .$

Describing this solution process in words, the values of the solution $u(t, x)$
are given by $h(\beta)$ where $(\beta, h(\beta))$ is the point where the characteristic curve
$(t(s, \beta), x(s, \beta), z(s, \beta))$ intersects the $\{t = 0\}$ coordinate plane. Let us as-
sume that the initial data satisfies $h \in C^1(\mathbb{R}^1)$. To present the solution as a
graph, we need to solve the above relations (8.7) for $u(t, x) = z(s, \beta)$. That
is, one considers the Jacobian of the mapping $(s, \beta) \to (t, x)$, which is given
by

(8.8) $\det \begin{pmatrix} t_s & x_s \\ t_\beta & x_\beta \end{pmatrix} = \det \begin{pmatrix} 1 & z(0, \beta) \\ 0 & 1 + s\partial_\beta z(s, \beta) \end{pmatrix} \ .$

For small times $t = s$ the Jacobian will be invertible, but the fact is that
for larger times t the Jacobian determinant has the possibility to vanish.
Indeed whenever $1 + t\partial_\beta h(\beta) = 0$ this is the case, in other words when

$$t = \frac{-1}{\partial_\beta h(\beta)} \ .$$

Therefore, for $h \in C^1(\mathbb{R}^1)$ then $\partial_\beta h$ is bounded and there is an interval of
time for which the above construction gives a C^1 solution to (8.1). However
at the first time t for which the Jacobian vanishes, the graph $z = u(t, x)$ will
fold, developing a vertical tangent, and a discontinuity, or shock, will form.

Theorem 8.1. *If the initial data $h(x)$ for Burger's equation is decreasing at some point $x = \beta$, then the solution will become singular at some time $T^* > 0$, where*

$$T^* = \frac{-1}{\inf_\beta \partial_x h(\beta)} \ .$$

Proof. We will give two proofs of this result. The first follows from the Jacobian calculation that appears above. Let β_0 be a point which minimizes $\partial_x h(x)$. As $t \to T^* = -\big(\partial_x h(\beta_0)\big)^{-1}$ the Jacobian determinant (8.8) tends to zero as the tangent plane of the graph $z = u(t, x)$ becomes vertical. In the case where there is no point which achieves the minimum, nonetheless the Jacobian will tend to zero on a sequence (t_n, x_n) where $t_n \to T^*$ as $n \to +\infty$, implying that the solution $u(t, x)$ has unbounded C^1 norm in the limit.

A second proof of this theorem on the inevitable formation of shocks comes from an implicit relation satisfied by the solution. Namely, since $u = z(s, \beta) = z(0, \beta) = h(\beta)$ and $\beta = x - sz(s, \beta)$, then

$$u(t, x) = h(\beta) = h(x - tu) \ .$$

Taking a derivative of this relation with respect to x,

$$\partial_x u(t, x) = h'(x - ut)(1 - t\partial_x u) \ ,$$

and solving for $\partial_x u$ we get

$$\partial_x u(t, x) = \frac{h'(\beta)}{1 + th'(\beta)} \ .$$

If $h'(\beta_0) < 0$ for some β_0, this expression becomes singular for $t = -(h'(\beta_0))^{-1}$. If β_0 is the infimum of $h'(\beta)$, then the first time $t > 0$ at which this expression becomes singular is precisely T^*. $\qquad\square$

The outcome of these considerations is that we are forced to take into account a sense of a solution of the differential equations which is not necessarily even continuous.

Definition 8.2. The function $u(t, x)$ is a *weak solution* of Burger's equation (8.1) if it satisfies the original conservation law (8.2) for all intervals $[a, b] \subseteq \mathbb{R}^1$.

At points (t, x) at which $u \in C^1$ the notion of weak solution coincides with our usual sense of interpretation of the PDE. However suppose that $u(t, x)$ were discontinuous across a C^1 curve $x = \gamma(t)$, then on every interval

$[a, b)$ which contains a point on the curve a weak solution must satisfy

$$0 = \partial_t \left(\int_a^{\gamma(t)} u \, dx + \int_{\gamma(t)}^b u \, dx \right) + f(u(t, b)) - f(u(t, a))$$

$$= \int_a^{\gamma(t)} \partial_t u \, dx + \dot{\gamma}(t) u_-(t, \gamma(t)) + \int_{\gamma(t)}^b \partial_t u \, dx - \dot{\gamma}(t) u_+(t, \gamma(t))$$

$$+ f(u(t, b)) - f(u(t, a))$$

$$= \int_a^{\gamma(t)} \partial_t u \, dx + f(u_-(t, \gamma(t))) - f(u(t, a))$$

$$+ \int_{\gamma(t)}^b \partial_t u \, dx + f(u(t, b)) - f(u_+(t, \gamma(t)))$$

$$+ \dot{\gamma}(t)[u_-(t, \gamma(t)) - u_+(t, \gamma(t))] - [f(u_-(t, \gamma(t))) - f(u_+(t, \gamma(t)))] .$$

We have used the notation of the limit from the left $\lim_{x \to \gamma(t)_-} u(t, x) = u_-(t, x)$ and similarly for the right limit. Using the definition of a solution in the two regions of regularity $[a, \gamma(t))$ and $(\gamma(t), b]$, we obtain

$$(8.9) \quad 0 = \dot{\gamma}(t)[u_-(t, \gamma(t)) - u_+(t, \gamma(t))] - [f(u_-(t, \gamma(t))) - f(u_+(t, \gamma(t)))] .$$

This is the *jump condition*, matching the speed of propagation of the discontinuity with the magnitude of the jump, that is to be satisfied in order to be a weak solution at a discontinuity.

Theorem 8.3. *A piecewise $C^1(\mathbb{R}_{tx}^2)$ solution $u(t, x)$ of (8.3) which is discontinuous across a curve $x = \gamma(t) \in C(\mathbb{R}^1)$ is a weak solution if:*

(1) it satisfies the PDE at a C^1 points, and

(2) across discontinuities it satisfies the jump condition (8.9), namely

$$(8.10) \qquad\qquad \dot{\gamma}[u_- - u_+] = [f(u_-) - f(u_+)] .$$

One could ask about the variety of scalar conservation laws, for different flux functions $f(u)$. Consider the general case as in (8.3),

$$\partial_t u + f'(u) \partial_x u = 0 .$$

Suppose that $u(t, x) \in C^1$ in some neighborhood $\Omega \in \mathbb{R}_{tx}^2$, and assume that $f(u)$ is strictly convex, which is to say that $f'(u)$ is a strictly increasing function in u. Then $g(v) = (f')^{(-1)}(v)$ is well defined and the transformation $u = g(v)$ is such that in Ω the function $v(t, x)$ satisfies

$$\partial_t u = g'(v) \partial_t v , \quad f'(u) \partial_x u = f'(g(v)) g'(v) \partial_x v .$$

Since $f'(g(v)) = v$ therefore $v(t, x)$ satisfies

$$\partial_t v + v \partial_x v = 0 ,$$

which is of course Burger's equation. That is, for hyperbolic conservation laws with a convex flux function, for smooth solutions all such equations are

identical up to a change of dependent variable. This is not necessarily the case for weak solutions however; Exercise 8.4 discusses the effect of changes of variables on the jump condition.

8.2. The Riemann problem

Under dilations $t' = \alpha t$, $x' = \alpha x$ the equation

$$\partial_t u + c(u)\partial_x u = 0$$

remains invariant. The class of solutions that are also invariant under dilations is particularly simple, and they play an important role in the theory and the applications of such conservation laws. In particular, initial data which is dilation invariant is given by

$$u(0, x) = h(x) \ , \quad h(x) = h_- \text{ for } x < 0 \ , \quad h(x) = h_+ \text{ for } x \geq 0 \ ,$$

where h_\pm are two constants. This is the *Riemann problem*. For Burger's equation

(8.11) $$\partial_t u + u\partial_x u = 0$$

for which solutions are simple and explicit.

Case (1): Given $h_- = 0$ and $h_+ = 1$, then for $t > 0$ a solution is

$$u(t, x) = 0 \ , \text{for } x \leq 0 \ ,$$
$$u(t, x) = \frac{x}{t} \ , \text{for } 0 \leq x \leq t \ ,$$
$$u(t, x) = 1 \ , \text{for } x \geq 0 \ .$$

Such solutions are *rarifaction waves*, as they propagate a decrease in the density of the quantity u. Notice that the solution $u(t, x)$ is not $C^1(\mathbb{R}^2)$ for $t > 0$ but $u \in Lip(\mathbb{R}^2)$.

Case (2): Given $h_- = 1$ and $h_+ = 0$, then for $t > 0$ a solution is necessarily discontinuous; indeed

$$u(t, x) = 1 \ , \text{for } x < \frac{t}{2} \ ,$$
$$u(t, x) = 0 \ , \text{for } x \geq \frac{t}{2} \ .$$

The line of discontinuity given by $x = \frac{t}{2}$ is a *shock* curve. Its speed is determined by the jump condition (8.10); indeed we check this;

$$u_- = 1 \ , \quad u_+ = 0$$
$$u_- - u_+ = 1 \ , \quad f(u_-) - f(u_+) = \tfrac{1}{2}u_-^2 - \tfrac{1}{2}u_+^2 = \tfrac{1}{2} \ ; \quad \text{thus } \dot{\gamma}(t) = \tfrac{1}{2} \ .$$

Case (3): There is another case to consider, namely starting with the initial data of Case (1), $h_- = 0$ and $h_+ = 1$ there is a discontinuous solution

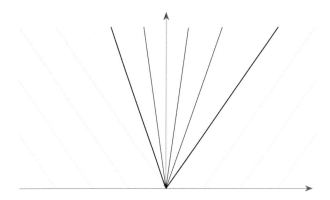

Figure 2. A rarifaction wave for Burger's equation (8.11).

that satisfies all of the conditions that we have so far imposed on solutions. Namely

$$u(t,x) = 0 \text{ , for } x < \frac{t}{2} \text{ ,}$$

$$u(t,x) = 1 \text{ , for } x \geq \frac{t}{2} \text{ .}$$

Checking the jump condition (8.10), we have

$$u_- = 0 \text{ , } \quad u_+ = 1$$

$$u_- - u_+ = -1 \text{ , } \quad f(u_-) - f(u_+) = \tfrac{1}{2}u_-^2 - \tfrac{1}{2}u_+^2 = -\tfrac{1}{2} \text{ ; } \quad \text{thus } \dot{\gamma}(t) = \tfrac{1}{2} \text{ .}$$

This is a primary example of nonuniqueness of weak solutions. In relaxing the definition of a solution in order to accommodate discontinuities, we have increased the class of allowable solutions, and in doing so have lost the property of uniqueness of solutions for given initial data. In order to regain it, one must make a selection of the appropriate solution by imposing a further principle in addition to the definition of a weak solution through the law of conservation.

Definition 8.4 (entropy condition). If $u(t,x)$ is a weak solution of (8.3) which is piecewise C^1, and $x = \gamma(t)$ is a curve along which it has a jump discontinuity, we admit $u(t,x)$ as an *entropy solution* if

(8.12) $$f'(u_-) := c(u_-) > \dot{\gamma} \text{ , } \quad \text{and } f'(u_+) := c(u_+) < \dot{\gamma} \text{ .}$$

This condition brings back uniqueness to the initial value problem, as we will see in the following section. It is important to understand that this is an

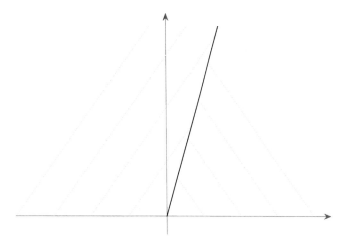

Figure 3. A shock wave for Burger's equation (8.11).

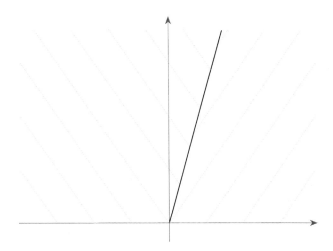

Figure 4. A shock wave for Burger's equation (8.11) that does not satisfy the entropy condition.

additional condition that has been added to the evolution problem for (8.3), above and beyond the concept of a weak solution to a conservation law. In particular, this choice of acceptable solution has introduced a distinction between future and past, a so-called *arrow of time*. It means that as time increases towards the future, characteristics which neighbor a shock curve must run into the shock. The solution of the Riemann problem for Burger's equation in Case (2) satisfies the entropy condition, while the solution of

the Riemann in Case (3) does not satisfy it, and characteristics can and
do originate on the shock curve and propagate away from it. In terms of
entropy, for a shock that satisfies the entropy condition, information carried
along characteristics of a solution will pass into the shock and disappear.
However in Case (3), information could be generated in the shock curve itself,
and propagate into the future; indeed another possible weak solution for the
initial data given in Case (3) is a modification of the shock curve $\gamma(t) = t/2$,
for which at each second after $t > 0$ (and for some small value of β) the
shock curve satisfies $\dot\gamma = 1/2 \pm \beta$. Choosing the sign of $\pm\beta$ each subsequent
second gives a coding in binary, and in principle we may encode all of the
Oxford English Dictionary in a weak solution of Burger's equation, which
itself is one of a infinite number of nonunique solutions. Thus it makes sense
to impose the entropy condition as a selection principle for weak solutions.

8.3. Lax – Olenik solutions

So far, for scalar hyperbolic conservation laws we have constructed solutions
locally in time using the method of characteristics, and for special Riemann
initial data we have global in time and quite explicit solutions that exhibit
shocks and rarifaction waves. There is a beautiful extension of these con-
siderations that gives global weak solutions for general $L^1(\mathbb{R}^1)$ initial data,
solutions which satisfy the entropy condition of Definition 8.4. Furthermore
uniqueness holds for this class of solutions. A nice reference for this material
is [Lax].

Consider a general scalar conservation law for $f \in C^2$

$$\partial_t u + \partial_x f(u) = 0 \ ,$$

which we rewrite as

$$(8.13) \qquad\qquad \partial_t u + a(u)\partial_x u = 0 \ ,$$

where evidently $a(u) = \partial_u f(u)$. Without loss of generality we may assume
that $f(0) = 0$. We take up the study of the initial value problem for initial
data $h(x) = u(0,x) \in L^1(\mathbb{R}^1)$. The principal hypothesis is that the flux
function $f(u)$ is strictly convex; this assures that the coefficient $a(u)$ is
monotone increasing in u. This hypothesis is satisfied for example in the
case of Burger's equation, where $f(u) = \frac{1}{2}u^2$.

Convexity and convex duality. The properties of $f(u)$ and $a(u)$ are used
in several ways. Firstly the following inequality holds for arbitrary u and v;

$$(8.14) \qquad\qquad f(v) + a(v)(u-v) \le f(u) \ ,$$

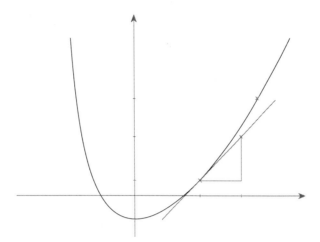

Figure 5. Property of convexity, as described in the inequality (8.14).

and because of strict convexity, equality holds only for $u = v$. Being convex, $f(v)$ has a convex dual defined by

$$g(z) := a(v)v - f(v) \;, \quad \text{where} \quad z = a(v) \;.$$

The dual has the alternative definition

$$g(z) = \min_v \big(zv - f(v)\big) \;,$$

where the minimum is taken on when $\partial_v\big(zv - f(v)\big) = 0$, namely for $z - \partial_u f(v) = 0$. This is similar in the setting of a Lagrangian $L(\dot u, u)$ to the Legendre transform , which is globally defined when L is convex in the variables $\dot u$.

Since $a(v)$ is increasing in v we may define its inverse function; setting $v = b(z)$ whenever $a(v) = z$. Incidentally, when $v = b(z)$, z is the minimizer of the function

$$f(v) = \min_z \big(zv - g(v)\big) \;,$$

namely $v = \partial_z g(z) = b(z)$. It follows from a short calculation that $g(z)$ is convex. Examples of convex functions and their convex duals are given by

$$f(v) = \frac{A}{2}v^2 \;, \quad g(z) = \frac{1}{2A}z^2 \;,$$

and

$$f(v) = \frac{1}{p}v^p \;, \quad g(z) = \frac{1}{p'}z^{p'} \;, \quad \text{where} \quad \frac{1}{p} + \frac{1}{p'} = 1 \;;$$

both of which are straightforward to check.

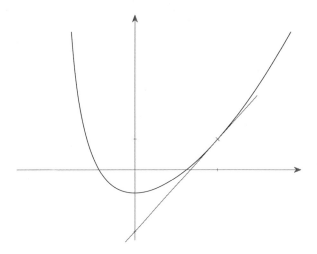

Figure 6. Convex duality.

Hamilton – Jacobi equations. It is useful to change the problem to the setting of a Hamilton – Jacobi equation, namely to study

$$U(t, x) = \int_{-\infty}^{x} u(t, x') \, dx' \ ,$$

so that $\partial_x U = u$. Then U satisfies

(8.15) $$\partial_t U + f(\partial_x U) = 0 \ .$$

Initial data is given by

$$H(x) = \int_{-\infty}^{x} h(x') \, dx' \ ,$$

which is Lipschitz continuous since we have asked that $h \in L^1$. Furthermore for almost all x_1 we have[1]

$$H(x_2) - H(x_1) = h(x_1)(x_2 - x_1) + o(|x_2 - x_1|) \ .$$

Whenever $u(t, x) \in C^1(\mathbb{R}^1)$ then $U(t, x)$ is a classical solution to (8.15). By convexity, given a solution U of (8.15), for any v then (8.14) implies that

(8.16) $$\partial_t U + \partial_u f(v) \partial_x U = \partial_u f(v) \partial_x U - f(\partial_x U) \leq \partial_u f(v) v - f(v) \ .$$

Because of strict convexity, equality holds only for $v = \partial_x U$.

For purposes of constructing a solution, given a space-time point (t, x) with $t > 0$, consider the line through it with slope $a(v) = \partial_u f(v)$; the

[1]Using big $\mathcal{O}(\cdot)$ and little $o(\cdot)$ notation:

intersection with the x-axis defines y such that

$$\frac{x-y}{t} = a(v) = z .$$

The LHS of inequality (8.16) has the interpretation as the directional derivative of the function $U(t,x)$ along this line, while the RHS depends only on the parameter v. Integrating (8.16) along this line gives that

$$(8.17) \quad U(t,x) \le U(0,y) + t\big(a(v)v - f(v)\big) = H(y) + t\big(a(v)v - f(v)\big) .$$

Interpret this inquality in terms of convex duality; take $z = a(v)$ and $g(z) = a(v)v - f(v)$ as above. That is, $b(z) = v$ the inverse function, so that when

$$z = \frac{x-y}{t} = a(v) , \quad \text{then} \quad b(z) = b\big(\frac{x-y}{t}\big) = v .$$

This gives a reinterpretation of the inequality (8.17), articulated in the following proposition.

Proposition 8.5. If $u(t,x)$ is a solution of (8.13) which is Lipschitz at $x \in \mathbb{R}^1$ at time $t > 0$, then

$$(8.18) \qquad\qquad u(t,x) = b\big(\frac{x-y}{t}\big) = h(y(t,x)) ,$$

where $y = y(t,x)$ minimizes the relation involving the initial data $H(y)$;

$$(8.19) \qquad\qquad H(y) + tg\big(\frac{x-y}{t}\big) := G(x,y;t) .$$

The ray $(x - y(t,x))/t$ is the backwards characteristic between (t,x) and $(0, y(t,x))$ over the time interval $[0,t]$.

Lax – Olenik solutions. Now suppose that $u(t,x)$ is a weak solution, with possible jump discontinuities. Then nonetheless

$$U(t,x) = \int_{-\infty}^{x} u(t,x')\, dx'$$

which is Lipshitz (as long as $u(\cdot, x) \in L^1$), and the inequality still holds that

$$\partial_t U + \partial_u f(v)\partial_x U \le \partial_u f(v)v - f(v) .$$

If $u(t,x)$ is a weak solution that in addition satisfies the entropy condition (8.12) at each discontinuity,

$$u_+ \le \frac{d\gamma}{dt} \le u_- ,$$

then every point $(t,x) \in \mathbb{R}_t^+ \times \mathbb{R}_x$ is connected to the initial data at $t = 0$ by at least one ray $(x - y)/t = a(v)$ since backward characteristics do not intersect shock curves. For each minimizing value of y, equality holds in (8.16). The elegant aspect of the theory is that the converse holds. Namely, the variational formula given by (8.18)(8.19) defines a weak solution to (8.13) that in addition satisfies the entropy condition at every discontinuity.

Theorem 8.6. *Formulae* (8.18)(8.19) *define a possibly discontinuous function* $u(t, x)$ *for arbitrary initial data* $h(x) \in L^1(\mathbb{R}^1)$, *which is a weak solution with at most countably many jump discontinuities, and which satisfies the entropy condition at such discontinuities.*

The function $u(t, x)$ defined by (8.18)(8.19) is called the *Lax – Olenik* solution.

Proof. First of all, because $h(x) \in L^1$ then $H(x)$ is bounded, and the convex dual $g(z) = a(v)v - f(v)$, for $v = b(z)$ taken over the range of $H(y)$ has its minimum at some $z = c$ where $\partial_z g(z) = 0$. Therefore $G(x, y; t)$ is minimized, and takes on its minimum at some finite y. This minimizer is possibly nonunique. If y is the unique minimizer of $G(x, y; t)$ then $\partial_y G(x, y; t) = 0$, at least for *a.e.* y at which H' exists, which implies that

$$0 = H'(y) - g'\left(\frac{x - y}{t}\right) = h(y) - b\left(\frac{x - y}{t}\right) .$$

In fact this $y = y(t, x)$ is the minimizer for all points on the ray between $(0, y)$ and (t, x); indeed for $0 < t_1 < t$ and for x_1 such that

$$\frac{x_1 - y}{t_1} = \frac{x - y}{t}$$

then $\partial_y G(x_1, y; t_1) = 0$ so that $h(y) = b(\frac{x_1 - y}{t_1})$ as well. Thus the partial differential equation (8.13) is satisfied along this ray, and $u(t, x) = h(y) = u(t_1, x_1)$.

However it could be that for given (t, x) then $G(x, y; t)$ has more than one minimizer y. In this case the following property of $y(t, x)$ is useful.

Lemma 8.7. *Fix* $t > 0$ *and denote* $y = y(t, x)$ *the minimizers of* $G(x, y; t)$. *Then* $y(t, x)$ *is a nondecreasing function of* x.

proof of Lemma 8.7. The result will follow from the following fact, which we shall prove; Take $x_2 > x_1$, then $G(x_2, y_1) < G(x_2, y)$ for all $y < y_1$. This fact depends upon the convexity of the function g;

$$(8.20) \qquad g\left(\frac{x_2 - y_1}{t}\right) + g\left(\frac{x_1 - y}{t}\right) < g\left(\frac{x_1 - y_1}{t}\right) + g\left(\frac{x_2 - y_1}{t}\right) .$$

The intervals $[(x_2 - y_1)/t, (x_1 - y)/t]$ and $[(x_1 - y_1)/t, (x_2 - y)/t]$ share the same midpoint, and by convexity the sketch in Figure 7 proves the inequality:

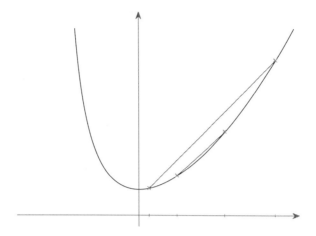

Figure 7. Geometric proof of the inequality.

Recall that $G(x, y; t) = H(y) + tg((x - y)/t)$; multiply inequality (8.20) by t and respectively add $G(x_1, y_1; t) \leq G(x_1, y; t)$ to each side, obtaining

$$t\Big(g\big(\frac{x_2 - y_1}{t}\big) + g\big(\frac{x_1 - y}{t}\big)\Big) + G(x_1, y_1; t)$$
$$\leq t\Big(g\big(\frac{x_1 - y_1}{t}\big) + g\big(\frac{x_2 - y}{t}\big)\Big) + G(x_1, y; t) \ .$$

Using the definition (8.19) for $G(x, y; t)$, this is the statement that

$$tg\big(\frac{x_2 - y_1}{t}\big) + H(y_1) \leq tg\big(\frac{x_2 - y}{t}\big) + H(y) \ ,$$

which is to say that for $y < y_1$

$$G(x_2, y_1; t) \leq G(x_2, y; t) \ .$$

Thus if y_1 is a minimizer for $x = x_1$, then any minimizer for $x_2 > x_1$ must satisfy $y_2 > y_1$. □

The first conclusion we draw from this monotonicity is that for fixed $t > 0$ the mapping $x \mapsto y(t, x)$ is increasing in x, with only countably many jump discontinuities. Suppose that $G(x, y; t)$ has more than one minimizer, and let y^- be the least minimizer of $G(x, y; t)$ and $y^+ > y^-$ the greatest. Because of the property of monotonicity, for fixed $t > 0$ if $x_1 < x$ then any y_1 that is a minimizer of $G(x_1, y; t)$ must satisfy $y_1 < y^-$, while if $x_1 > x$ then $y_1 > y^+$. Therefore the interval $[y^-, y^+]$ is a jump discontinuity of $y(t, x)$; and it follows that there can only be countably many points x for which the minimizer $y = y(t, x)$ is not unique.

Figure 8. The characteristics in cases of unique and nonunique min-
imzers of the Lax – Olenik variational principle.

Now consider $t_1 > t$; for all $x_1 \in \mathbb{R}^1$ a minimizer $y(t_1, x_1)$ either satis-
fies $y(t_1, x_1) < y^-(t, x)$ or else $y^+(t, x) < y(t_1, x_1)$; this is because for any
$y^-(t, x) < y < y^+(t, x)$ the ray from (t_1, x_1) to $(0, y)$ will intersect one of
the rays (t, x) to $(0, y^\pm(t, x))$, and therefore cannot have the minimizing
slope of the latter. Hence when $t_1 > t$, for each interval $[y^-(t, x), y^+(t, x)]$
of jump discontinuity of $y(t, \cdot)$ there is a point x_1 with multiple minimizers
of $G(x_1, y; t_1)$ and a corresponding interval $[y^-(t_1, x_1), y^+(t_1, x_1)]$ represent-
ing a jump in $y(t_1, x)$. In particular, if $\{x^k\}$ and $\{x_1^j\}$ are the points of
discontinuity of $y(t, x)$ and $y(t_1, x)$ at times t and $t_1 > t$ respectively, then

$$\bigcup_k [y^-(t, x^k), y^+(t, x^k)] \subseteq \bigcup_j [y^-(t_1, x_1^j), y^+(t_1, x_1^j)] .$$

The union of these points with nonunique minimizers form a set of *shock
curves*, which by the above property may merge and may come into exis-
tence, but which may not split as t increases. The presence of such space-
time points for which $G(x, y; t)$ has nonunique minimizers implies that a
solution given through the Lax – Olenik variational principle is not a clas-
sical solution. We now show that it is a weak solution in the sense that it
satisfies the jump condition (8.9) at points on shock curves.

Consider $t_1 > t$ and points (t, x) and (t_1, x_1) on a shock curve, where
each has nonunique minimizers y^\pm and y_1^\pm respectively, and such that

$$[y^-(t, x), y^+(t, x)] \subseteq [y_1^-(t_1, x_1), y_1^+(t_1, x_1)] .$$

Since they are nonunique minimizers, from the Lax – Olenik variational
principle we know that

(8.21) $G(x, y^-; t) = G(x, y^+; t) , \quad G(x_1, y_1^-; t_1) = G(x_1, y_1^+; t_1) ,$

where of course $G(x, y; t) = H(y) + tg(\frac{x-y}{t})$. Interpreting (8.21) in terms
of $f(v)$, and denoting $v^\pm = b(z^\pm) = b(\frac{x-y^\pm}{t})$, $v_1^\pm = b(z_1^\pm) = b(\frac{x_1-y_1^\pm}{t_1})$, the
equalities (8.21) become

(8.22) $t[f(v^+) - f(v^-)] - [v^+(x - y^+) - v^-(x - y^-)] = H(y^+) - H(y^-) ,$

and

(8.23) $t_1[f(v_1^+) - f(v_1^-)] - [v_1^+(x_1 - y_1^+) - v_1^-(x_1 - y_1^-)] = H(y_1^+) - H(y_1^-) .$

Taking the difference of (8.23) and (8.22) and using that

$$H(y_1^{\pm}) - H(y^{\pm}) = h(y^{\pm})(y_1^{\pm} - y^{\pm}) + o(y_1^{\pm} - y^{\pm}) \,,$$

we find

(8.24) $(t_1 - t)[f(v^+) - f(v^-)] - (x_1 - x)[v^+ - v^-]$

$$= -t_1[f(v_1^+) - f(v^+) - f(v_1^-) + f(v^-)]$$

$$+ [(v_1^+ - v^+)(x_1 - y^+) - (v_1^- - v^-)(x_1 - y^-)] + o(y_1^{\pm} - y^{\pm}) \,.$$

Now

$$f(v_1^{\pm}) - f(v^{\pm}) = a(v^{\pm})(v_1^{\pm} - v^{\pm}) + o(v_1^{\pm} - v^{\pm}) \,,$$

therefore the RHS of (8.24) is given by

$$- t_1[a(v^+)(v_1^+ - v^+) - a(v^-)(v_1^- - v^-)]$$

$$- [(v_1^+ - v^+)(x_1 - y^+) - (v_1^- - v^-)(x_1 - y^-)]$$

$$+ o(v_1^{\pm} - v^{\pm}) + o(y_1^{\pm} - y^{\pm})$$

$$= -t_1[a(v^+)(v_1^+ - v^+) - a(v^-)(v_1^- - v^-)$$

$$- (v_1^+ - v^+)\left(\frac{x - y^+}{t}\right) + (v_1^- - v^-)\left(\frac{x - y^-}{t}\right)]$$

$$+ o(v_1^{\pm} - v^{\pm}) + o(y_1^{\pm} - y^{\pm}) + o(x_1 - x) + o(t_1 - t) \,.$$

Observing that $a(v^{\pm}) = \frac{x-y^{\pm}}{t}$ and that $o(v_1^{\pm} - v^{\pm})$ and $o(y_1^{\pm} - y^{\pm})$ are $o(x_1 - x) + o(t_1 - t)$, we have shown that the LHS is $o(x_1 - x) + o(t_1 - t)$. This is tantamount to the jump condition (8.9), and hence the function $u(t, x)$ defined through the Lax – Olenik variational principle (8.18)(8.19) is indeed a weak solution of (8.13).

It remains to verify that the solution given by (8.18)(8.19) in Proposition 8.5 satisfies the entropy condition for the conservation law (8.13). Use again that $f \in C^2$ is convex so $b(z) \in C^1$ is increasing, and that $y = y(t, x)$ is increasing in x. Therefore for $x_1 < x_2$

(8.25) $$u(t, x_1) = b\left(\frac{x_1 - y_1}{t}\right) \geq b\left(\frac{x_1 - y_2}{t}\right)$$

$$\geq b\left(\frac{x_2 - y_2}{t}\right) - C_b\frac{x_2 - x_1}{t}$$

$$= u(t, x_2) - C_b\frac{x_2 - x_1}{t} \,,$$

where one uses in the second line that $b(z)$ has Lipschitz constant C_b;

$$b(z_2) - b(z_1) \leq C_b(z_2 - z_1) \quad \text{for} \quad z_1 \leq z_2 \,.$$

Therefore approaching a point x of discontinuity of $u(t, x) = b((x - y)/t)$ from the left by x_1 and from the right by x_2, our solutions satisfies

$$u^-(t, x) \geq u^+(t, x) \,,$$

which is the entropy condition for a jump discontinuity. □

Uniqueness. The solution satisfying the entropy condition constructed by the Lax – Olenik variational principle is unique, as we show with an argument involving contractions in L^1. Consider two initial conditions $h_1(x), h(2(x) \in L^1$ and their resulting Lax – Olenik solutions $u_1(t,x)$ and $u_2(t,x)$. We will show that the difference in L^1 norm of the two solutions is a decreasing function of time. The L^1 norm of their difference is

$$\|u_1(t,\cdot) - u_2(t,\cdot)\|_{L^1} = \int_{-\infty}^{+\infty} |u_1(t,x) - u_2(t,x)|\, dx$$

$$= \sum_n (-1)^n \int_{y_n(t)}^{y_{n+1}(t)} (u_1(t,x) - u_2(t,x))\, dx \ ,$$

where the $y_n(t)$ are the points of sign changes of the difference $u_1(t,x) - u_2(t,x)$, with $\mathrm{sgn}(u_1(t,x)-u_2(t,x)) = (-1)^n$ over the interval $(y_n(t), y_{n+1}(t))$. We will analyse the behavior of the individual integrals of this sum.

Case (1): Suppose that $y_n(t)$ is a point of continuity for both $u_1(t,x)$ and $u_2(t,x)$. In this case both these solutions are constant along characteristics, which in turn are linear. Therefore $y_n(t)$ is linear in t, and $u_1(t,y_n(t)) - u_2(t,y_n(t)) = 0$.

Case (2): When $y_n(t)$ is a point of discontinuity of either $u_1(t,x)$ or $u_2(t,x)$ or both. Then $y_n(t)$ is a shock curve.

Using the nature of conservation laws and their weak solutions, the time derivative of the difference satisfies

$$\frac{d}{dt}\|u_1(t,x) - u_2(t,x)\|_{L^1} = \sum_n (-1)^n \frac{d}{dt} \int_{y_n(t)}^{y_{n+1}(t)} (u_1(t,x) - u_2(t,x))\, dx$$

$$+ \sum_n (-1)^n \int_{y_n(t)}^{y_{n+1}(t)} \partial_t(u_1(t,x) - u_2(t,x))\, dx$$

$$+ \sum_n (-1)^n \Big[(u_1(t,y_{n+1}(t)) - u_2(t,y_{n+1}(t)))\frac{dy_{n+1}}{dt}$$

$$- u_1(t,y_n(t)) - u_2(t,y_n(t))\frac{dy_n(t)}{dt}\Big] \ .$$

Each term of the sum, after integration, takes the form

$$(-1)^n \frac{d}{dt} \int_{y_n(t)}^{y_{n+1}(t)} (u_1(t,x) - u_2(t,x))\, dx$$

$$= (-1)^n \Big((f(u_1(t,\cdot)) - f(u_2(t,\cdot)))\Big|_{y=y_n(t)}^{y_{n+1}(t)} \Big) + (u_1(t,y) - u_2(t,y))\frac{dy}{dt}\Big|_{y=y_n(t)}^{y_{n+1}(t)}$$

For endpoints $y_n(t)$ in case (1), $u_1(t, y_n) = u_2(t, y_n)$ and there is no contribution to the sum. For endpoints in case (2) there are subcases, of which we will do one example. Suppose that it is $u_1(x, t)$ that has an entropy condition satisfying jump at $y = y_{n+1}(t)$, at which $u_1^+ \leq u_2 \leq u_1^-$, while u_2 is continuous. Then over the left-hand interval (y_n, y_{n+1}) we know that $u_1(t, x) - u_2(t, x) > 0$ so n is even. The jump condition at $y_{n+1}(t)$ is that

$$\frac{dy}{dt} = \frac{f(u_1^-) - f(u_1^+)}{u_1^- - u_1^+}$$

and by the convexity of $f(u)$ we have

$$f(u_2) - f(u_1^-) + (u_1^- - u_2)\left(\frac{f(u_1^-) - f(u_1^+)}{u_1^- - u_1^+}\right)$$

$$\leq f(u_2) - \left(\frac{u_2 - u_1^+}{u_1^- - u_1^+}f(u_1^-) + \frac{u_1^- - u_2}{u_1^- - u_1^+}f(u_1^+)\right) \leq 0 .$$

Hence this boundary term gives a negative contribution;

$$(-1)^n (u_1 - u_2)(y)\frac{dy}{dt}\bigg|_{y=y_{n+1}(t)} \leq 0 .$$

Inspecting the other cases, they also only give negative contributions. Hence the L^1 norm of the difference is decreasing. In case that the initial data satisfies $h_1 = h_2$, this implies the uniqueness of entropy condition satisfying solutions, and thus uniqueness for the class of Lax – Olenik solutions.

Exercises: Chapter 8

Exercise 8.1. Suppose that $f(x, u) = b(x)u$ is the flux function for a linear scalar conservation law, and consider a solution $u(t, x) \in C^1(\mathbb{R}^2)$;

$$\partial_t u + \partial_x(b(x)u) = 0 .$$

Suppose that $x = X_1(t)$ and $x = X_2(t)$ are two characteristic curves such that $X_1(t) < X_2(t)$. Show that for all $t \in \mathbb{R}^1$

$$\int_{X_1(t)}^{X_2(t)} u(t, x)\, dx = \int_{X_1(0)}^{X_2(0)} u(0, x)\, dx .$$

Exercise 8.2. Solve the linear scalar conservation law with flux function $f(x, u) = x^3 u$;

$$\partial_t u + \partial_x(x^3 u) = 0 , \qquad u(0, x) = h(x) .$$

Is the solution unique? Does $h(x) \in C^\infty$ imply that $u(t, x) \in C^\infty$?

Exercise 8.3. (i) Give the general (entropy condition satisfying) solution to Burger's equation with the Riemann data

$$u(0, x) = h(x) \ ;$$
$$h(x) = h_- \quad x < 0 \ , \qquad h(x) = h_+ \quad x \geq 0 \ .$$

(ii) Work out the more complicated but still explicit (entropy condition satisfying) solution to the family of problems with piecewise constant initial data $u(0, x) = h(x)$, where

$$h(x) = h_- \quad x < -1 \ , \qquad h(x) = h_0 \quad -1 \leq x < 1 \ , \qquad h(x) = h_+ \quad x \geq 1 \ .$$

Note: These solutions are global in $(t, x) \in \mathbb{R}^1_+ \times \mathbb{R}^1$, and they involve shock interactions and interactions between shocks and rarifaction waves. There are eight cases, depending on the relative inequalities between h_-, h_0, h_+.

Exercise 8.4. On a domain $\Omega \subseteq \mathbb{R}^2$ in which $u(t, x) \in C^1$ solves a general scalar conservation law with convex flux $f(u)$, we showed above that the problem (8.3) is equivalent to Burger's equation, up to transformation of dependent variables. Suppose now that $u(t, x)$ is only a piecewise C^1 weak solution of this conservation law, with C^1 shock curves. Under transformation does it satisfy the jump condition (8.9) for Burger's equation? If not, what condition does it satisfy?

Exercise 8.5. Problem exhibiting loss of smoothness for Euler's equations in \mathbb{R}^3 in a sheer flow (example of Bardos & Titi, and P.-L. Lions)